HISTORIC PHOTOS OF
CLEVELAND

TEXT AND CAPTIONS BY RONALD L. BURDICK AND
MARGARET L. BAUGHMAN

TURNER
PUBLISHING COMPANY
NASHVILLE, TENNESSEE PADUCAH, KENTUCKY

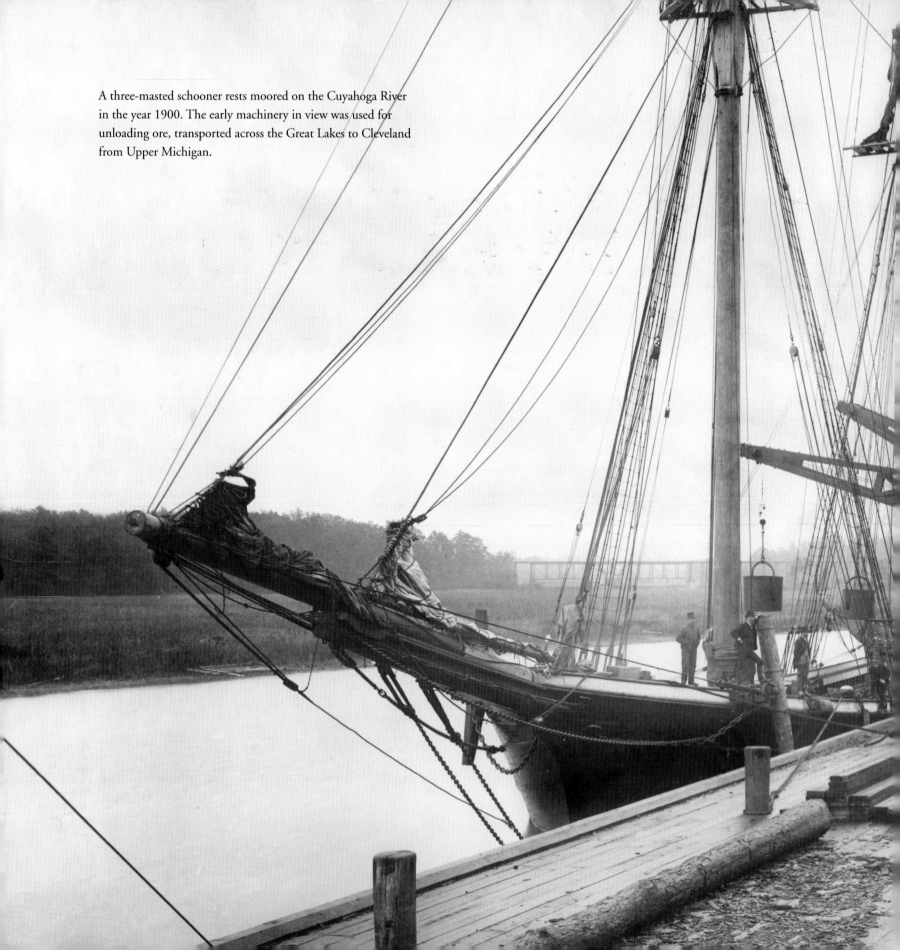

A three-masted schooner rests moored on the Cuyahoga River in the year 1900. The early machinery in view was used for unloading ore, transported across the Great Lakes to Cleveland from Upper Michigan.

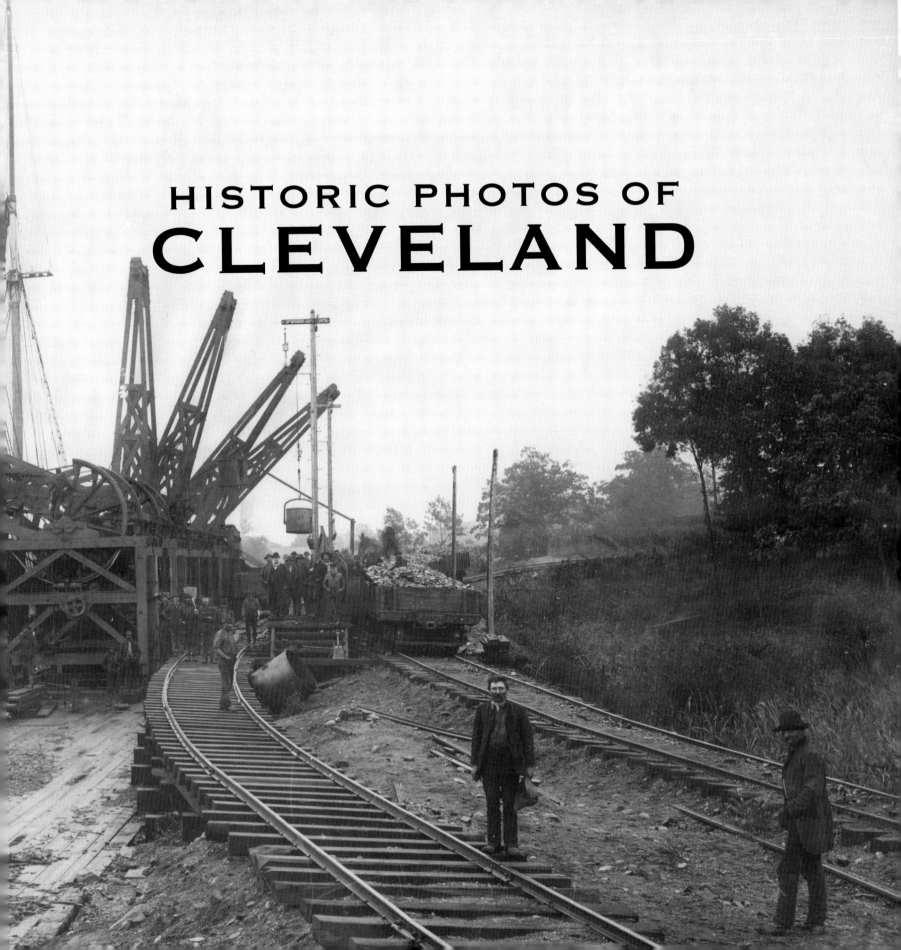

HISTORIC PHOTOS OF
CLEVELAND

Turner Publishing Company
200 4th Avenue North • Suite 950 412 Broadway • P.O. Box 3101
Nashville, Tennessee 37219 Paducah, Kentucky 42002-3101
(615) 255-2665 (270) 443-0121

www.turnerpublishing.com

Historic Photos of Cleveland

Library of Congress Control Number: 2006937087

ISBN: 1-59652-331-X
ISBN-13: 978-1-59652-331-9

Printed in the United States of America

08 09 10 11 12 13 14 15—0 9 8 7 6 5 4 3

Contents

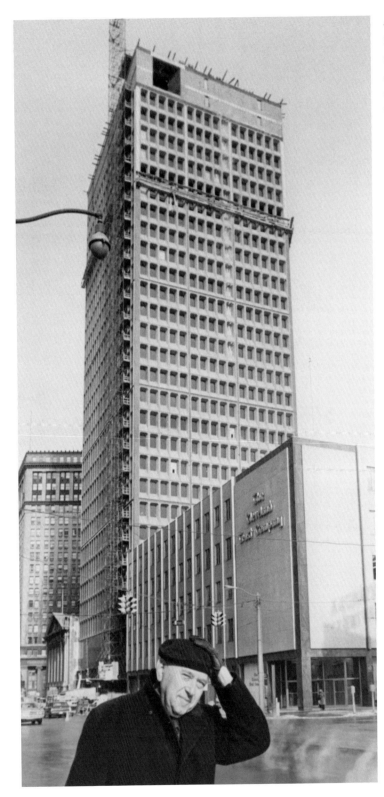

Architect Marcel Breuer stands in front of Cleveland Trust Tower, the addition he designed to accommodate the Cleveland Trust Co. offices. The future of this building is uncertain.

ACKNOWLEDGMENTS

This volume, *Historic Photos of Cleveland,* is the result of the cooperation and efforts of many individuals, organizations, and corporations. It is with great thanks that we acknowledge in particular the valuable contribution of the following for their generous support:

The Cleveland Public Library
The Library of Congress

The authors would like to thank the following individuals at Cleveland Public Library for their valuable contribution and assistance in making this work possible:

Colleagues
Jean M. Collins, Librarian, Literature Department
Amy E. Dawson, Librarian, Catalog Department
Maureen T. Mullin, Librarian, Head, Business, Economics, and Labor

Photograph Collection Staff
Venechor Boyd
Neletha Chambers
Elmer F. Turner III

PREFACE

Cleveland has thousands of historic photographs that reside in archives, both locally and nationally. This book began with the observation that, while those photographs are of great interest to many, they are not easily accessible. During a time when Cleveland is looking ahead and evaluating its future course, many people are asking, How do we treat the past? These decisions affect every aspect of the city—architecture, public spaces, commerce, infrastructure—and these, in turn, affect the way that people live their lives. This book seeks to provide easy access to a valuable, objective look into the history of Cleveland.

The power of photographs is that they are less subjective than words in their treatment of history. Although the photographer can make decisions regarding subject matter and how to capture and present it, photographs do not provide the breadth of interpretation that text does. For this reason, they offer an original, untainted perspective that allows the viewer to interpret and observe.

This project represents countless hours of review and research. The researchers and writers have reviewed thousands of photographs in numerous archives. We greatly appreciate the generous assistance of the individuals and organizations listed in the acknowledgments of this work, without whom this project could not have been completed.

The goal in publishing this work is to provide broader access to this set of extraordinary photographs that seek to inspire, provide perspective, and evoke insight that might assist people who are responsible for determining Cleveland's future. In addition, the book seeks to preserve the past with adequate respect and reverence.

With the exception of touching up imperfections caused by the damage of time and cropping where necessary, no other changes have been made. The focus and clarity of many images is limited to the technology and the ability of the photographer at the time they were taken.

The work is divided into eras. Beginning with some of the earliest known photographs of Cleveland, the first section

records photographs from the city's earliest days. The second section spans the years 1870 to 1929, Cleveland's "golden era." Section Three moves from the Great Depression to the post–World War II era. The last section concludes with a look at images from recent times.

In each of these sections we have made an effort to capture various aspects of life through our selection of photographs. People, commerce, transportation, infrastructure, religious institutions, and educational institutions have been included to provide a broad perspective.

We encourage readers to reflect as they go walking in Cleveland, strolling through the city, its parks, and its neighborhoods. It is the publisher's hope that in utilizing this work, longtime residents will learn something new and that new residents will gain a perspective on where Cleveland has been, so that each can contribute to its future.

Todd Bottorff, Publisher

A view of Public Square in 1857 looking east, with the Forest City House hotel, built in 1852, on the corner at right-center. The fences were erected to block traffic from running through the square. In the background is the steeple of Second Presbyterian Church, located on the south side of Superior just east of Public Square.

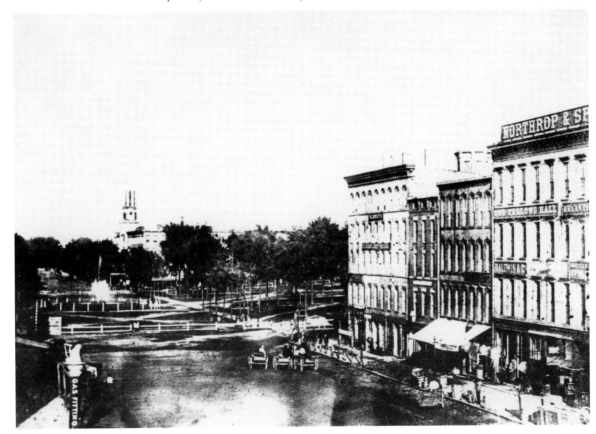

VILLAGE TO CITY

(1850–1869)

In the period leading up to the Civil War, Cleveland, like many other cities in the Great Lakes region, transformed itself from a small village into a thriving urban center.

As the decade of the 1850s opened Cleveland's population was 17,034. By the end of the 1860s it had more than doubled to 43,417. This small town laid out by Moses Cleaveland in 1796, at the mouth of the Cuyahoga River, had capitalized on its location and resources, and would emerge into one of the nation's leading urban centers.

Cleveland became an important port on Lake Erie, and served as the northern terminus of the Ohio and Erie Canal system connecting the Ohio River with Lake Erie. The lake port and canal made the city an important trading and processing center for grain. The arrival of the railroad strengthened Cleveland's position as a transportation center.

Iron ore was being shipped from Upper Michigan to steel mills in Cleveland and elsewhere in the region and sparked the growth of a ship-building industry, as well as the emergence of numerous manufacturing enterprises. By the end of the 1860s Cleveland was home to 35 oil refineries and 14 rolling mills, which provided more than 9,000 manufacturing jobs.

Central to Cleveland, and still a significant visual element in the city's landscape, is Public Square. Set aside in 1796 as a part of the city's original plan, the ten-acre open space reflects the New England roots of the original settlers. As new residential areas were developed eastward from the square, warehouses and related enterprises arose along the Cuyahoga's eastern banks.

The city played a significant role in events leading up to the Civil War. Clevelanders generally opposed slavery, and the city was a principal stop along the Underground Railroad. Following the fall of Fort Sumter in 1861, Cleveland responded to President Lincoln's call for troops and many citizens left behind businesses to help the Union battle the South in the Civil War.

The Morgan residence, Newburgh township, at what is now Broadway
and Aetna Road in Cleveland, 1850.

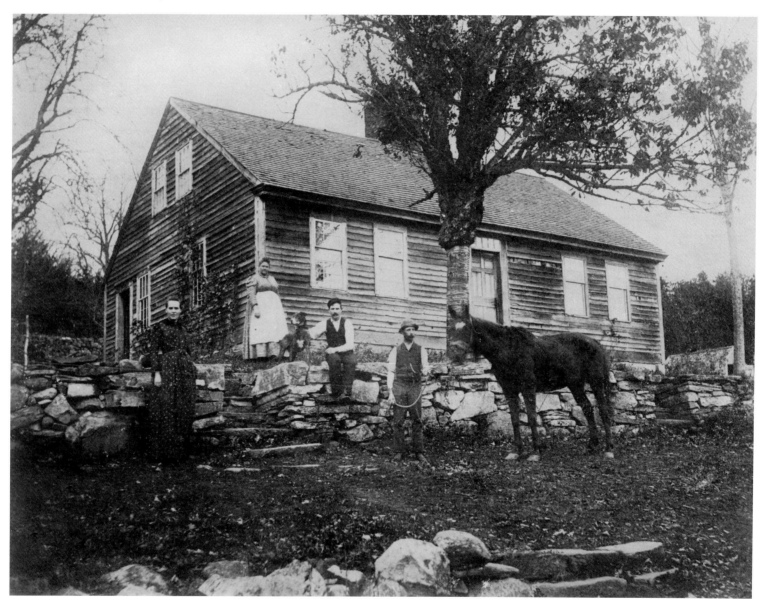

McIlrath Tavern, ca. 1850. The hostelry was built by Abner McIlrath in 1832 at the northwest corner of Euclid and Superior avenues in East Cleveland. It served as tavern, voting place, and as an informal community center for many years. Following McIlrath's death the business closed, and after many years of neglect the building was razed, in 1890.

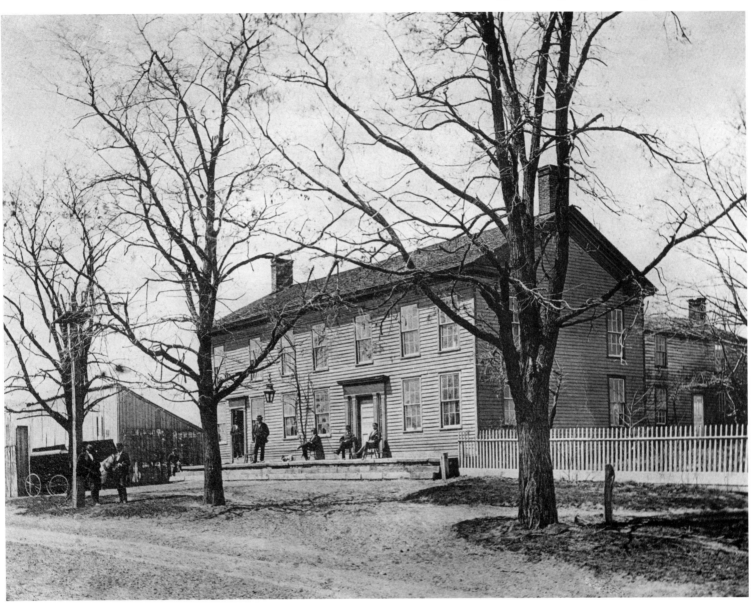

Civil War veterans gather on Public Square in front of the post office building. The veterans display their battle flags during the ceremony for mustering out of the regiment.

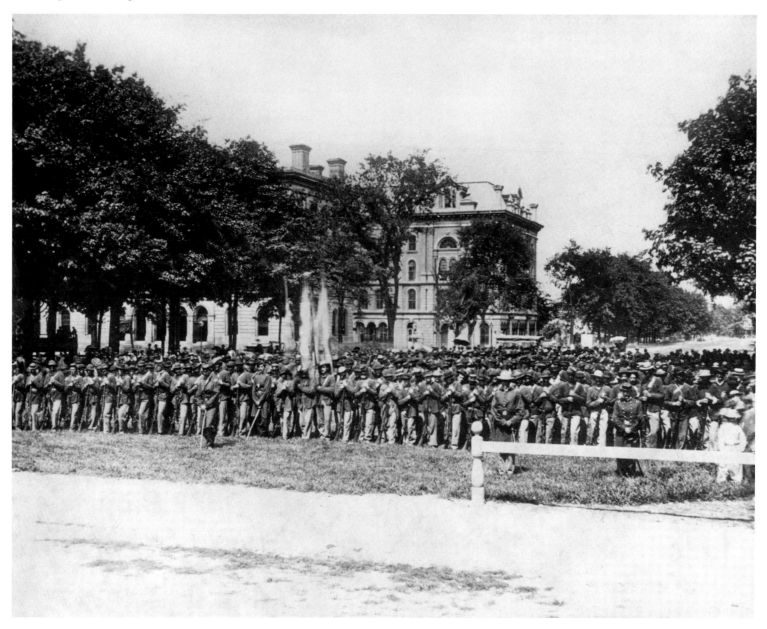

President Abraham Lincoln's body lies in state, April 28, 1865. Cleveland was one of the many railroad stops made by the funeral train carrying the president's body to its final stop in Springfield, Illinois. An elaborate, canopied pavilion was erected on Public Square to hold the slain president's catafalque for public viewing. In front of the pavilion is the Commodore Oliver Hazard Perry monument.

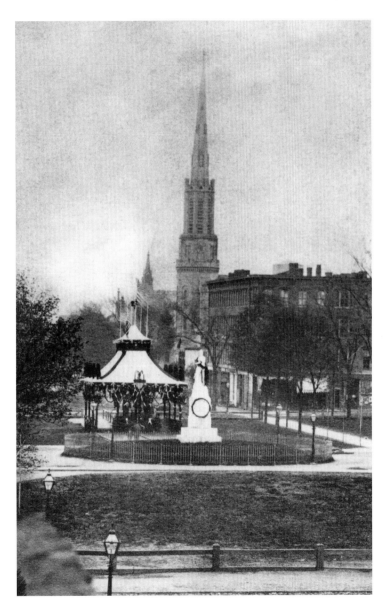

A view of the pavilion and catafalque for the coffin of President Abraham Lincoln. The hearse and six white horses used to move Lincoln's coffin from the railroad terminal to the square are visible to the right of the pavilion.

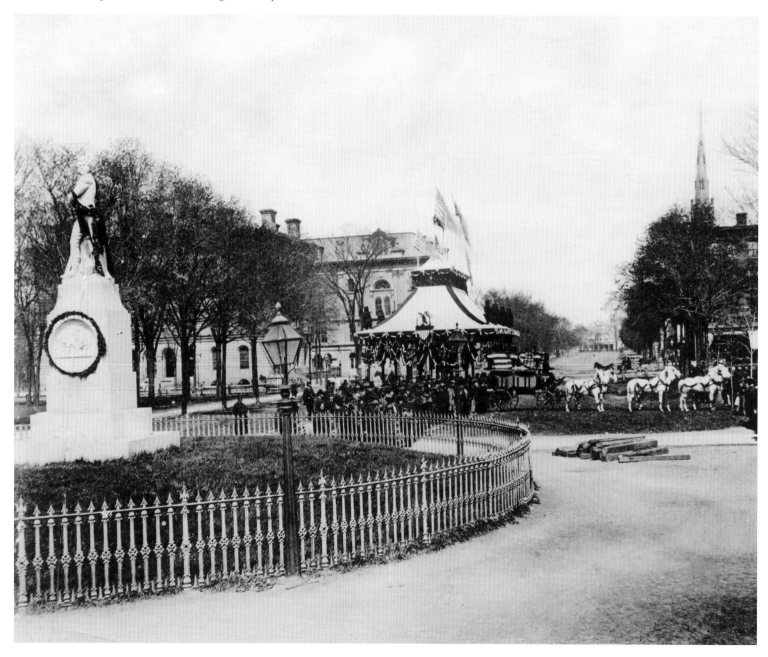

The steam locomotive *Nashville* at Union Station in 1865. The crew is waiting to take President Abraham Lincoln's body from Cleveland to Columbus.

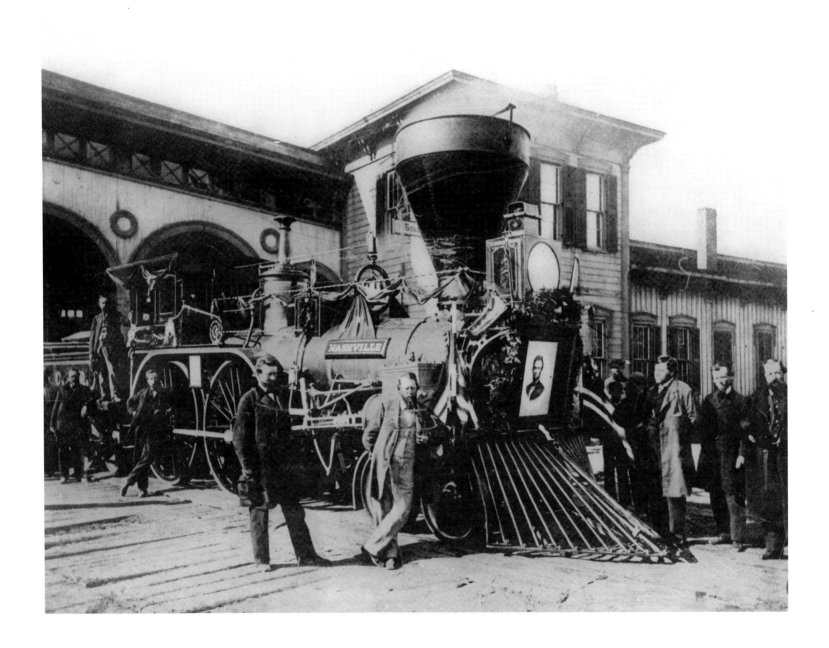

Residence of John Blair at 802 Prospect Street, 1865. John Blair came to Cleveland in 1819 from Maryland with $3 in his pockets. Within a few years he turned his speculation in pork into a large and prosperous produce and commission business, with a warehouse along the Cuyahoga River. Blair also served on the board of directors of the Commercial Bank of Lake Erie, and was elected Cleveland councilman in 1836.

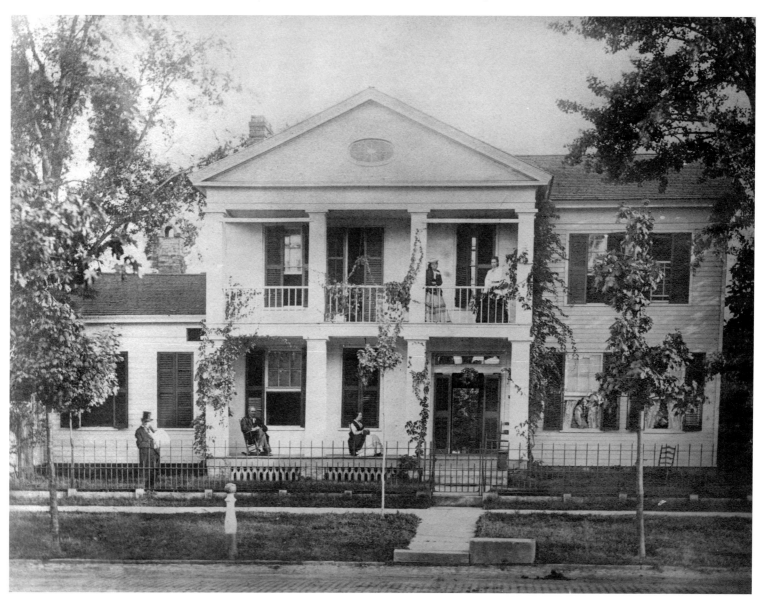

The Cuyahoga River as seen from the Center Street Bridge, looking south, 1865. The Center Street Bridge was the only swing bridge in the area and was purportedly located at the site of Moses Cleaveland's landing in 1796.

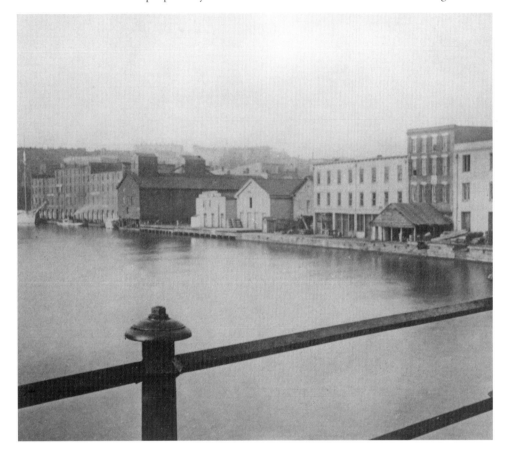

This is the earliest known photograph of the Ohio and Erie Canal in Cleveland, ca. 1859. Built in 1832, the canal's usefulness was ending as railroads became the preferred means of transport. These buildings stood in the Flats, east of the Cuyahoga River. The high ground visible at rear is a residential area south and east of downtown Cleveland.

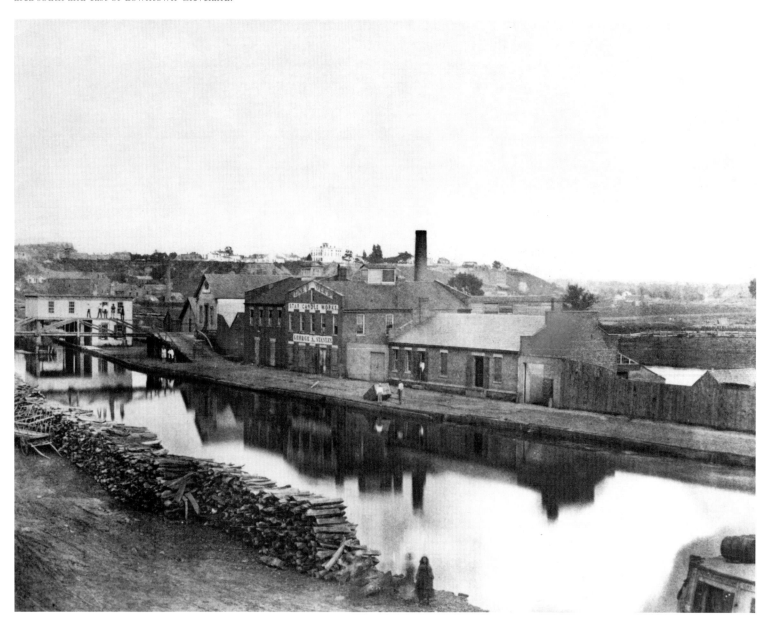

The west side of Public Square looking north toward the old Cuyahoga County courthouse, at the northwest corner of the square. Near the end of the row of commercial buildings is the Forest City House hotel.

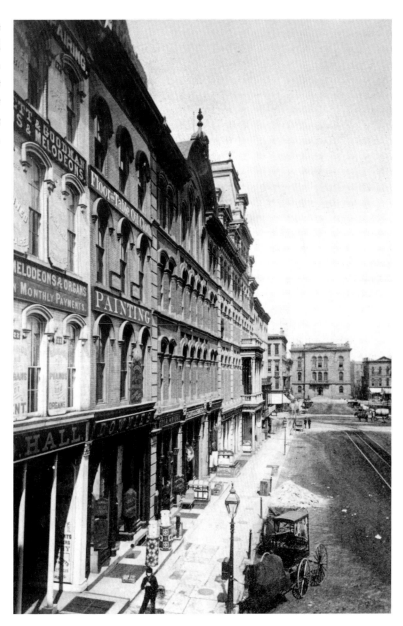

The office of John D. Rockefeller and Samuel Andrews, in the
Sexton Building at the foot of Superior Avenue in the Flats, 1865.
Rockefeller's Standard Oil Company was founded in 1870.

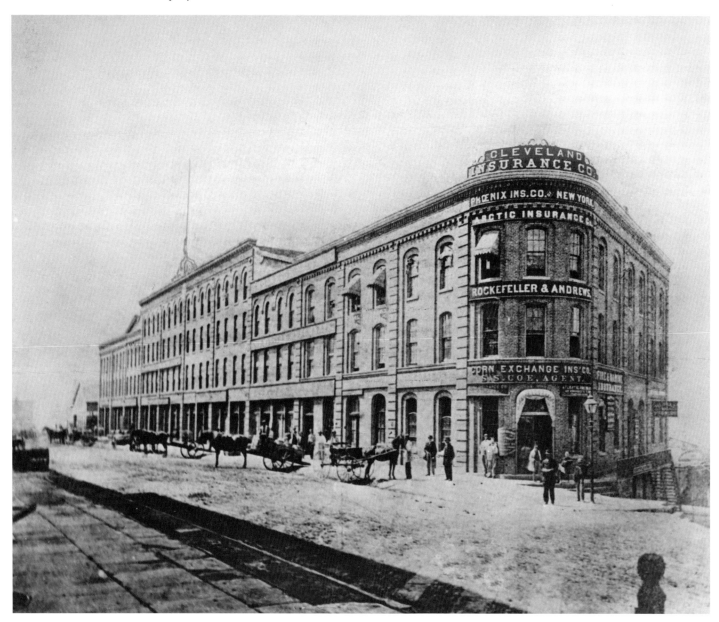

CLEVELAND'S "GOLDEN ERA"

(1870–1929)

Following the Civil War the iron and steel industry continued to expand, creating great wealth in the city. Fortunes were also made in shipping, finished product manufacturing, and oil-related industries. Many of those who benefited from this period of economic growth created the Cleveland residential district known as "Millionaires' Row" along Euclid Avenue.

John D. Rockefeller's Standard Oil Company, organized in 1870, put Cleveland at the center of the refining industry in the United States. Inventors also found a hospitable environment in Cleveland. Charles F. Brush, originator of the carbon arc lamp, founded the Brush Electric Light and Power Company, which installed arc lamps throughout the city. Garett Morgan used a device he invented, and later patented—the Morgan safety hood and smoke detector—to rescue 32 men trapped during an explosion in an underground tunnel 250 feet beneath Lake Erie, and was the first to patent an inexpensive traffic signal.

Following the lead of Alexander Winton, many other Cleveland entrepreneurs began building automobiles, and for a brief time the Cleveland area was the center of the automobile industry in the nation. There were several hundred brands of automobiles produced in the area, and hundreds of companies manufacturing and supplying automotive parts.

Cleveland also became a center of labor activity. The Brotherhood of Locomotive Engineers established headquarters in the city. Cleveland was the site of national labor meetings, walk-outs, and strikes that brought about better conditions for workers.

Thousands of immigrants from Central and Eastern Europe came to the United States in this period, and many of these new Americans moved into Cleveland to meet the rapidly growing demand for workers. These new residents formed numerous ethnic enclaves within the city giving it a cosmopolitan quality. Cleveland celebrated its centennial during the Gay Nineties, when the city's population of 261,353 gave it tenth rank in the nation.

The city gained a reputation as a reform city during the five-term administration of Mayor Thomas Loftin Johnson. Johnson, influenced by the American social philosopher Henry George, adapted many of George's ideas. The Johnson administration won high praise from muckraking journalist Lincoln Steffens, who called Johnson the nation's "best mayor," and Cleveland "the best governed city in the United States."

The triumphal arch constructed in 1871 to celebrate the German Peace Jubilee. The jubilee celebrated Germany's victory in the Franco-Prussian War. The Germans in Cleveland were a large and influential ethnic group throughout the nineteenth century.

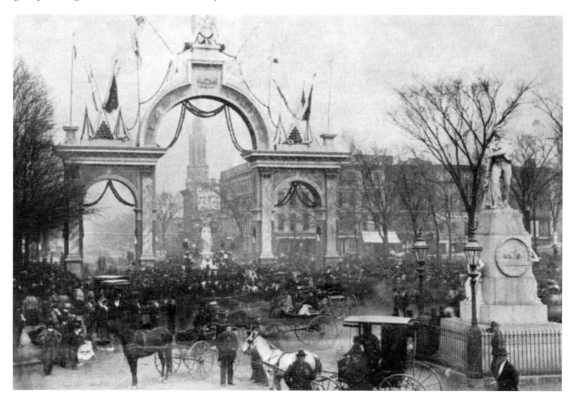

The Jewish Orphan Asylum was dedicated on July 14, 1868, and opened with more than 80 residents. In 1888 the orphanage moved to this spacious building on Woodland Avenue, near East 55th Street. The building was leveled in 1929 to make way for new commercial and industrial development.

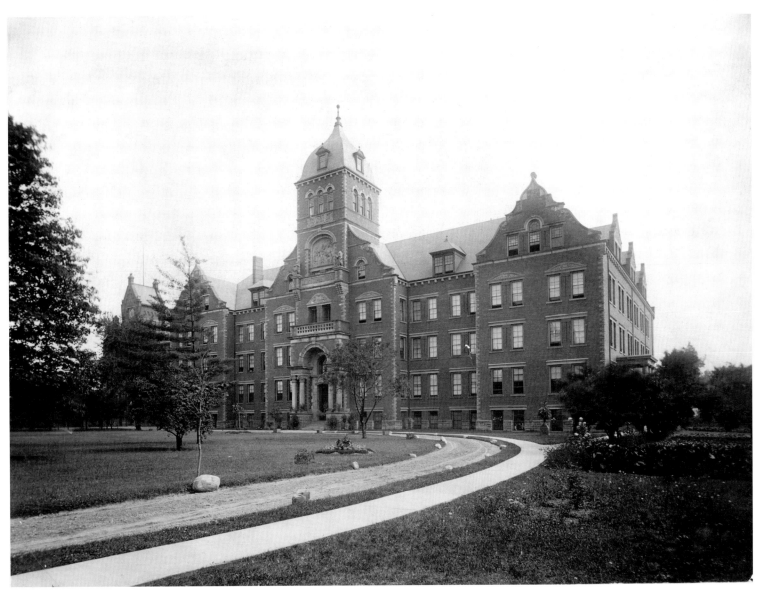

Looking across Public Square at the Lily Fountain in 1888. The tall building in the center background is the third building to serve as a courthouse for Cuyahoga County. The building to the right of the courthouse was the Hick Block, home to the Lyceum Theater for many years.

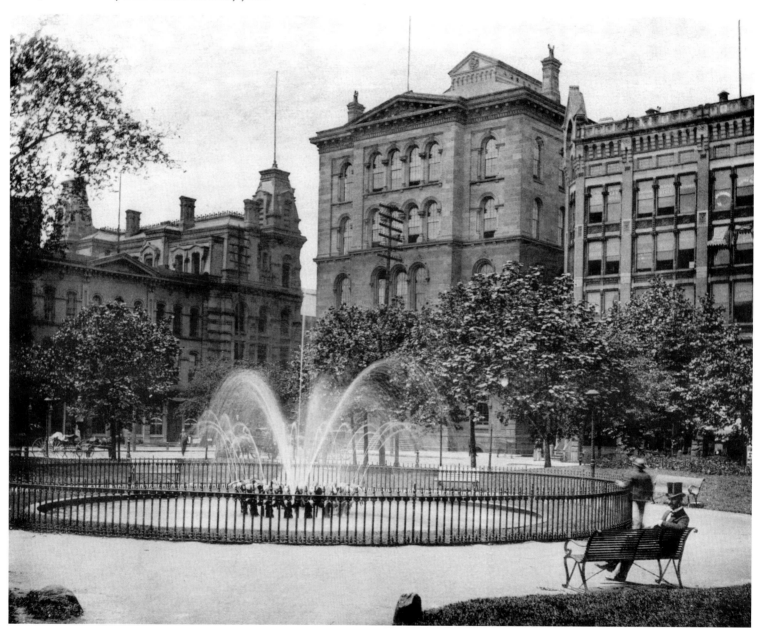

Uniformed war veterans march in the Washington
Birthday parade past the house of D. W. Cross, located at
483 Euclid Avenue, in 1889. Cross was president of the
Cleveland Steam Gauge Company.

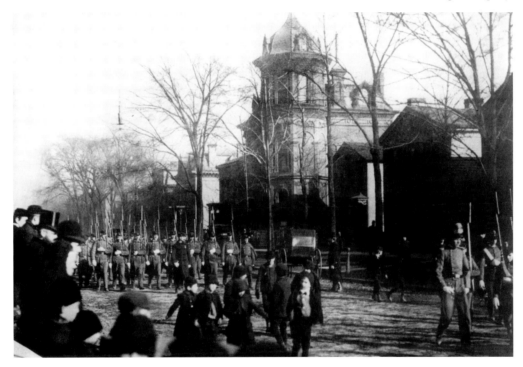

Funeral arch, part of a larger pavilion and catafalque, built on Public Square to honor President James A. Garfield, who had been assassinated on July 2, 1881. President Garfield's body lay in state on the square from September 24 through 26, before being interred in Lake View Cemetery.

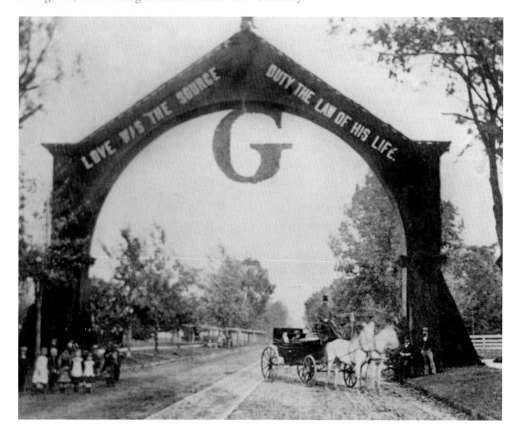

Cleveland General Hospital, 1894. Operated by the Medical Department at the University of Wooster, the hospital's mission was to provide clinical training for medical students and a training school for nurses. It was located at Woodland Avenue near East 20th Street.

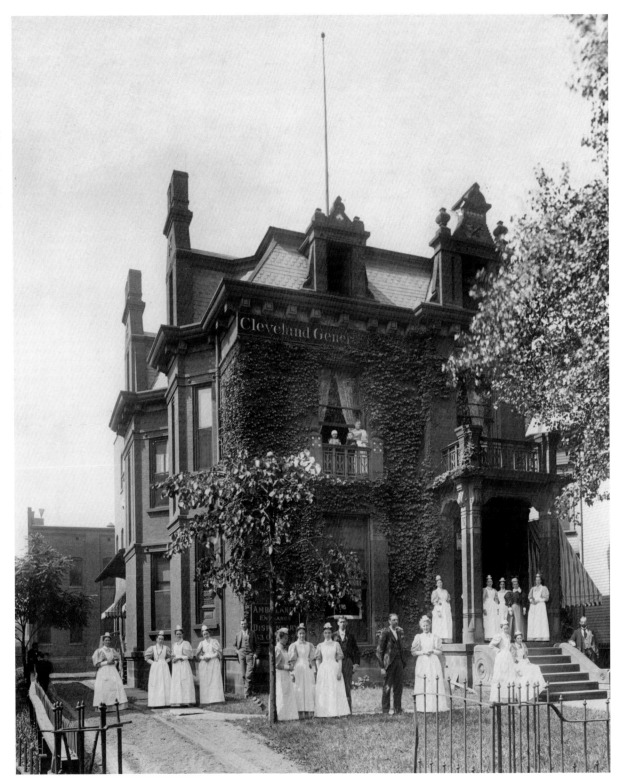

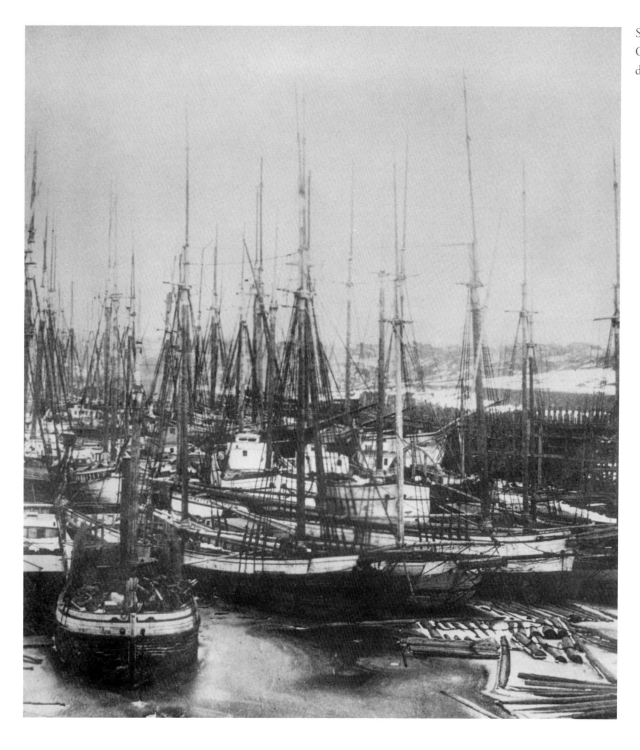

Schooners on the
Cuyahoga River in dry
dock for the winter, 1870.

The Cuyahoga River at "Collision Bend," 1893. The flooded river damaged Bohn and Stuhr's Lumber Yard and Planing Mill. The mill was destroyed by fire in 1895.

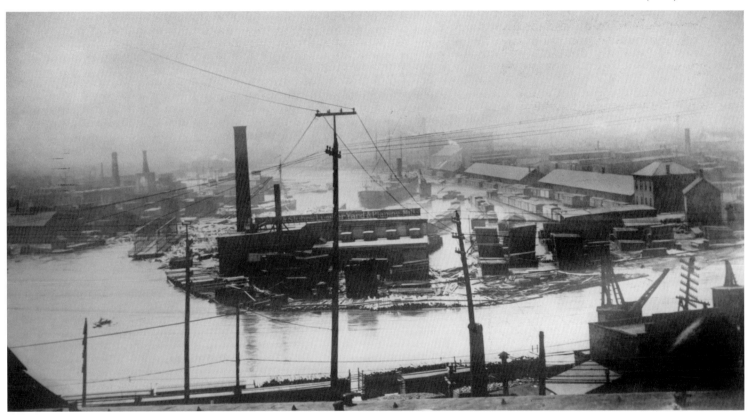

A piano is delivered to a residence on Rockwell Street ca. 1880 by the
B. Dreher's Sons Company, sales agent for Knabe and Haines Brothers
Pianos and Organs, 371 and 373 Superior and 29 the Arcade.

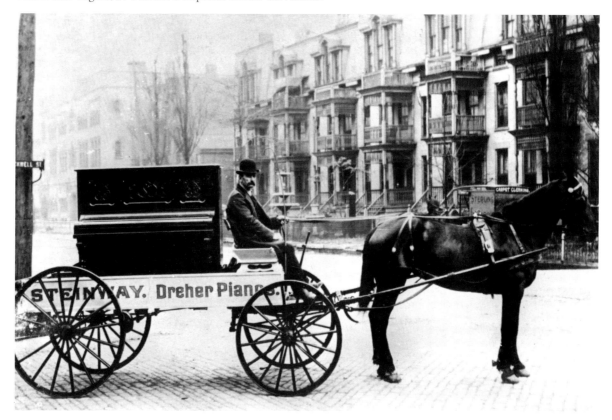

Euclid Avenue, 1890. The tall building on the right is the Arcade. On the left is the Clarence Building at 122 Euclid. Theo Endean's portrait photography studio was located in room 62. At the time the business district still enjoyed mature stands of trees.

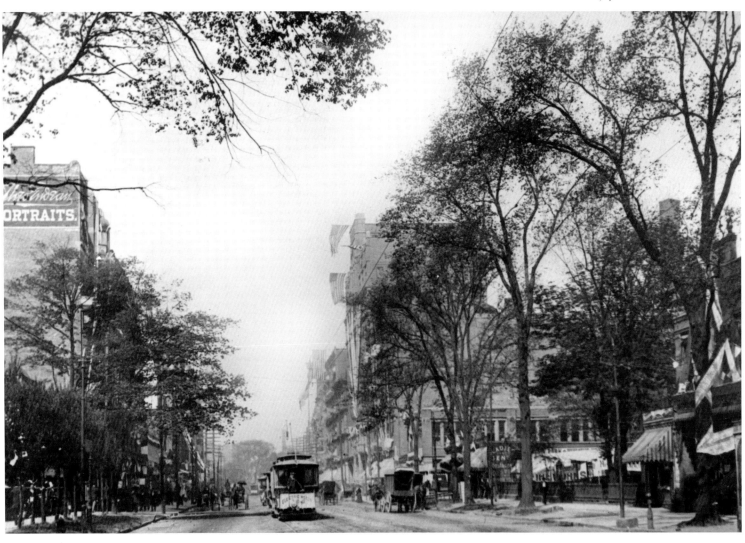

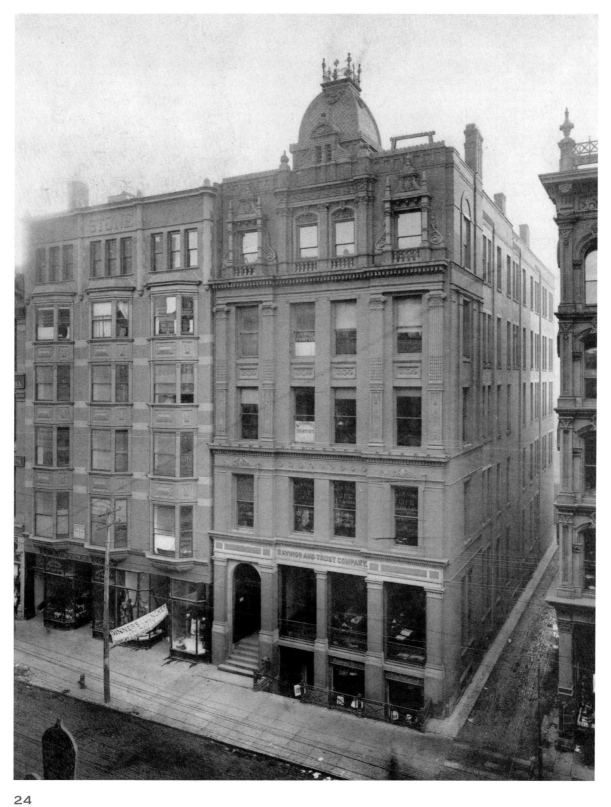

The south side of Euclid
Avenue east of Public Square
in 1889. Visible here are the
N. O. Stone and Company
shoe store and the Savings
and Trust Company.

Pictured here are businesses along the north side of
Euclid Avenue, just east of Public Square, in 1890.

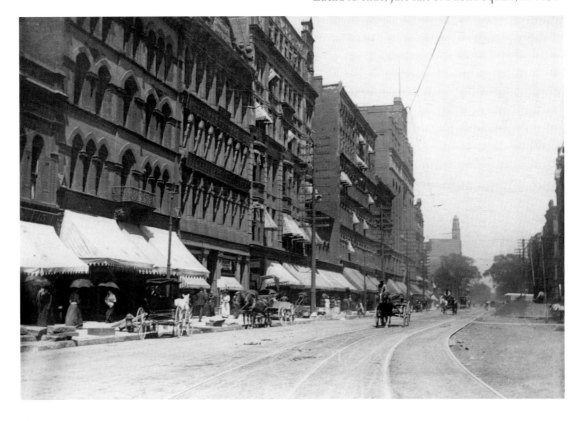

A parade advances down Franklin Avenue, in the Ohio City
neighborhood along the west side of the Cuyahoga River, in 1890.
Ohio City and Cleveland had been competing communities until
1836, when the two villages merged to become the City of Cleveland.

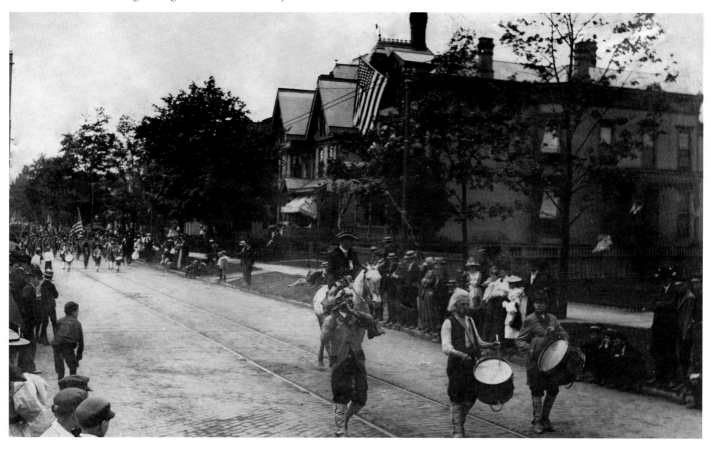

The Pennsylvania Railroad depot at the corner of Euclid Avenue and East 55th Street (formerly Willson Avenue), in 1890.

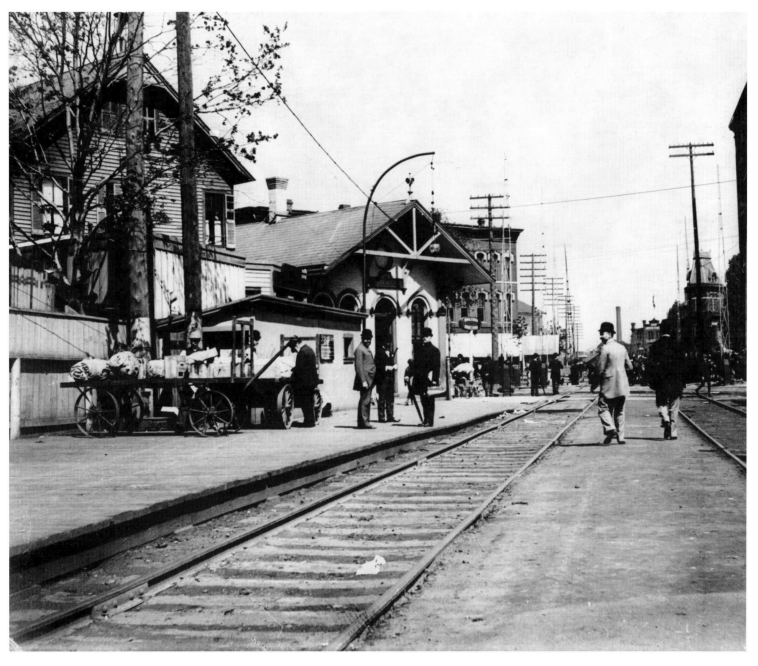

Shown here is a portable voting booth at Public Square in 1890. Behind it are the Society for Savings building (left) and the Brainard building (right).

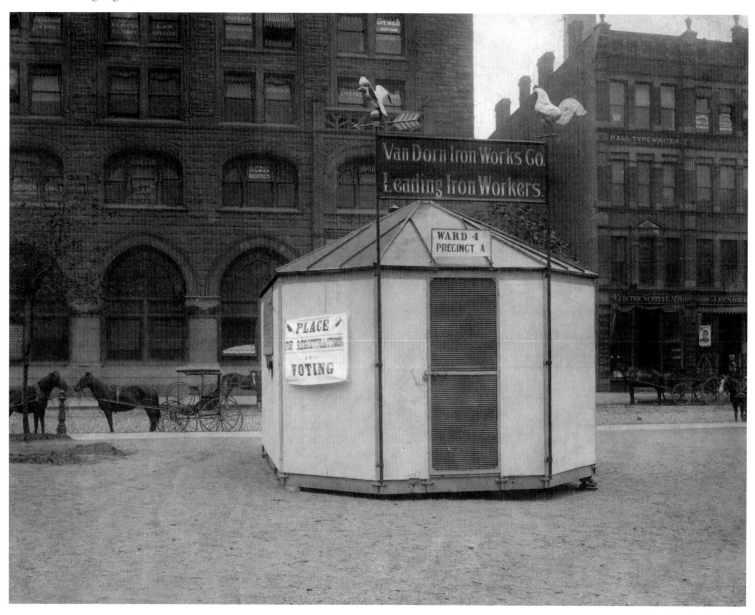

Public Square in 1896. The arch was a "Court of Honor" constructed as part of Cleveland's centennial celebration. Soldiers and Sailors Monument, honoring Cleveland's Civil War militia, is located to the right of the arch.

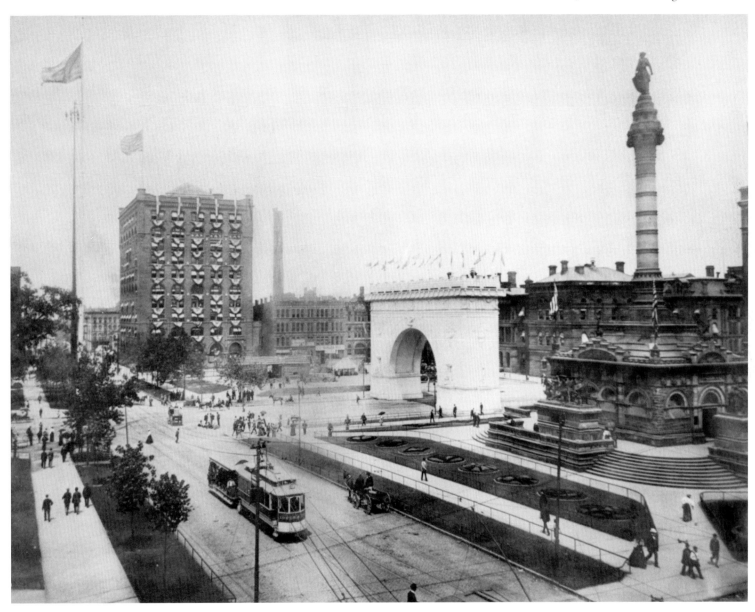

The Cleveland Spiders baseball team at League Park in 1892. The Spiders'
owner, Frank Dehaas Robinson, built League Park, also known as Dunn Field,
in 1891. The first game played there drew more than 9,000 spectators.

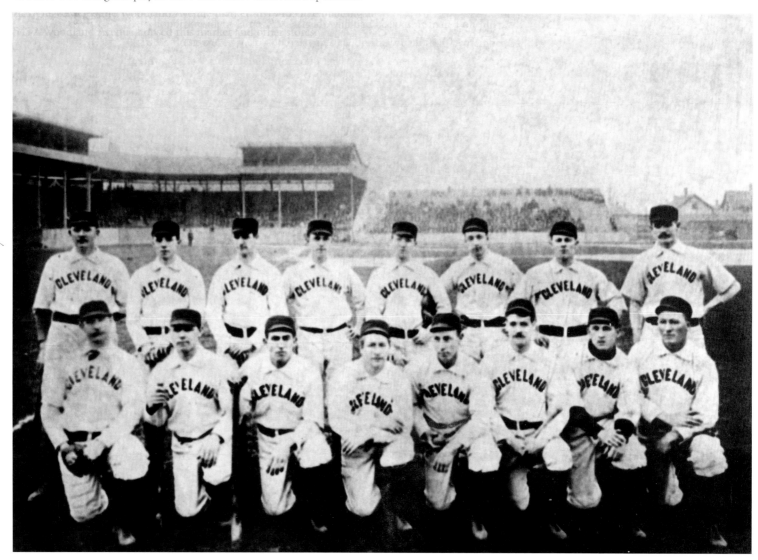

Female members of the Early Settlers Association pose for
the photographer as streetcar #719 pulls into view.

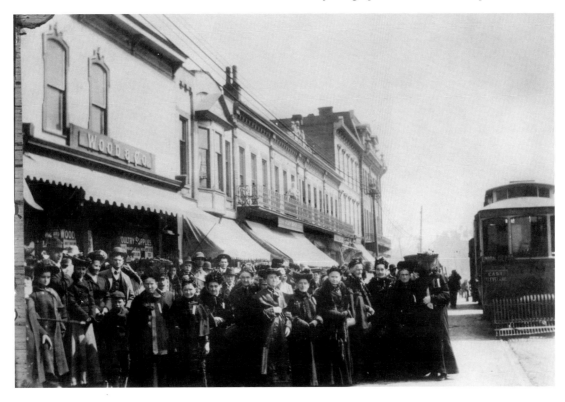

Alexander Winton is seated at the tiller on this first demonstration of an automobile in Cleveland, captured here in front of the Winton Motor-Carriage Company on Berea Road in 1896. The Winton Company would produce automobiles until 1924.

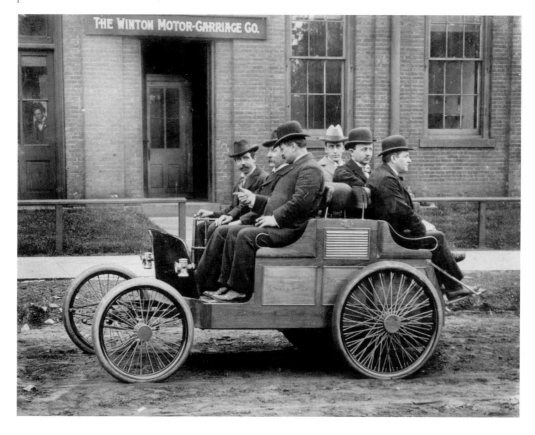

The north side of Euclid Avenue between East 4th Street and Public Square. In view are the Arcade and the Halle Brothers Department Store. Electric streetcars began running in Cleveland in 1884.

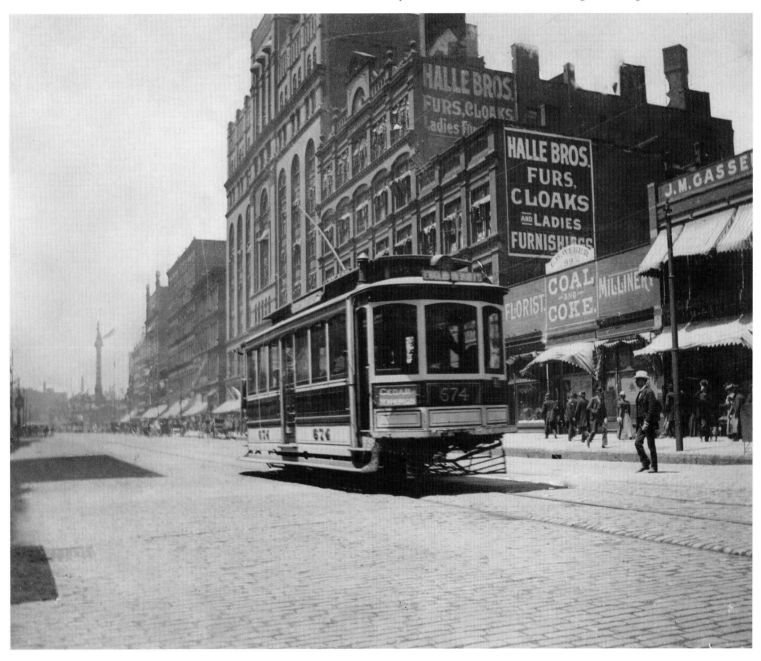

Pictured here ca. 1897, this ambulance belonged to Adolph P. Nunn, undertaker, whose horse was known for its speed.

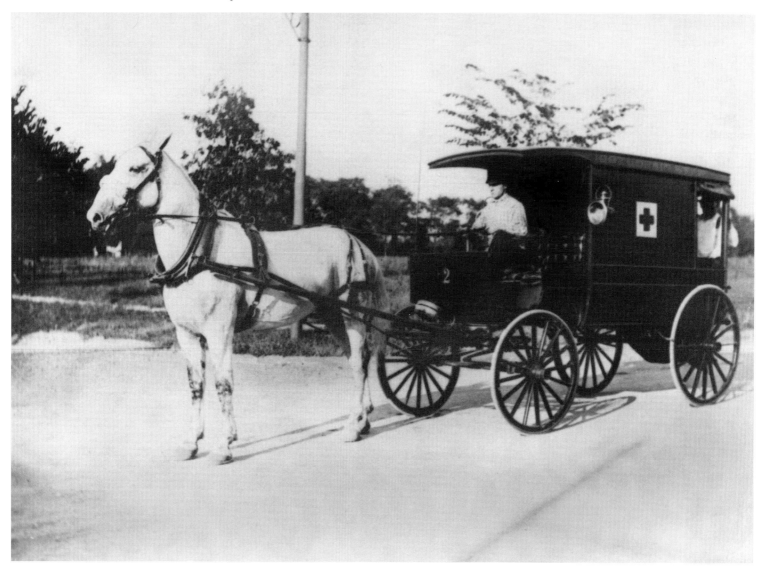

Willie McKevitt sits at the controls of the first electric automobile built by Walter Baker in 1898, who founded the Baker Motor Vehicle Company in 1900, producing electric automobiles for only a brief time. The Baker Electric was slow, quiet, and popular with women, but was unable to compete with gasoline-powered automobiles being manufactured, because the batteries had to be recharged after 20 minutes of driving.

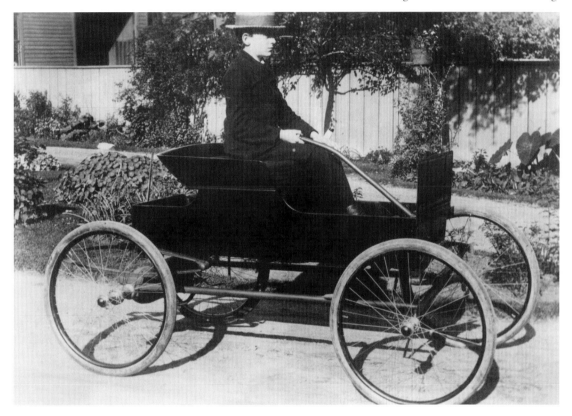

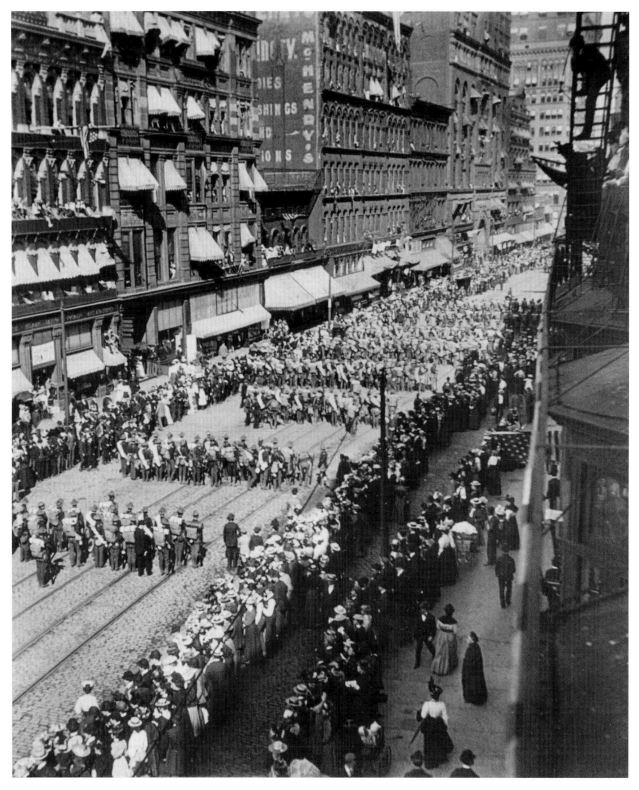

Spanish American
War veterans parade
down Euclid Avenue
in 1898.

A view of Rockefeller Park. In 1897 John D. Rockefeller gave the city of Cleveland 276 acres along the northern stretch of Doan Brook. The city now owned the entire Doan Brook Valley from its headwaters in Shaker Heights to Lake Erie.

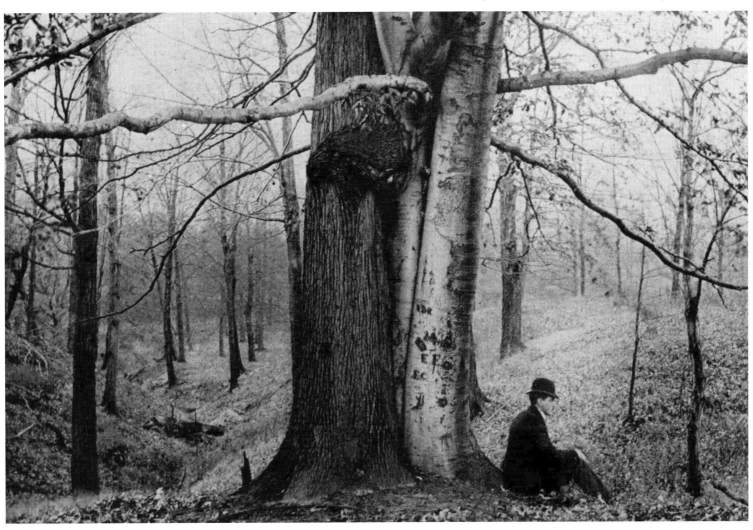

The Lake Erie lakefront, 1901. In the foreground is Lake View Park,
Cleveland's first public park. Railroad tracks trace the shoreline.

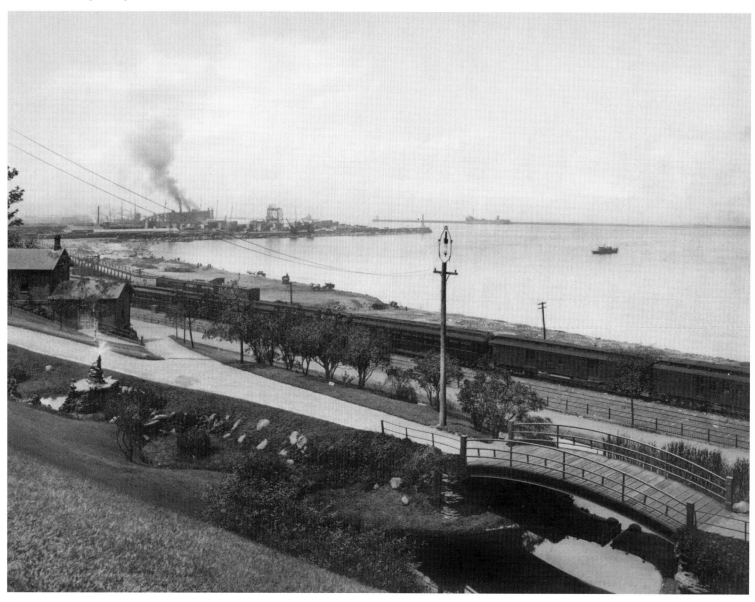

Euclid Avenue at the intersection of East 14th Street in 1900. Visible is the Euclid Avenue Presbyterian Church, where today stands the Hanna Building.

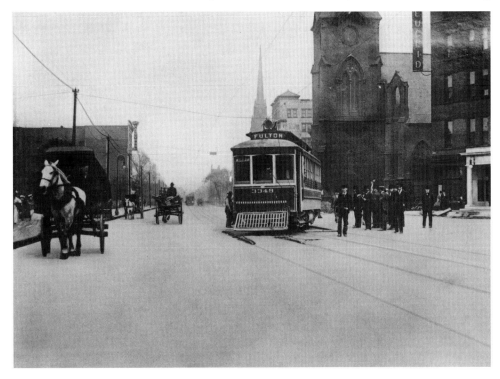

The second Union Passenger Depot (constructed 1864–1866) in 1890. The first Union Passenger Depot, located on this site at the foot of Water (now East 9th) and Bank (now East 6th) streets along the lakefront, was a wood structure and was destroyed by fire in 1864. The second depot pictured here was a massive stone building 603 feet long and 180 feet wide. It was demolished in 1959.

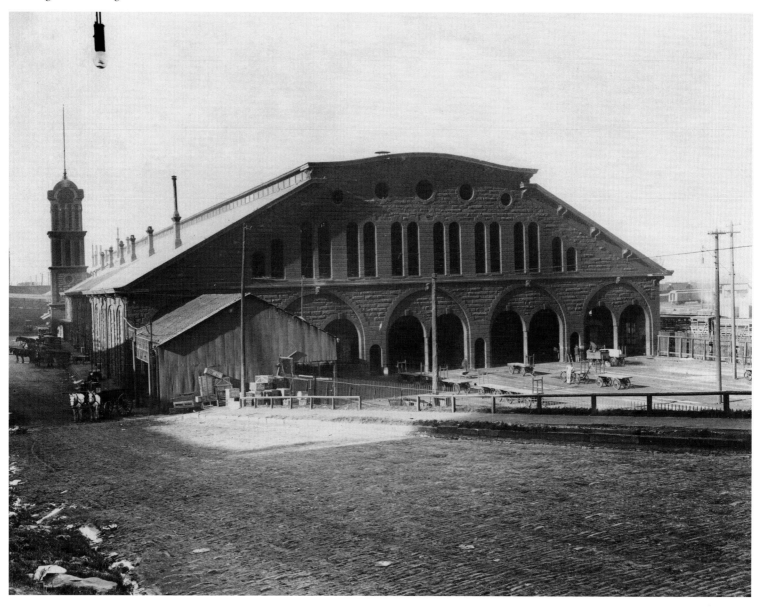

Sheriff Street Market, opened in 1891, was the largest food market in Cleveland until 1924 with the construction of the new Westside Market building on West 25th Street in Ohio City. Owned and operated by Sheriff St. Market and Storage Company, the market building was located at the corner of Huron Road and Sheriff Street (now East 4th Street). It was a Cleveland landmark until a large portion of the building was destroyed by fire in 1930.

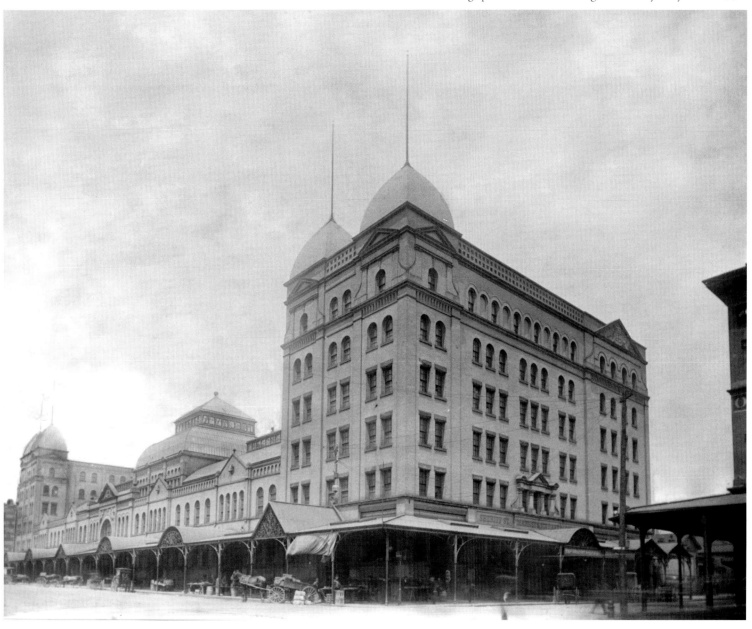

An interior view of the Winton Motor Carriage Company, sometime early in the twentieth century.

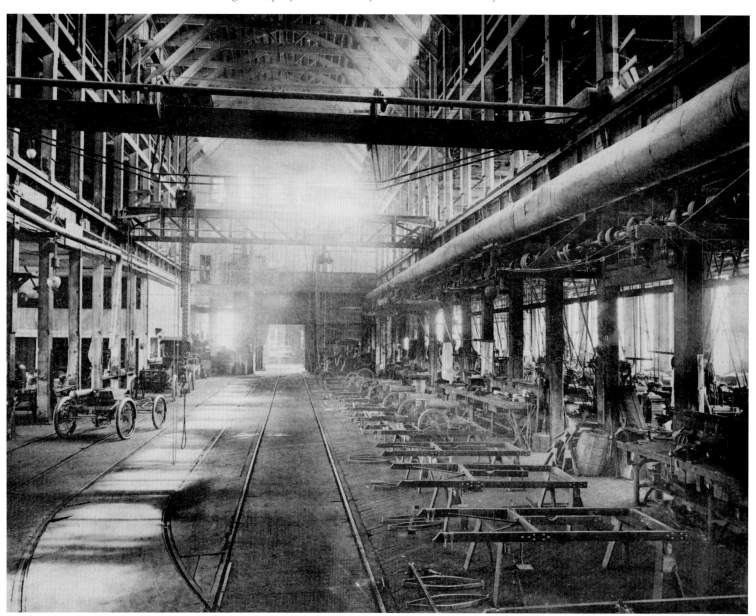

Soldiers and Sailors Monument in 1901. The monument was designed by Levi T. Scofield, and dedicated on July 4, 1894. It is located in the southeastern quadrant of Public Square and honors the men from Cleveland who served in the Civil War. The pillars surrounding the monument are swirled in black in this photograph in memory of President William McKinley, who had just been assassinated.

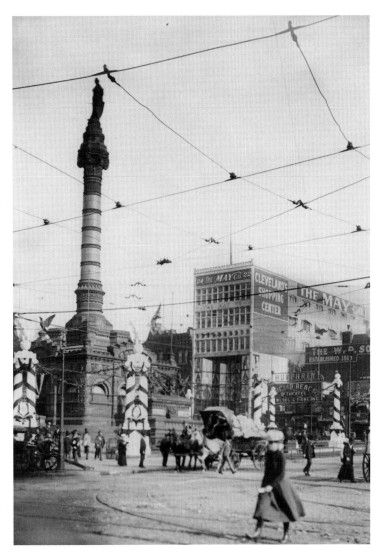

Decorated automobiles parade in celebration of the 35th Encampment of
the Grand Army of the Republic (G.A.R.), September 1901.

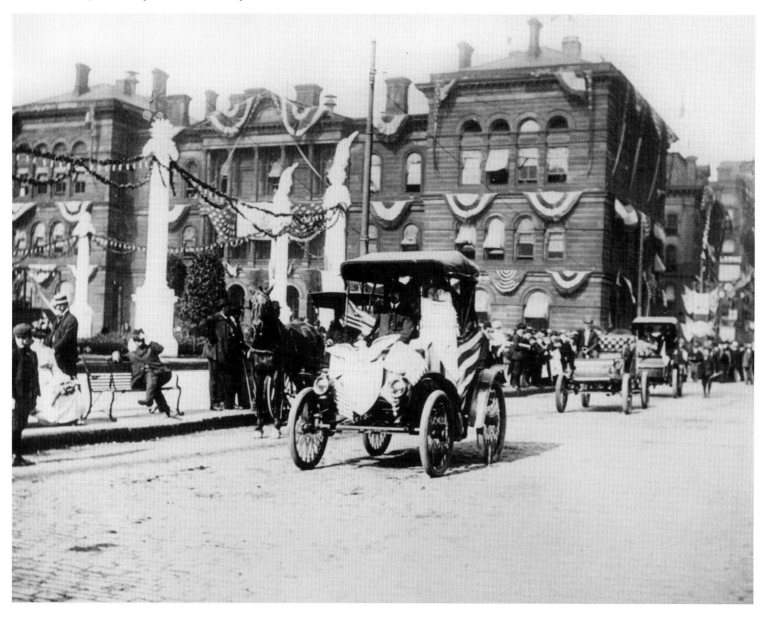

Edgewater Park, 1922. Located along Lake Erie west of downtown, the park was purchased in 1894 by the City of Cleveland, from Jacob B. Perkins, Cleveland industrialist. Recreational facilities included bathhouses, a pavilion, baseball diamonds, and picnic and playground areas. It also held the Edgewater Yacht Club and the Edgewater Lagoon.

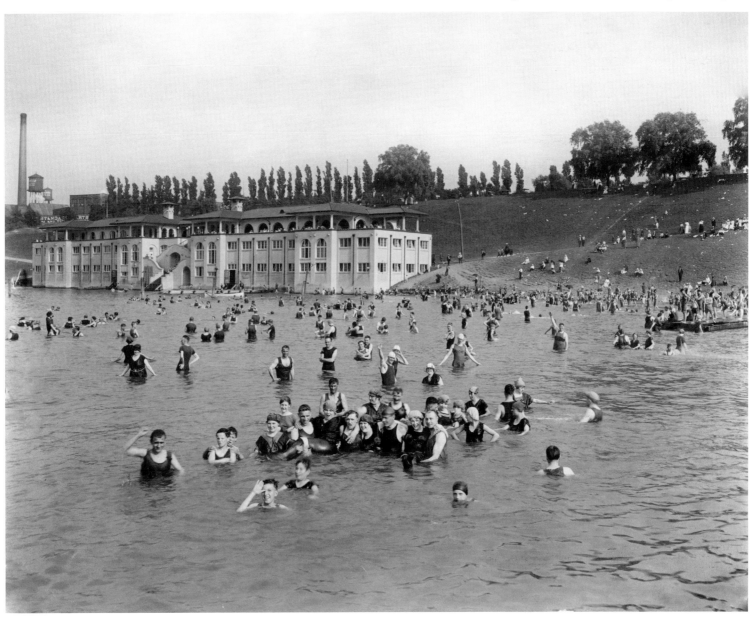

A winter view of Public Square in 1905. In the background
is the New United States Court House, Customs House, and
Post Office under construction.

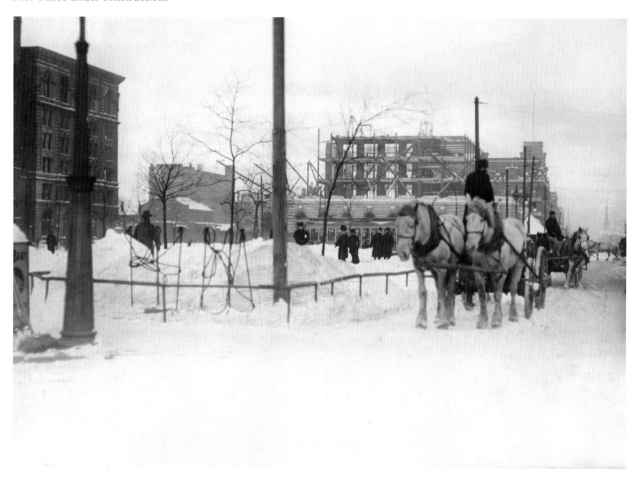

The start of a race at the Glenville race track in 1903. Officials are Samuel Butler and Arthur Pardington. Cars and drivers (left to right) are: Paul Bainey's 4-cylinder French car, with Meyers driving; Kenigslow's two-cylinder auto, Walter Stone driving; Baker's (the Torpedo Kid) electric car, with Walter C. Baker driving and Fred H. White at the rear wheel; and the Olds "Go-Devil," with D. Wurgis driving.

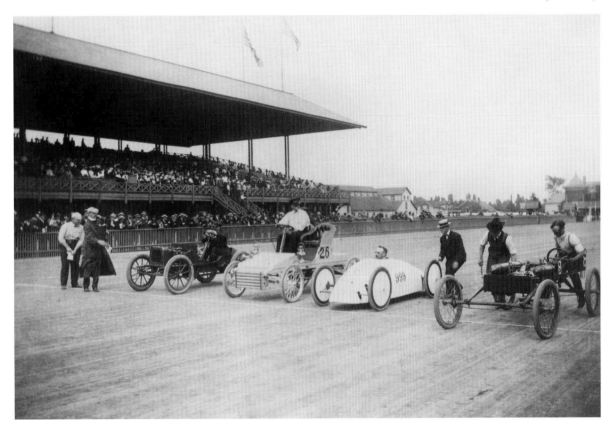

Public Square ca. 1900. Behind the Soldiers and Sailors Monument are the Cuyahoga and Williamson buildings. D. H. Burnham & Company designed the Cuyahoga, erected in 1893 as the first completely steel-framed building in Cleveland. The Williamson, the second building of that name to stand at the site, was built in 1899–1900. Both structures were leveled in 1982 to make way for the Standard Oil of Ohio building.

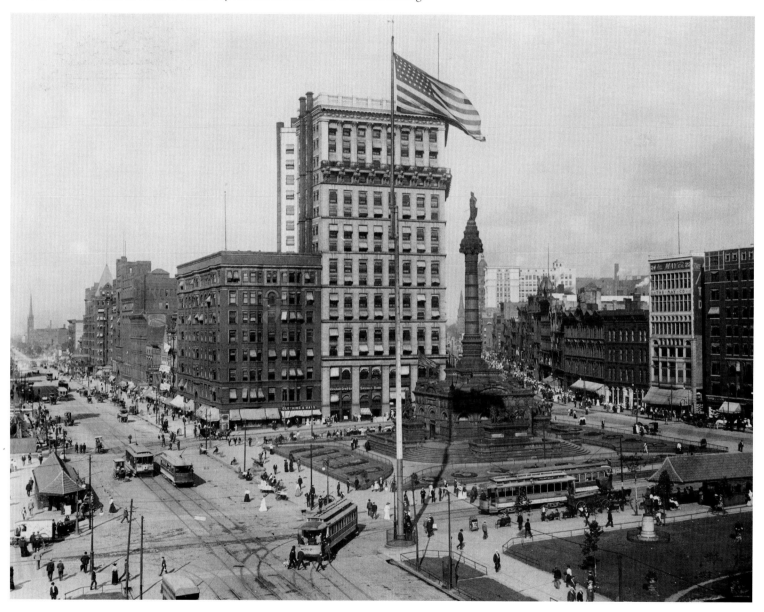

The U.S. Life Saving Service, 1905, with life-saving crew at drill. The service began in 1876 and was located at West Pier near the mouth of the Cuyahoga River. Eventually it would be merged with several other government agencies to form the U.S. Coast Guard.

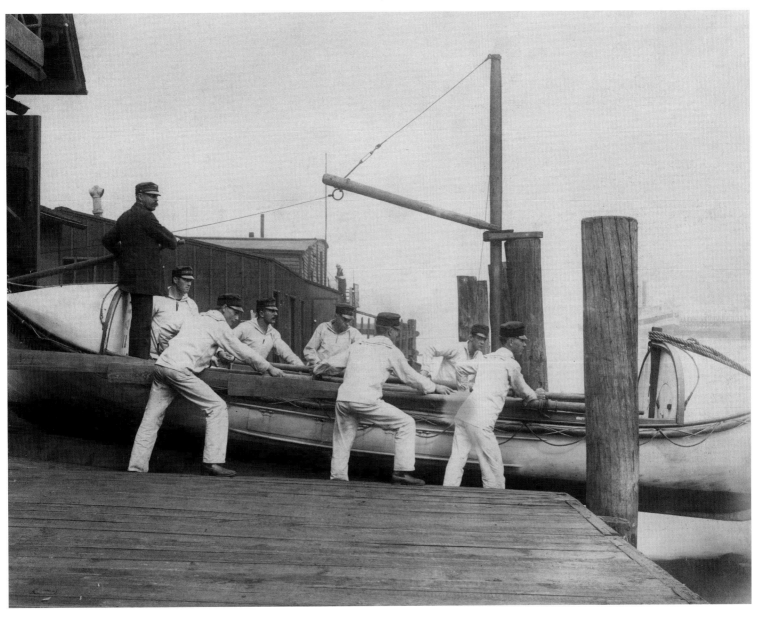

The northeast corner of Public Square at Rockwell Street facing the area between the Chamber of Commerce building (left) and the United States Courthouse, Customs House, and Post Office (right). At center is the Wayside Inn, formerly the house of Leonard Case, and from 1881 to 1885 the Case School of Applied Science. This building, along with the other buildings in the background, was leveled to make way for the Mall portion of the 1903 Group Plan.

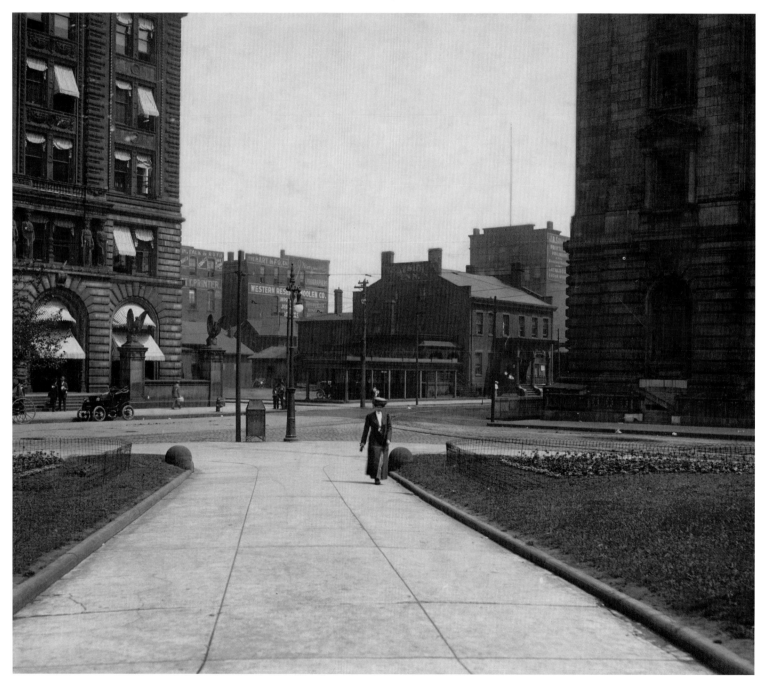

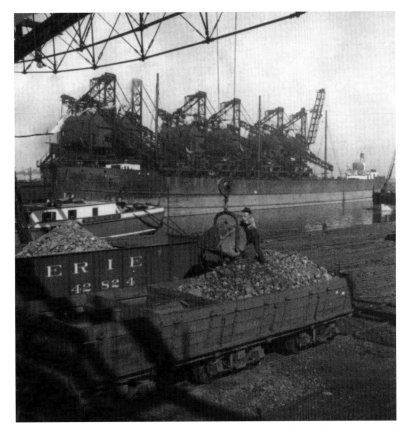

Hulett Automatic Ore Unloaders in the background unload iron ore from an ore ship, while in the foreground iron ore is being dumped from a bucket into a waiting railroad gondola car. In 1898, George H. Hulett, an Ohio native, patented the unloaders that bear his name, revolutionizing shipping on the Great Lakes.

Firemen and volunteers battle the remaining flames at Lakeview
Elementary School in Collinwood on March 4, 1908. This devastating fire
killed 171 students, two teachers, and one unidentified man.

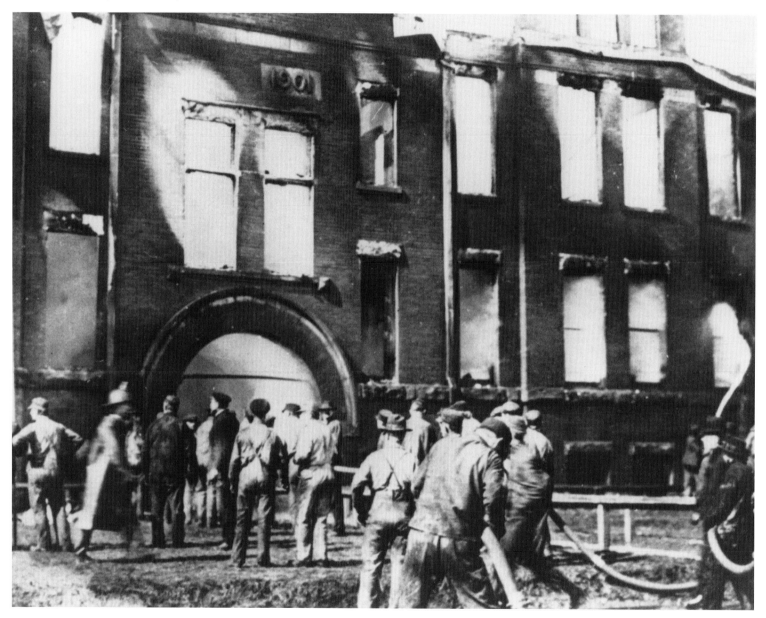

Winter fun on Lake Erie. Ice boating was a popular sport early in the 1900s, made possible by the cold winters in Northeastern Ohio.

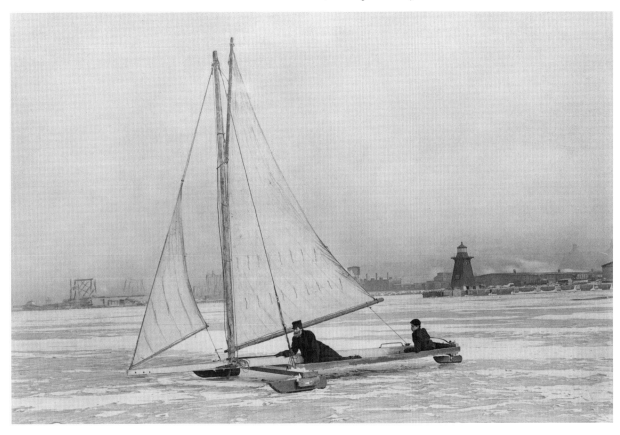

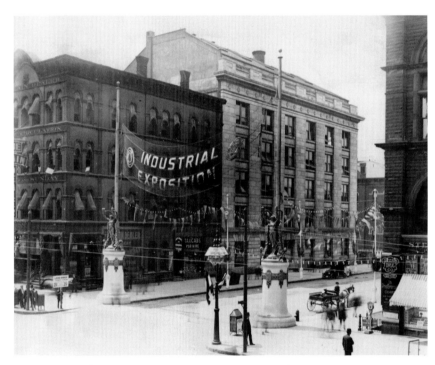

A banner on 6th Street at Superior Avenue announces the 1909 Industrial and Building Exposition, which was held at the end of 6th Street. The building on the left corner is the Plain Dealer's former headquarters.

Here in 1909, Clevelanders enjoy the "Great Aerial Swing" ride at Luna Park. The popular 35-acre park was developed by Fred Ingersoll, who specialized in amusement parks. Opening in 1905, it was located on Woodhill Road, near Woodland Avenue. Other attractions included a wooden track roller coaster, "Shoot the Chute" water ride, and a small replica of India's Taj Mahal.

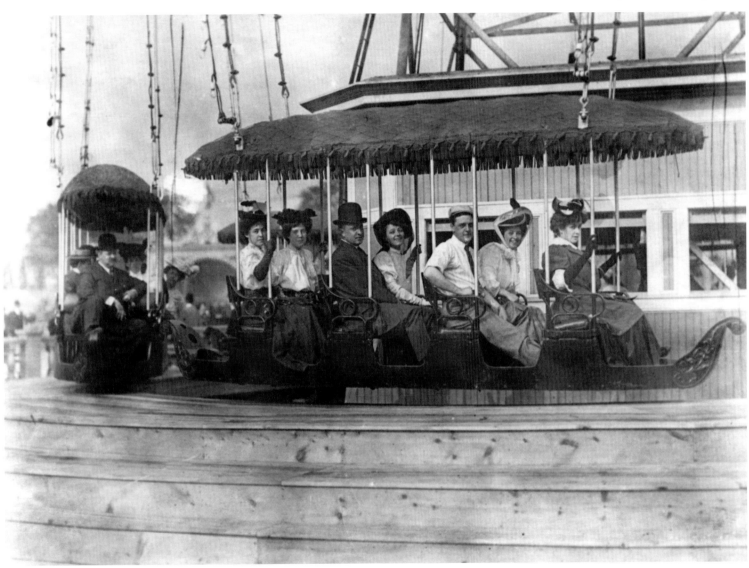

Mounted police pose for a photograph in 1909 in front of the Central Armory, located near the north end of East 6th Street. The armory was built in 1893 by Cuyahoga County to house the Ohio National Guard and was also used to host large public events when not being used by the Guard. It was demolished during Urban Renewal in the 1960s.

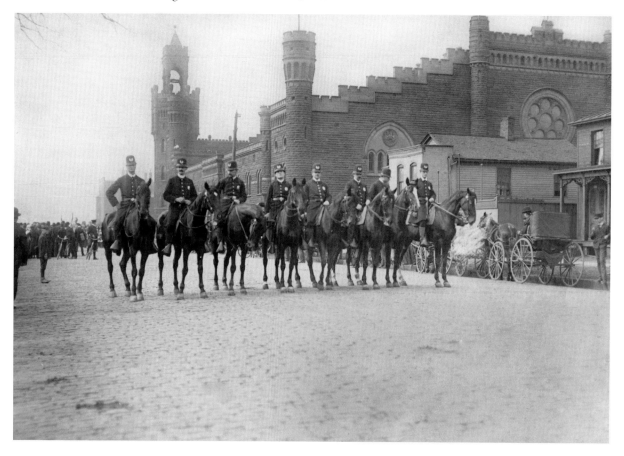

Ice skaters enjoy the day at Rockefeller Park early in the 1900s.

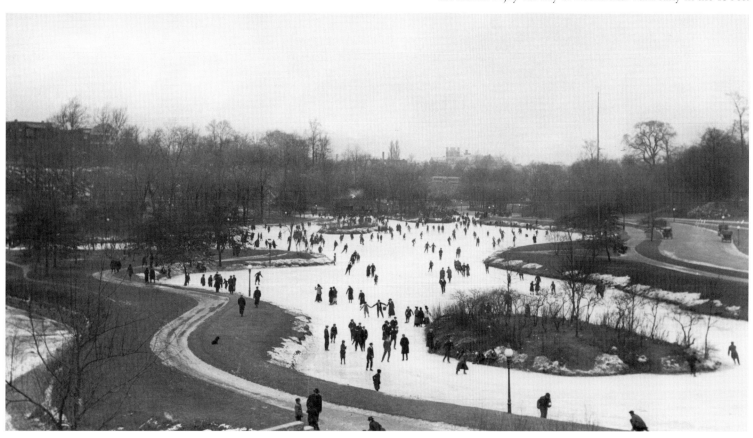

Pictured here in front of Rockwell School on East 6th Street in 1908, President William Howard Taft tours Cleveland in an automobile.

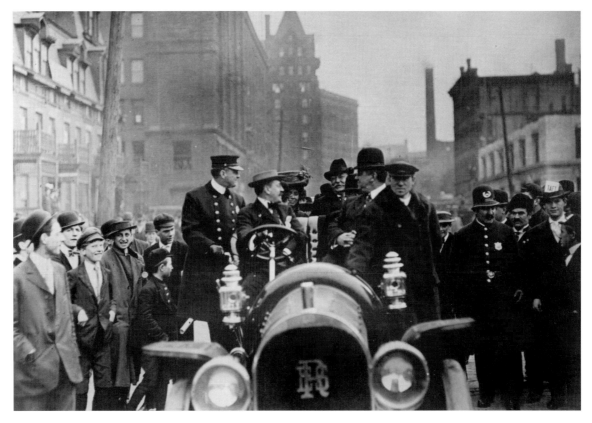

A view of the western end of the Pennsylvania Railroad depot on Euclid Avenue at the corner of East 55th Street.

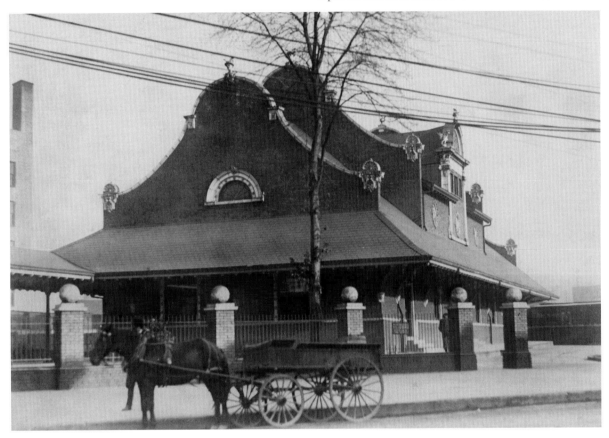

Following Spread: A wide view of the Detroit Superior Bridge. Built 1914–1918, it is a main artery connecting the east and west sides of Cleveland. The two-level bridge carried automobile and pedestrian traffic on the upper level and electric streetcars on the lower level. The central span is 592 feet long, rises 196 feet above the river, and is anchored by twelve concrete arches.

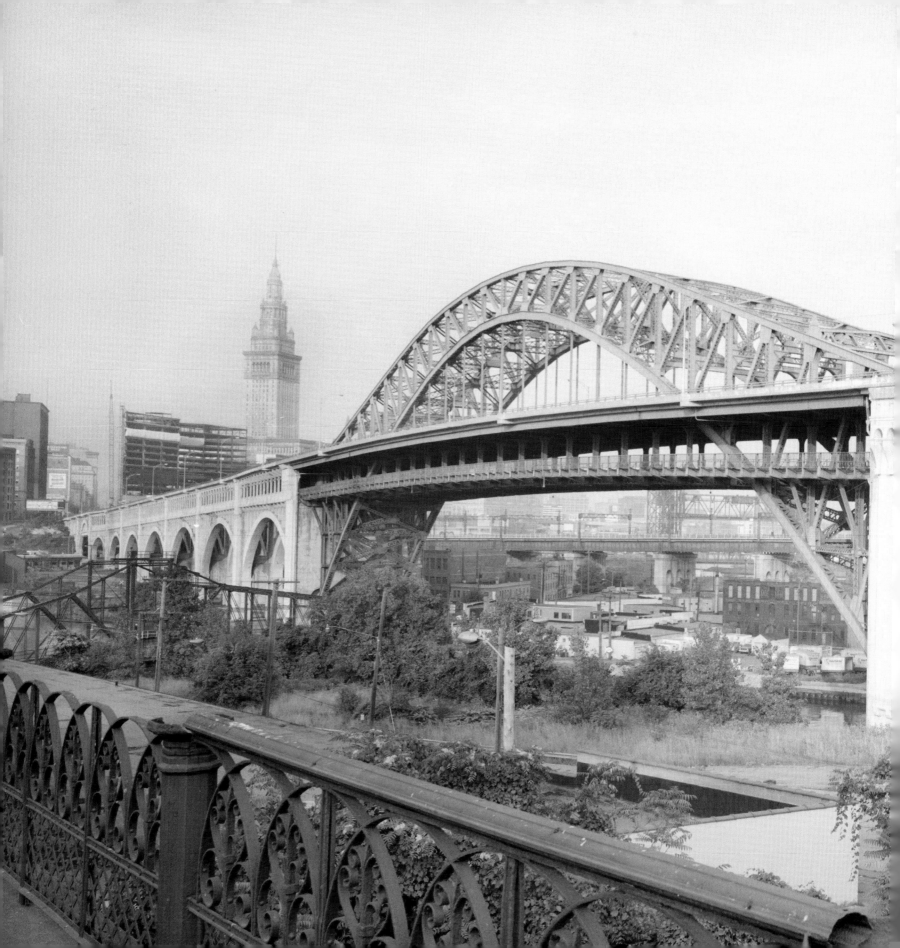

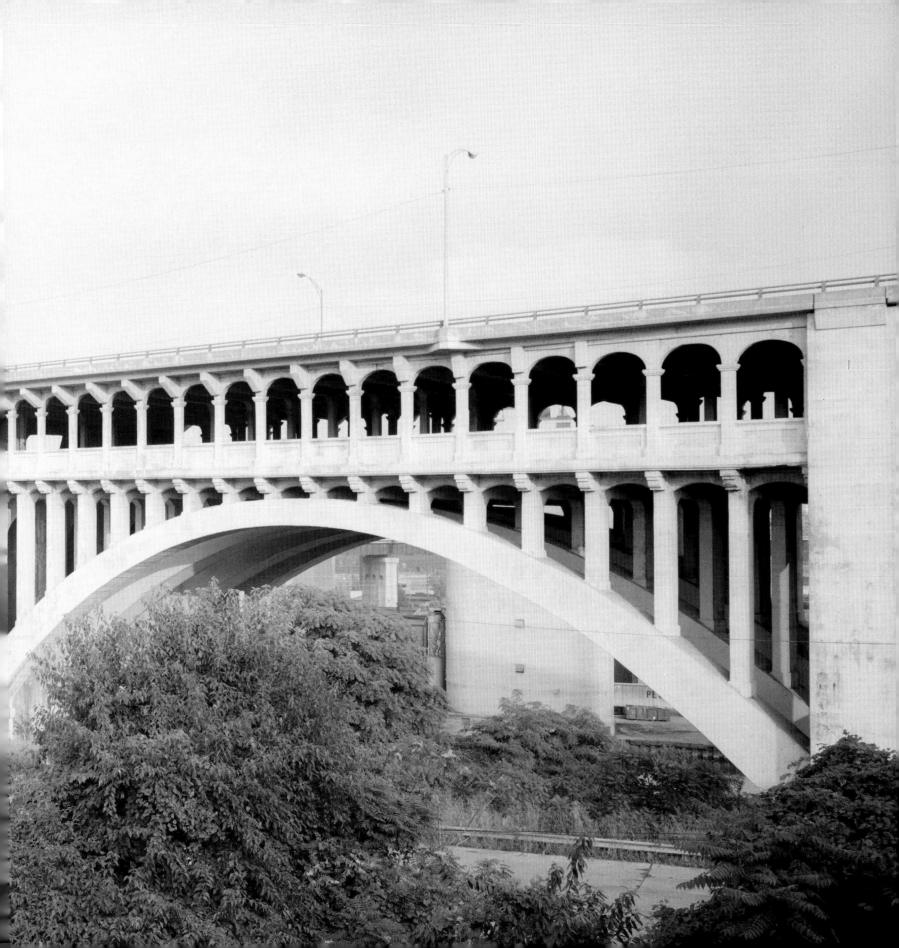

The First Methodist Church (1905) on Euclid Avenue at East 30th Street. Established as the First Methodist Episcopal Society in 1827, it was the first Methodist congregation in Cleveland.

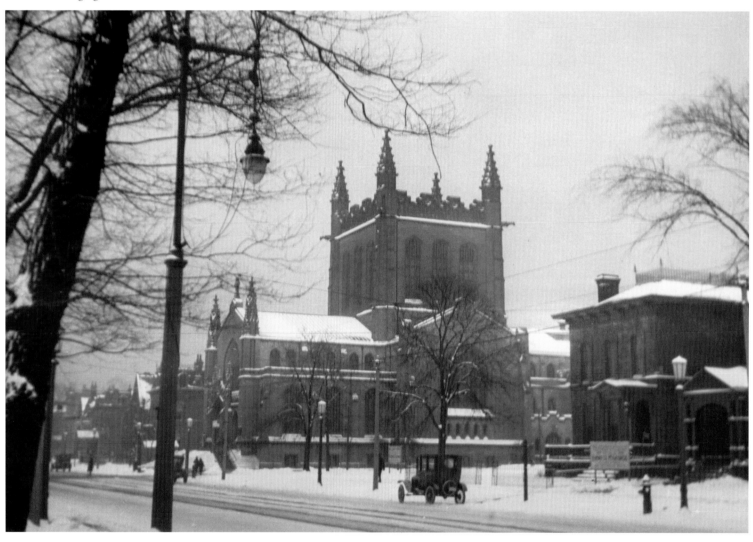

Charles Waddell Chesnutt, prominent author, at work in his home study at 9719 Lamont Avenue, Cleveland, 1905.

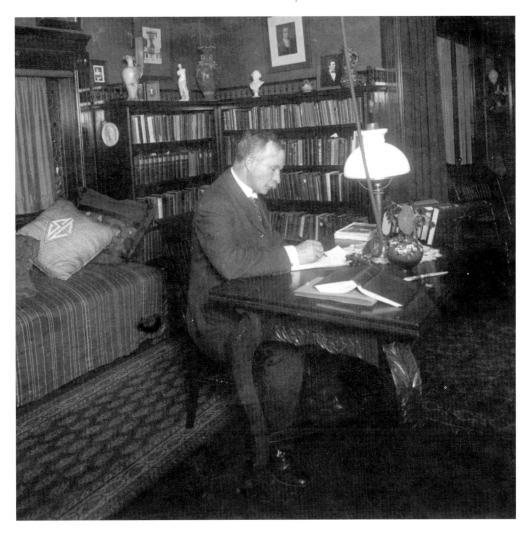

The Hollenden Hotel at the corner of Superior and East 6th Street ca. 1900. The grandest hotel in Cleveland at the time it opened in 1885, the eight-story hotel featured electric lights and its dining room was a popular gathering spot for visiting dignitaries including United States presidents, local politicians, and the well-to-do of Cleveland.

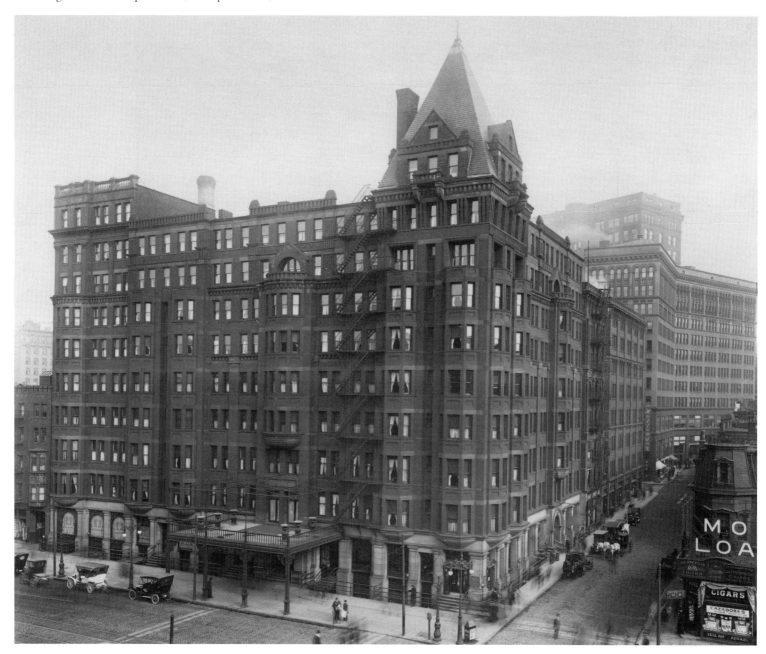

Edward J. Weigel's butcher shop inside the Westside Market on West 25th Street, in the Ohio City neighborhood.

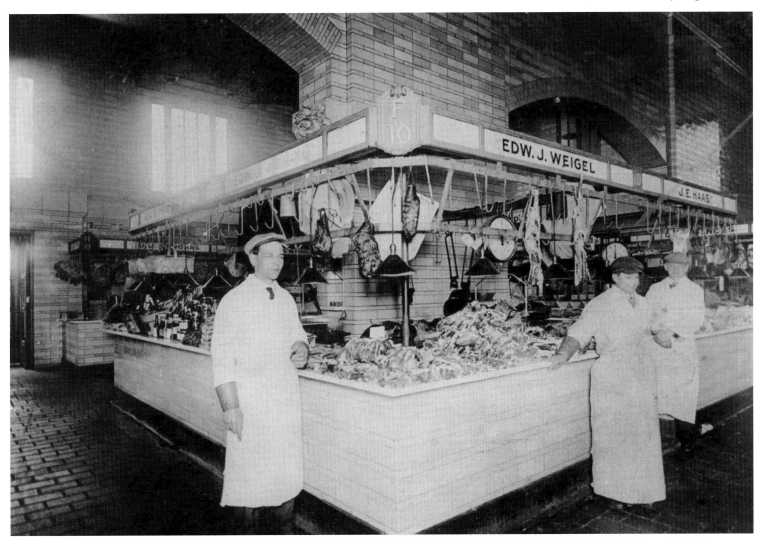

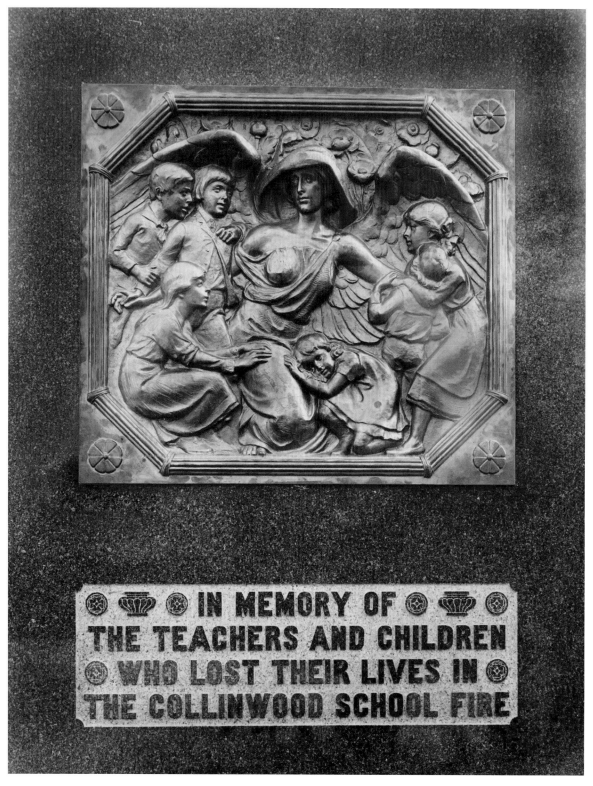

This plaque on a monument in Lake View Cemetery honors the memory of the students and teachers who died in the Collinwood School fire in 1908.

IN MEMORY OF
THE TEACHERS AND CHILDREN
WHO LOST THEIR LIVES IN
THE COLLINWOOD SCHOOL FIRE

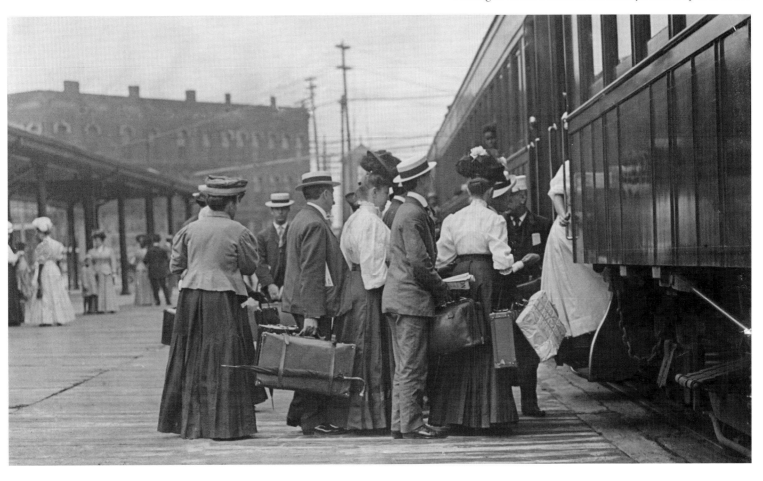

Passengers board a train at the Pennsylvania Depot in 1908.

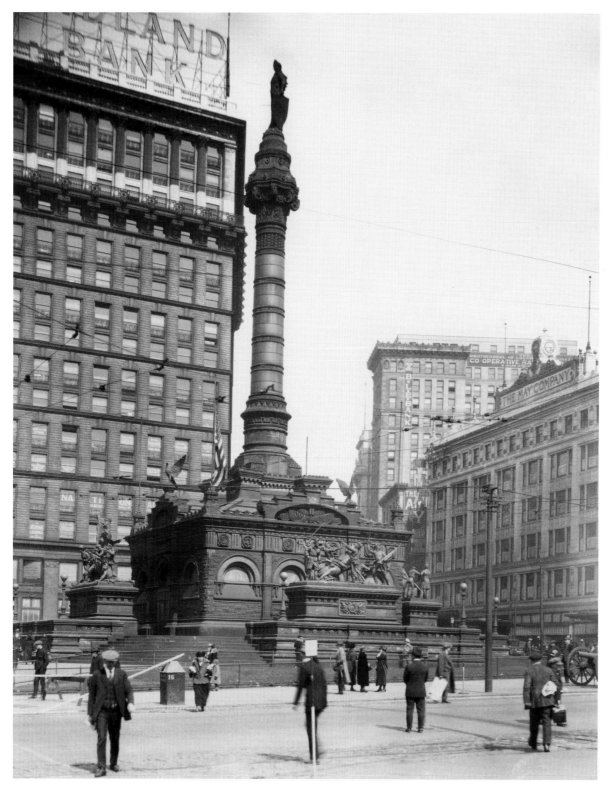

Soldiers and Sailors Monument on Public Square. At left is Midland Bank in the Williamson Building, and at right is the May Company building, as it appeared in 1914 before two floors were added to the structure (in 1931). The May building remains, but the Williamson Building was razed in 1982 to make room for the new Standard Oil of Ohio office building.

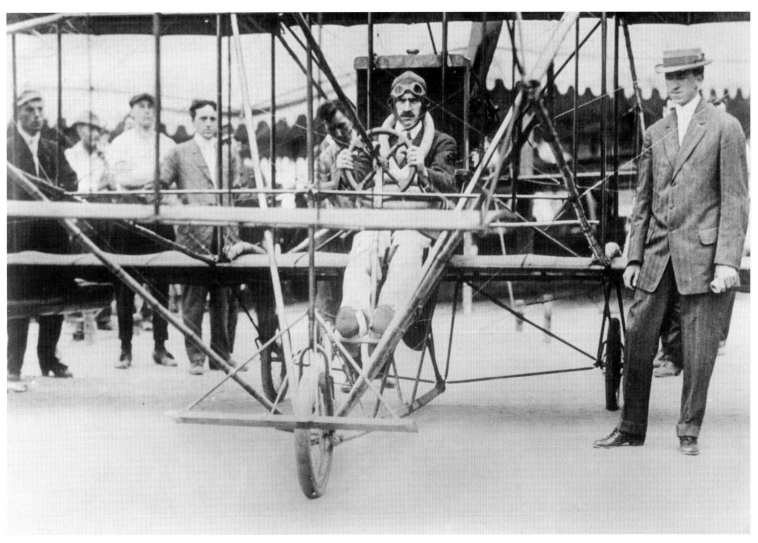

Glenn Curtiss in 1910 prepares to take off from Euclid Beach Park for a flight of sixty miles to Cedar Point, Sandusky, Ohio.

A sightseeing automobile filled with visitors departs Public Square in 1910 for a tour of the Euclid-Wade & Gordon parks and boulevard.

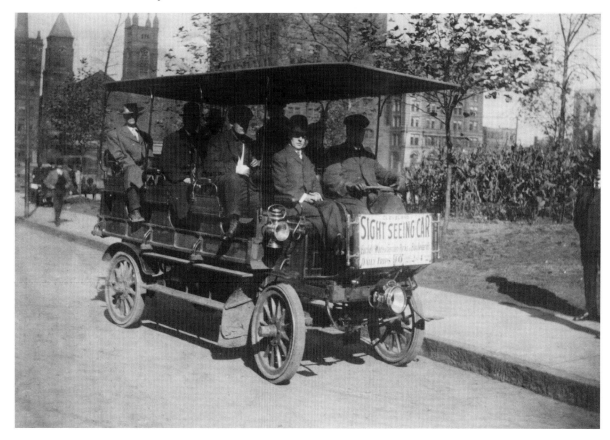

In October 1910, spectators climb onto parked streetcars in Public Square
for a view of the Cuyahoga County Centennial Parade.

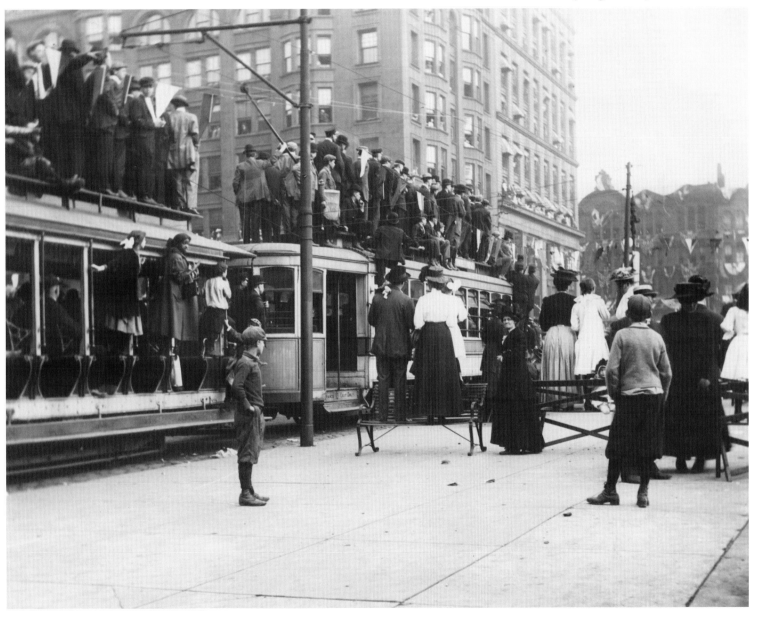

Street cleaners work along Franklin Hill in the Ohio City neighborhood about 1910.

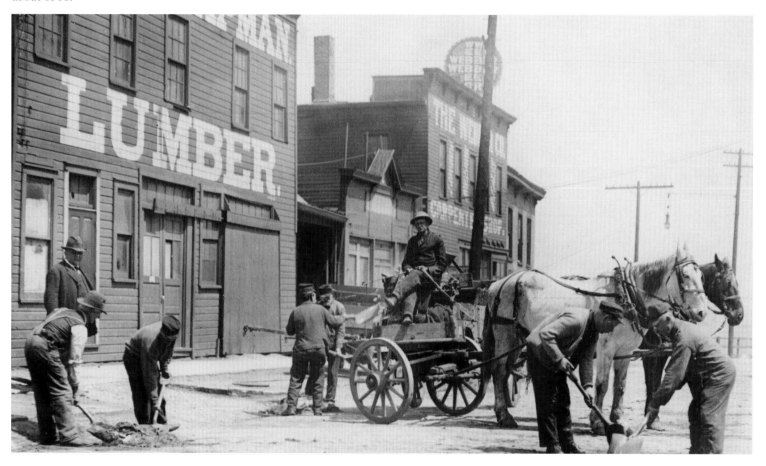

The lakefront, 1911. Seen from the breakwater, in front of the railroad tracks is the Cleveland Yacht Club (with the twin-gabled roof) sitting over Lake Erie at the foot of East 9th Street. Behind the yacht club and up the hill is the U.S. Marine Hospital and to the left is Lakeside Hospital. In the middle ground is a dumping platform.

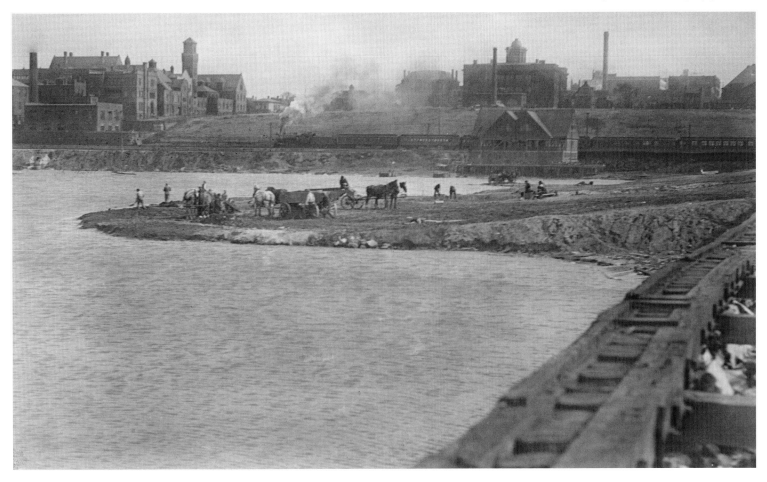

Grocery shopping, 1911-style.

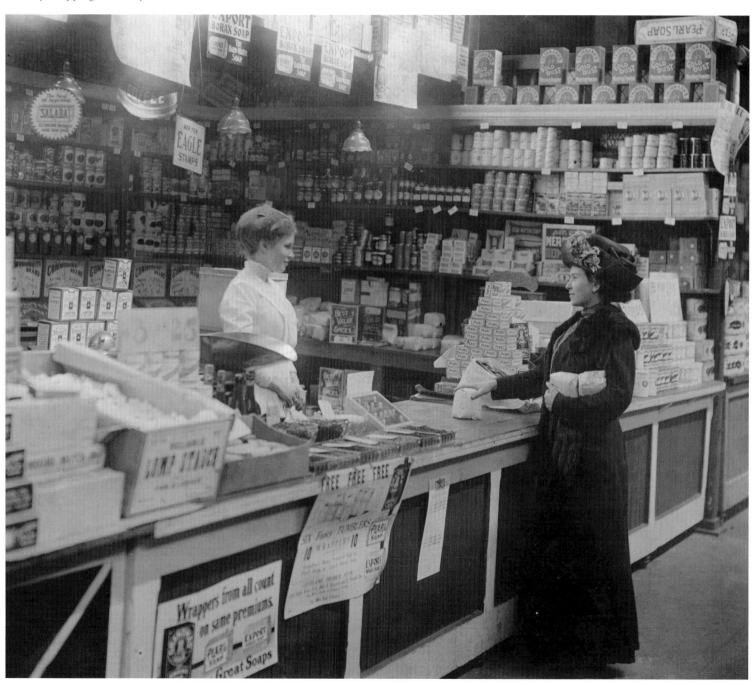

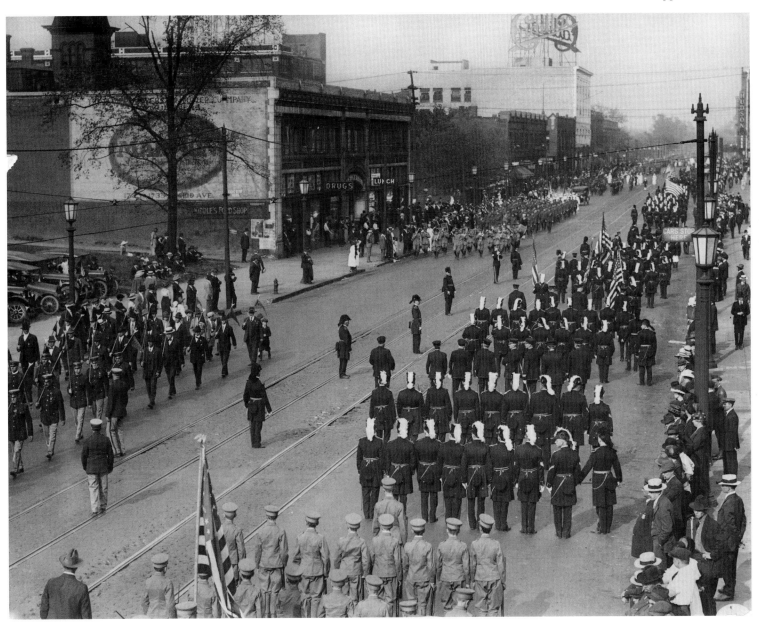

Euclid Avenue at E. 17th Street. Spanish American War veterans march on the far side of Euclid Avenue while the Knights of St. John march on the near side in the opposite direction.

Established in 1894, the Cleveland Trust Bank was an important banking institution. The bank moved into this imposing building in 1907. The building features a large Tiffany-glass rotunda 85 feet above the first floor. Currently being remodeled to serve county government offices, the building's future seems bright.

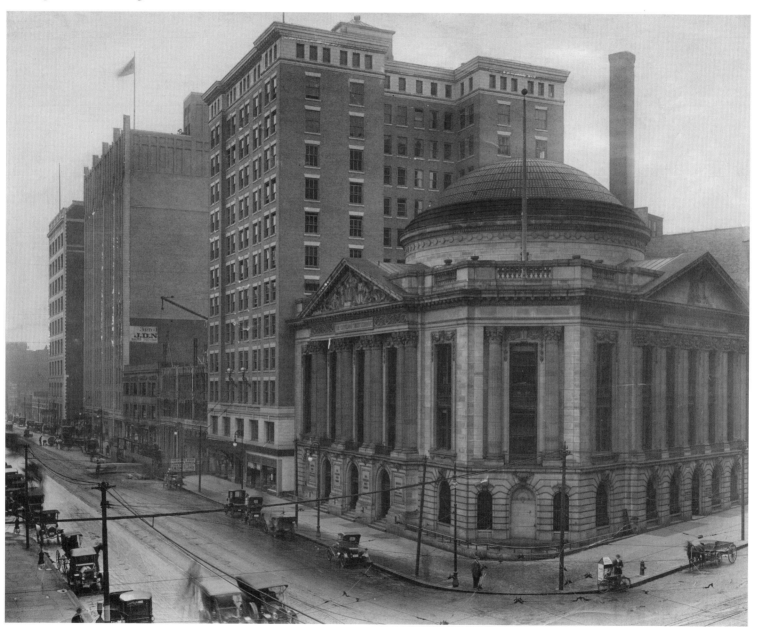

In 1911, a horse-drawn street-cleaning rig flushes Rockwell Avenue, just north of Superior Avenue, along the north side of the Plain Dealer Building.

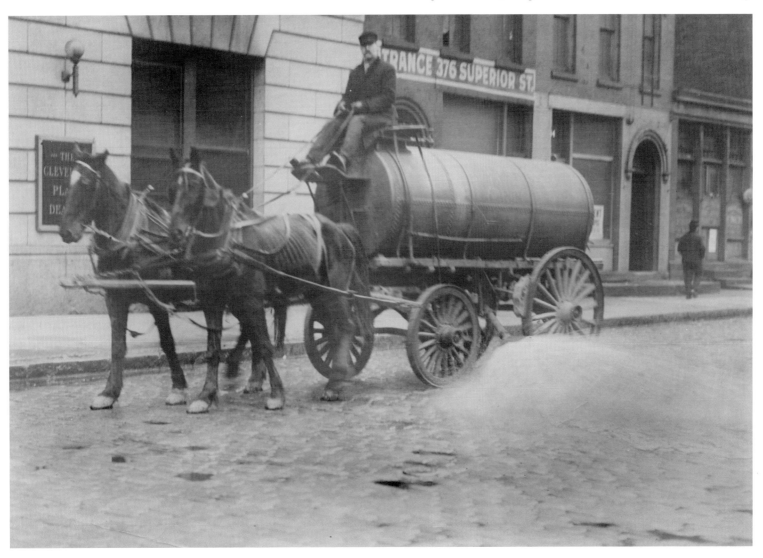

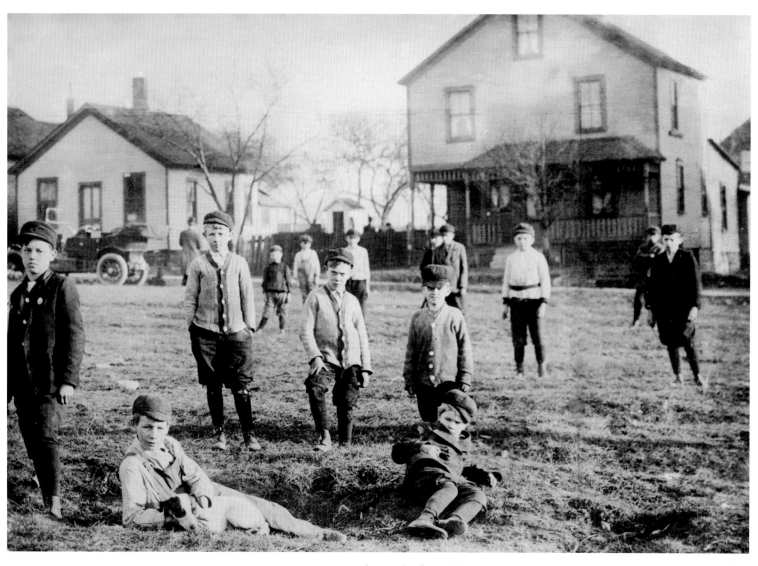

The youth of one Cleveland neighborhood pose for the photographer in 1911.

Interior view of the main floor of the iron-and-glass enclosed Arcade, designed by John M. Eisenmann and George H. Smith, which opened in 1890. The five-floor gallery connects two ten-story office buildings, one on Euclid Avenue and the other on Superior Avenue. The Arcade today is a part of the Hyatt Hotel and still provides downtown workers with a place for lunch and shopping.

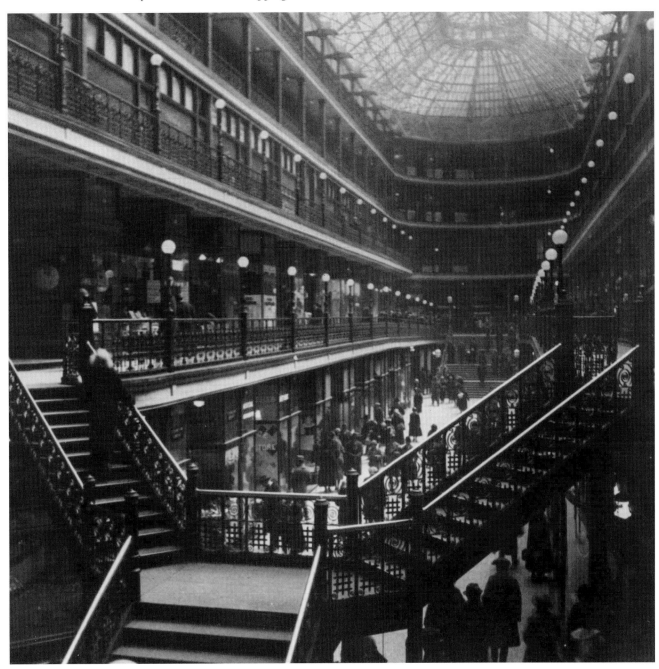

John D. and Laura Rockefeller debark a train at the Nickel Plate Station in Cleveland about 1912. Rockefeller built the Standard Oil Company, which he founded in Cleveland, into the largest oil-refining company in the world. His first oil refinery was located in the Flats area south of the city.

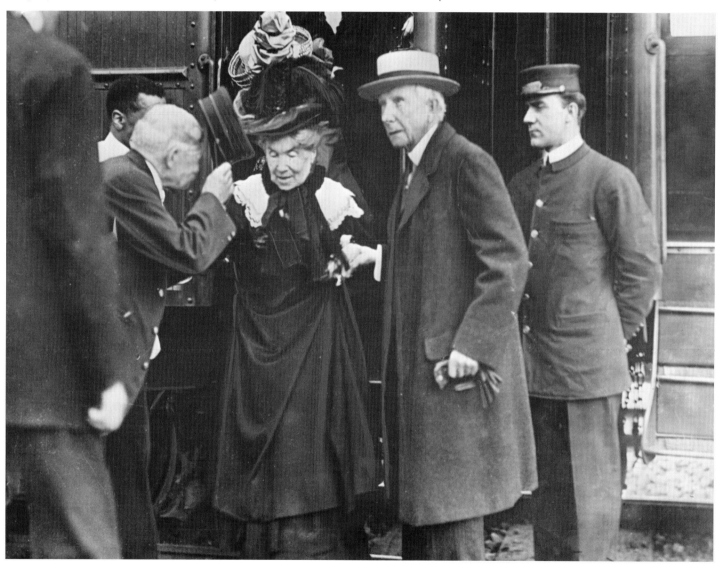

Horse-drawn vehicles, automobiles, streetcars, and pedestrians negotiate Euclid Avenue in 1912.

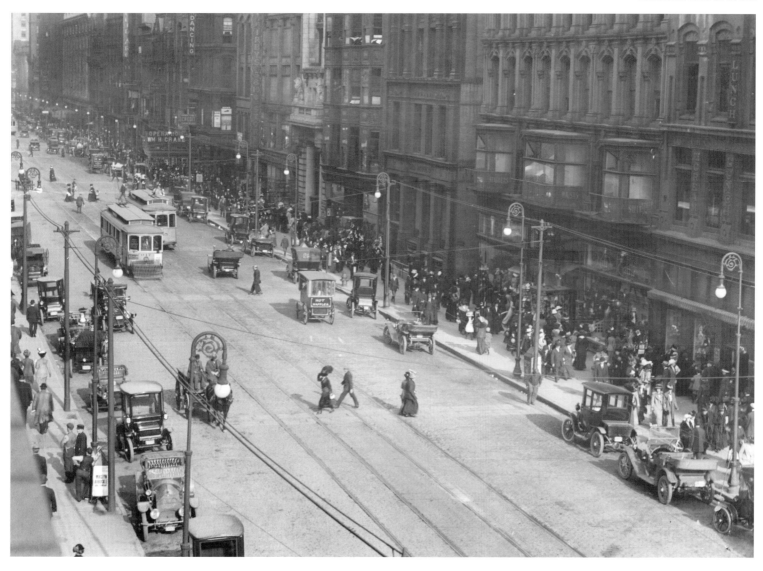

The blizzard of 1913. Snow started falling on November 9 and continued to fall for three days. At the height of the storm, winds exceeded sixty miles an hour. Before the snow ended over 22 inches covered the area and more than 75 percent of the city was without electrical power. Following the storm, a Painesville-Ashtabula streetcar waits for passengers in front of a shelter on Public Square.

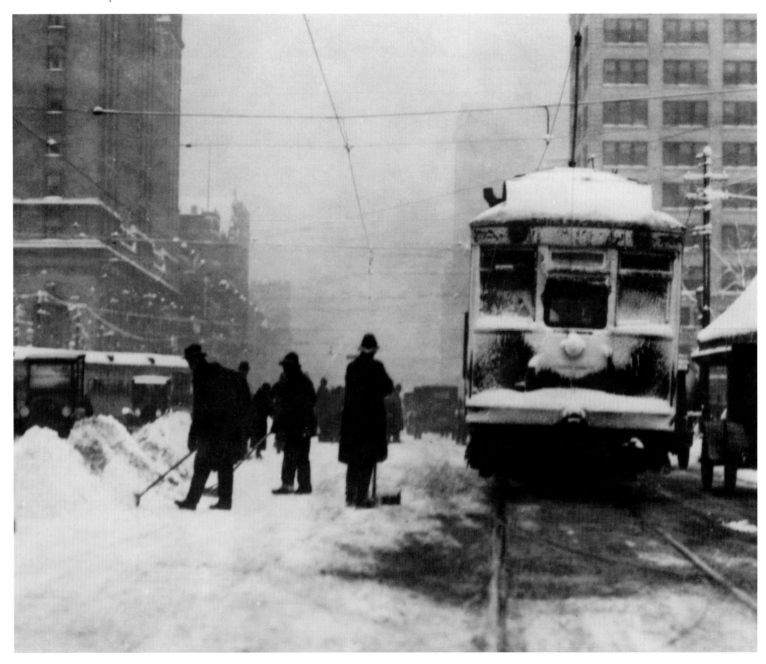

A busy street corner in downtown Cleveland in 1912, opposite Public Square. In view at center, next door to the May Co., the Crow & Whitmarsh Company sold dry goods and notions.

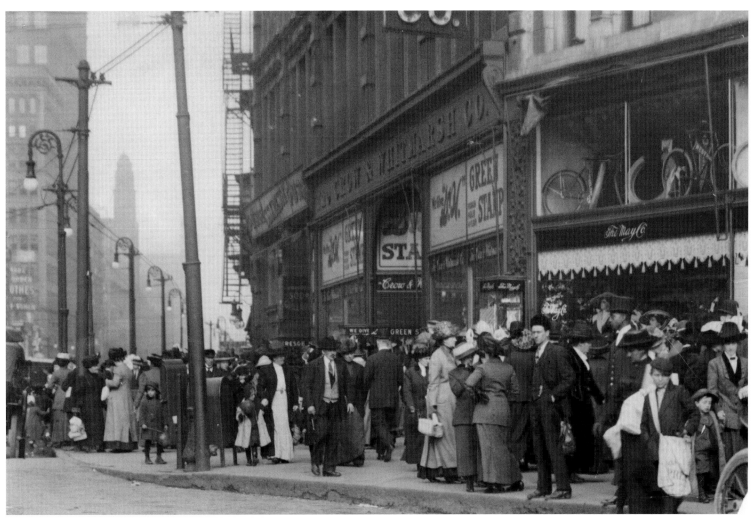

The Union Depot tracks and covered bridge in 1914. By the 1890s it had become difficult for Union Depot to handle the volume of train traffic coming into Cleveland. After Terminal Tower was built in 1927, Union Depot lost most of its business. The depot closed in 1953 and was demolished in 1959.

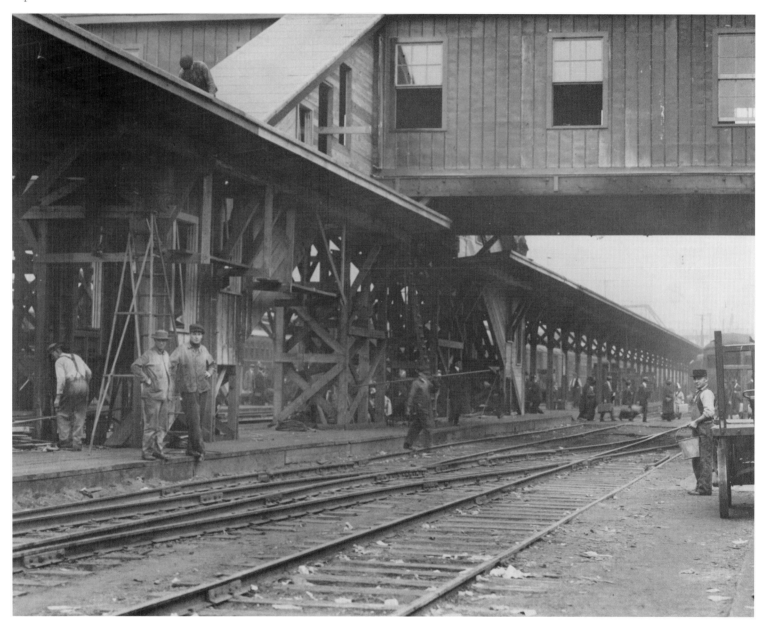

A bird's-eye view from East 6th Street. In 1914, Euclid Avenue was an important commercial, shopping, and entertainment center.

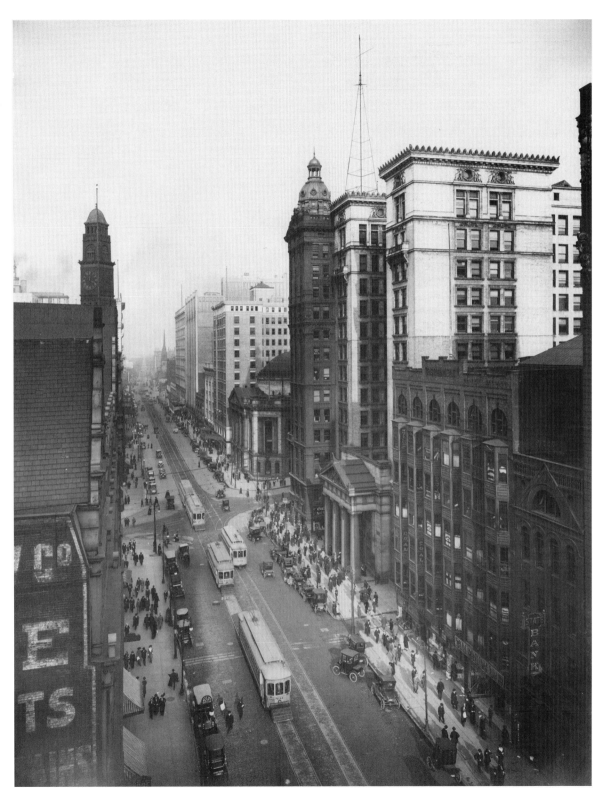

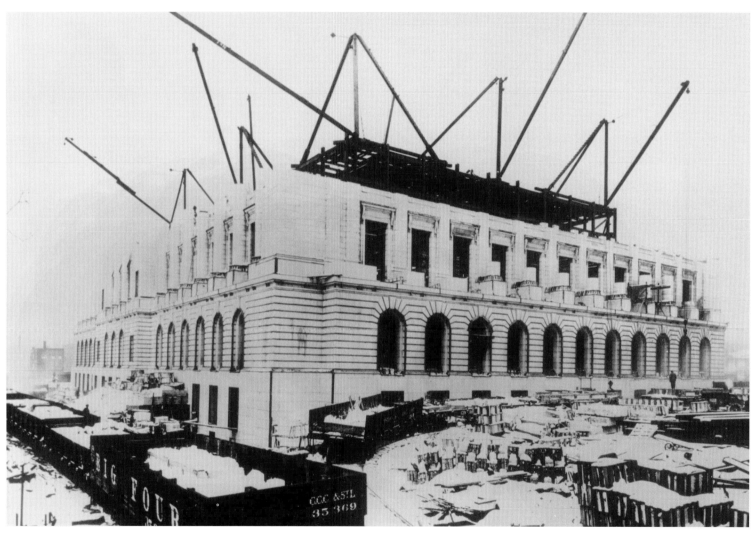

The current Cleveland City Hall is under construction ca. 1916. The building was planned as a nearly symmetrical beaux-arts twin to the Cuyahoga County Courthouse to the west. The architect was J. Milton Dyer. The courthouse and city hall were erected as part of the 1903 Group Plan.

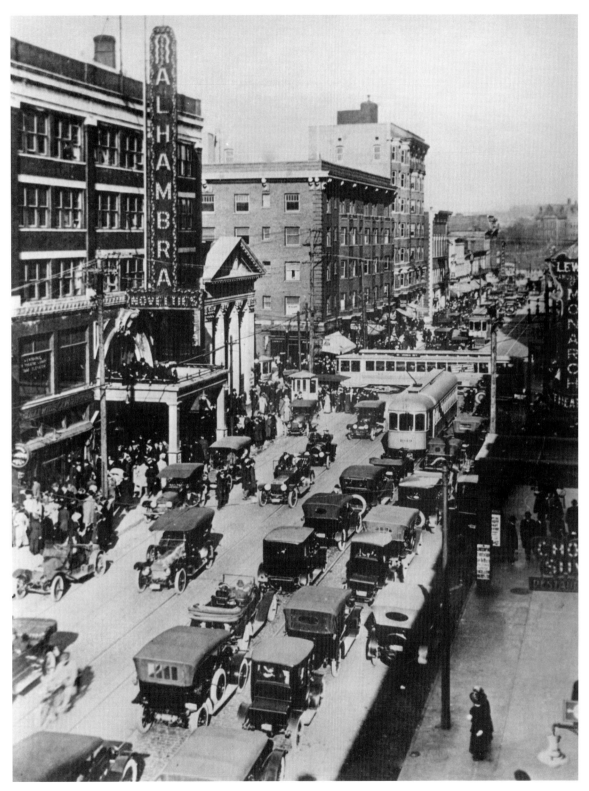

Euclid Avenue in 1915. Once known as Doan's Corners, Euclid Avenue between East 105th and 107th streets was considered Cleveland's second downtown.

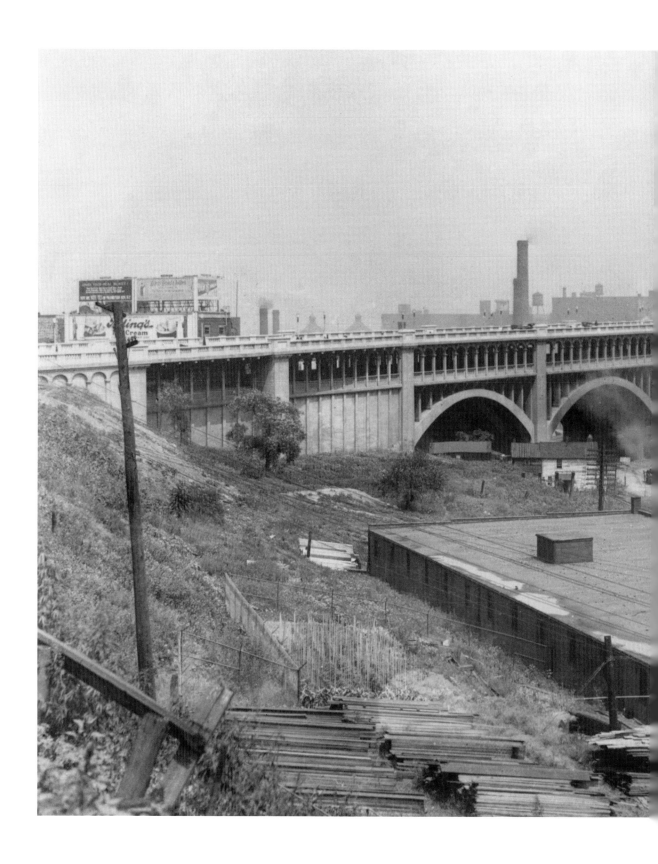

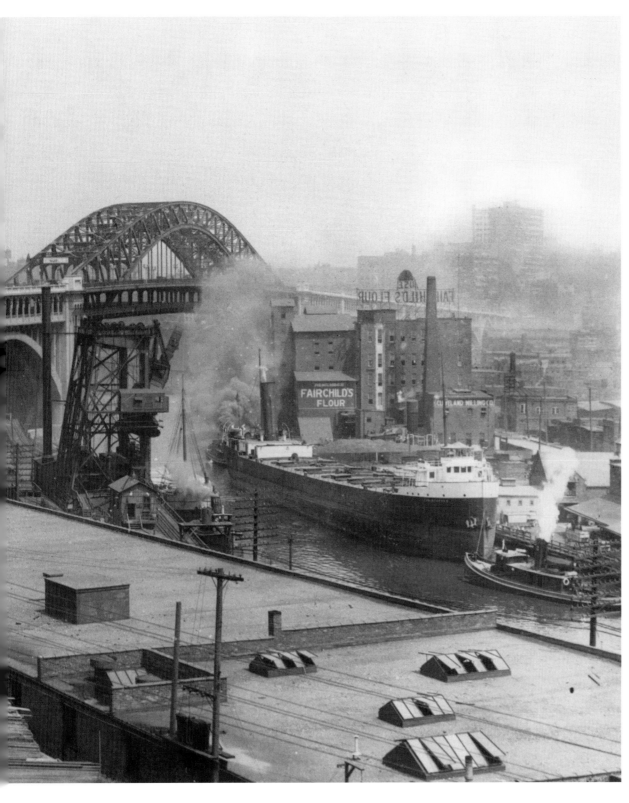

A view of the Detroit-Superior Bridge in 1915. The lake freighter *Christopher* in the Cuyahoga River is being moved by tugs. Fairchild's Flour Mill stands on the east bank.

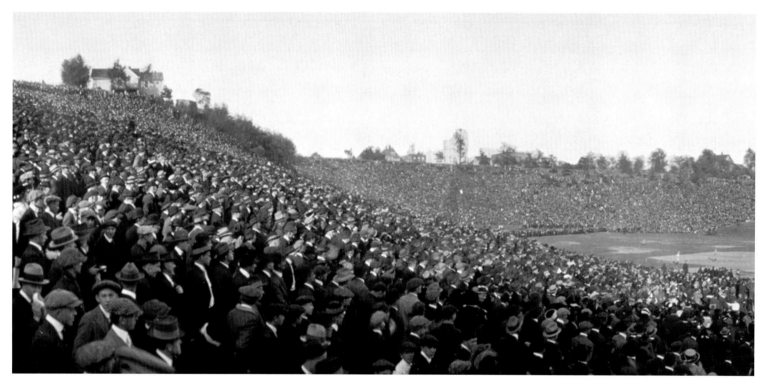

Brookside Park baseball field, 1915. On August 1, the White Autos defeated an Omaha, Nebraska, team by a score of 11-6 to win the National Amateur Baseball Championship. The crowd of 115,000 was said to be the largest ever to attend an amateur baseball game in the United States.

During World War I, visitors to Public Square were invited to ring a liberty bell to show their support for the Allied Forces and to "Wring the Kaiser's Neck."

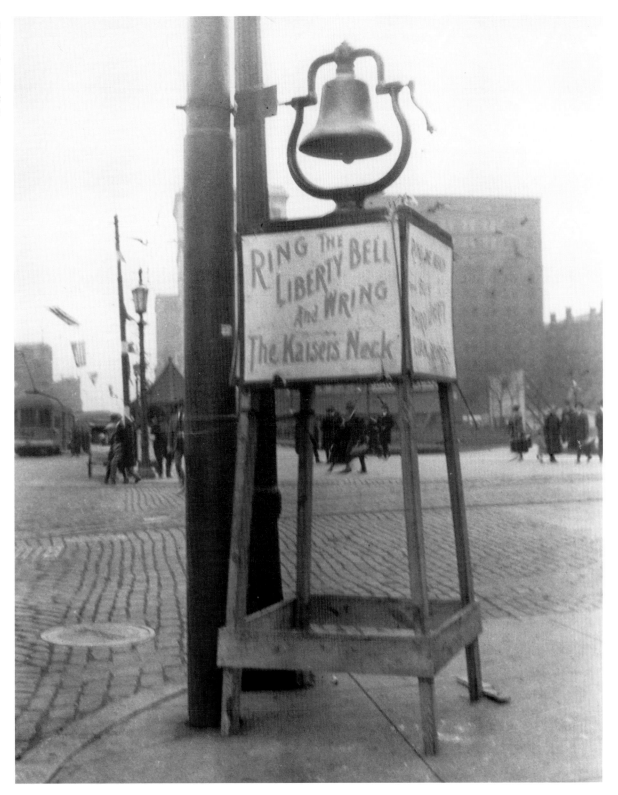

An American tank on display at Public Square serves as a booth for the sale of war bonds to support the American Expeditionary Forces in World War I.

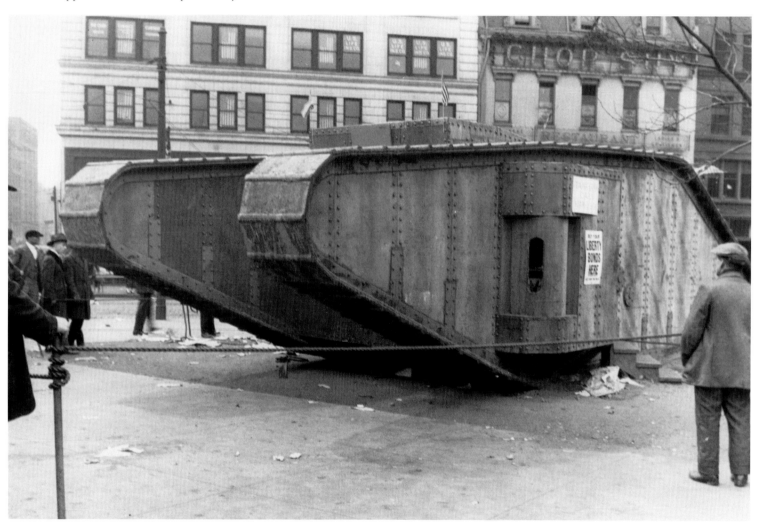

A crowd of Clevelanders gathers at the Union Terminal for the send-off of the 5th Regiment of the Ohio National Guard, to fight the Axis Forces in Europe in World War I.

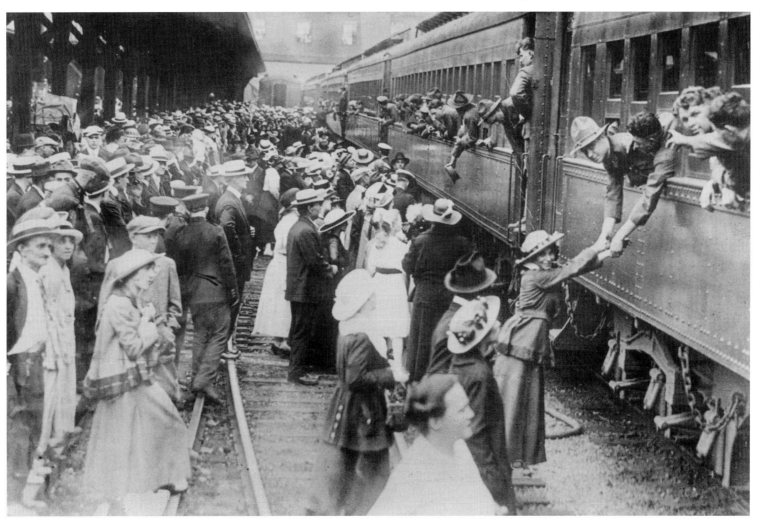

In 1918, a World War I war bonds tent on the northwest quadrant of Public
Square is open for business, helping to win the war by funding the war effort.

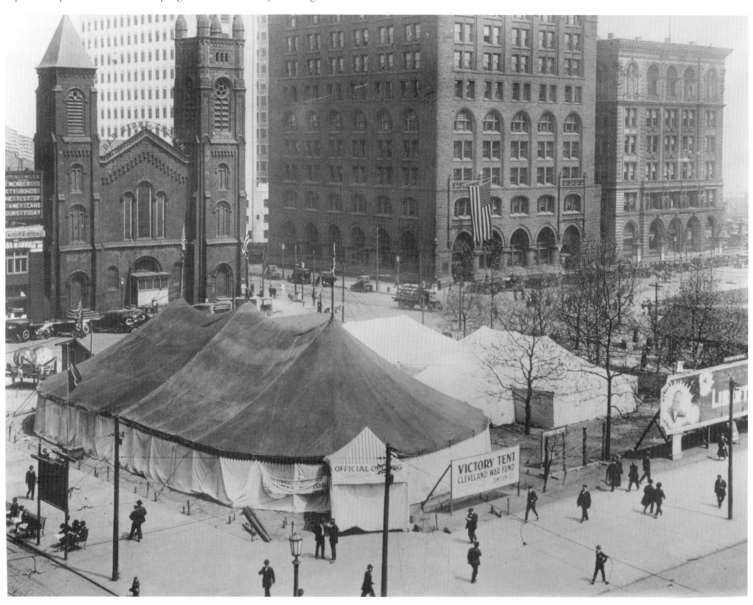

Pictured here are some of the Clevelanders who gathered on Public Square November 11, 1918, to celebrate the Armistice ending World War I.

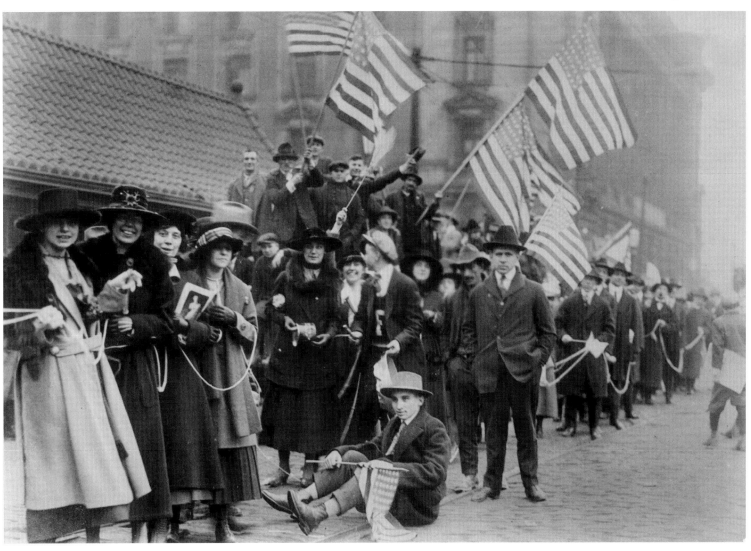

Mouth of the Cuyahoga River and the Flats area. A passenger steamboat is docked along the west bank of the river in front of the Cleveland Electric Illuminating Company's former powerhouse. At right-center is Whiskey Island, a peninsula formed by the old river bed and new river channel, and named for an early distillery, which operated on the site.

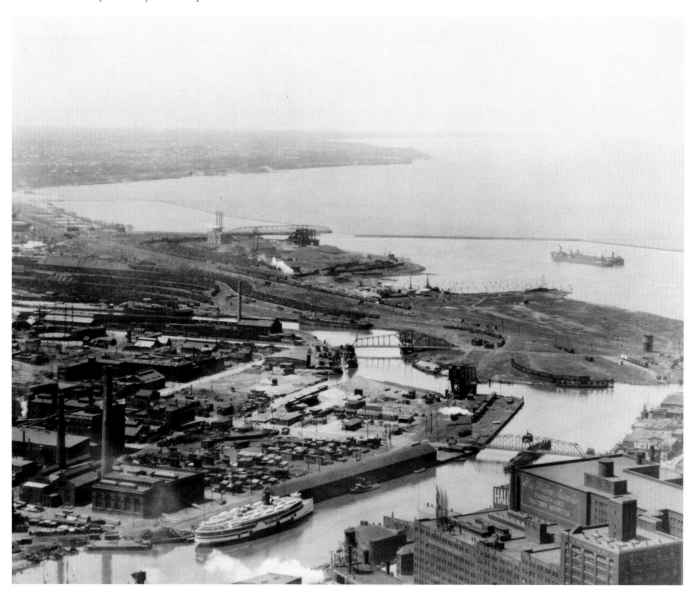

Huron Road, 1921. The triangle-shaped Osborn Block stands at the intersection of Huron Road and Prospect Avenue at East 9th Street.

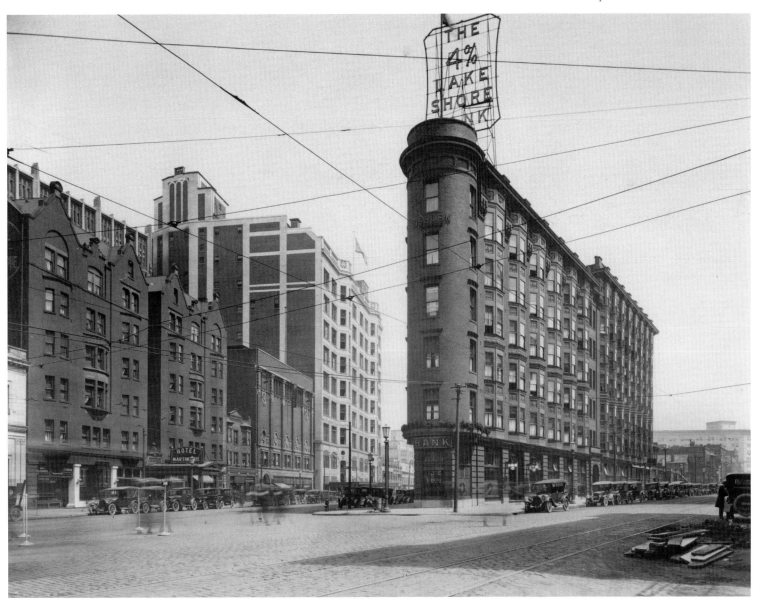

Shoppers examine merchandise in vendors' stalls outside the Westside Market on West 25th Street. Opened in 1924, the market is still in operation, and has become an important tourist attraction for the city, besides serving as the city's largest market for meat, poultry, fish, ethnic foods, fresh produce, fresh cut flowers, and other desired delicacies.

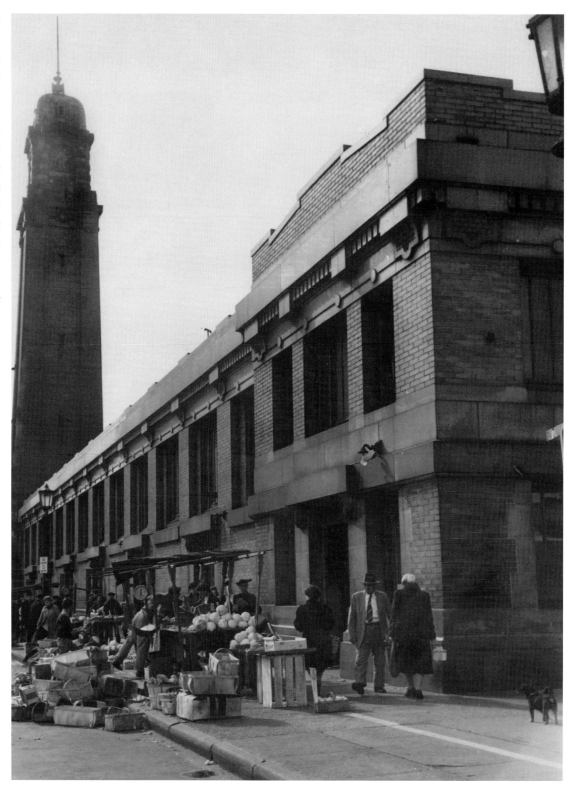

These retail and office buildings occupied the south side of Public Square before their demolition for the building of the Cleveland Union Terminal and Terminal Tower Complex.

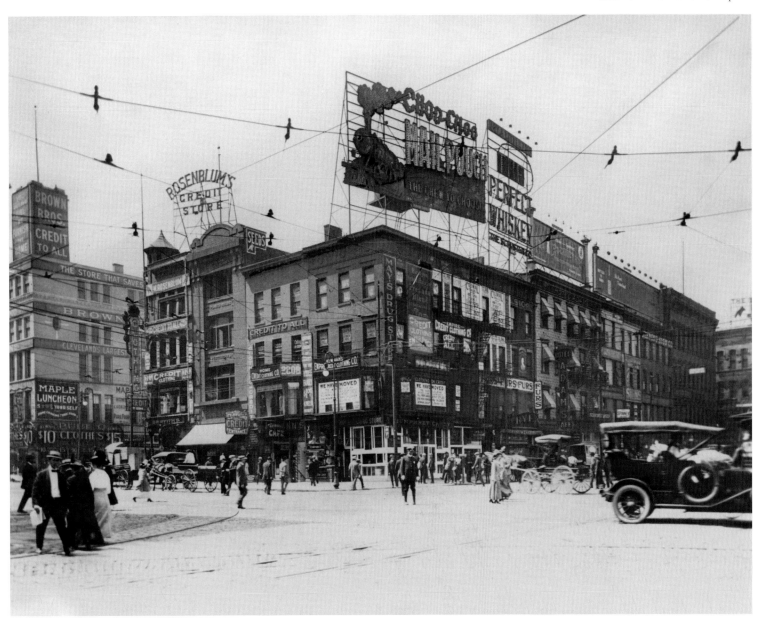

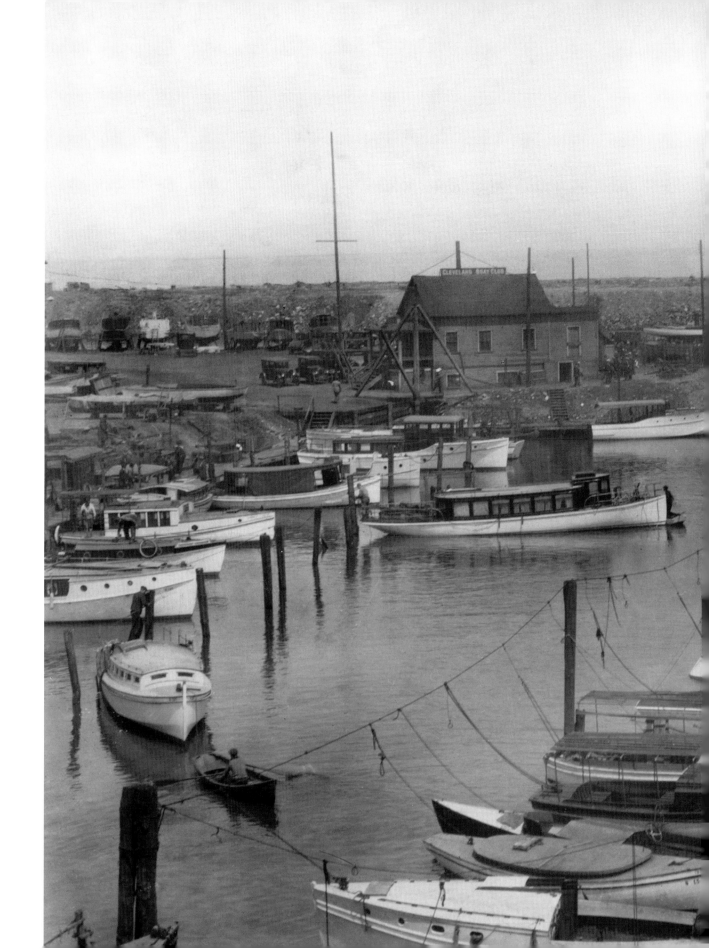

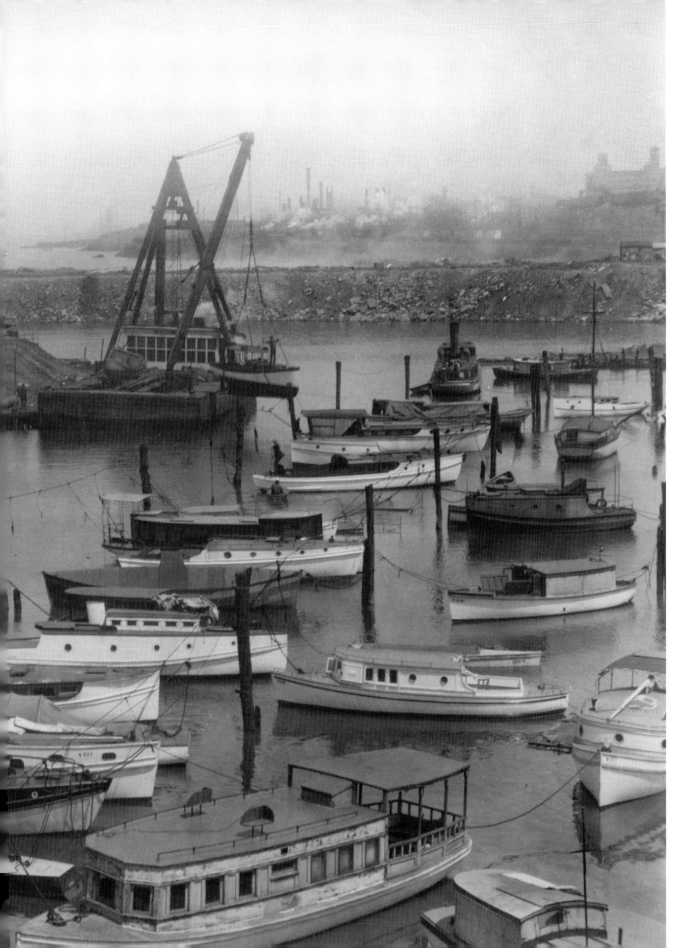

A view of the East 9th Street lagoon with several small private pleasure boats tied up at the docks. The Cleveland Boat Club building is visible at left.

Children in costume parade down Euclid Avenue around 1920, in the annual
Playground Parade, a highlight of Cleveland's summer recreation program.

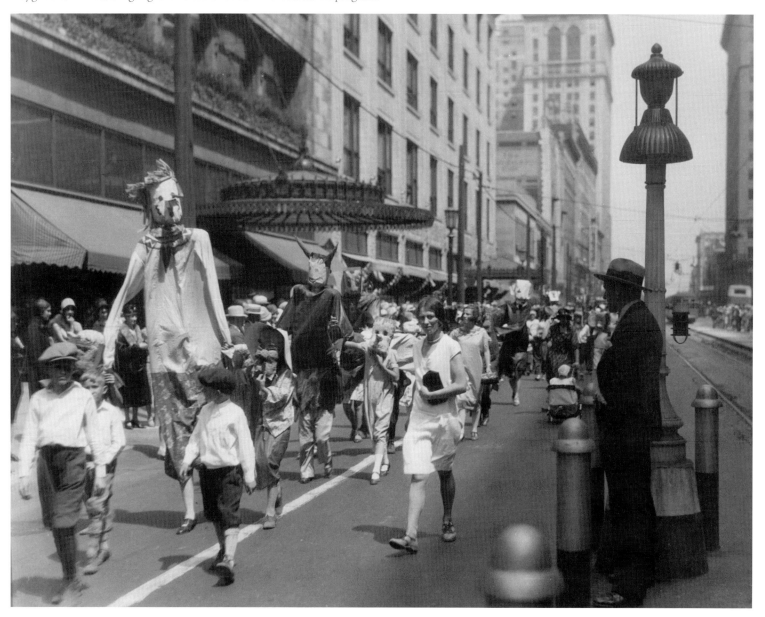

The western end of Euclid Avenue at Public Square ca. 1920. At left is the Euclid Avenue entrance to the Midland Bank in the Williamson Building, and at right is Bailey's Department Store and the western corner of the May Company building.

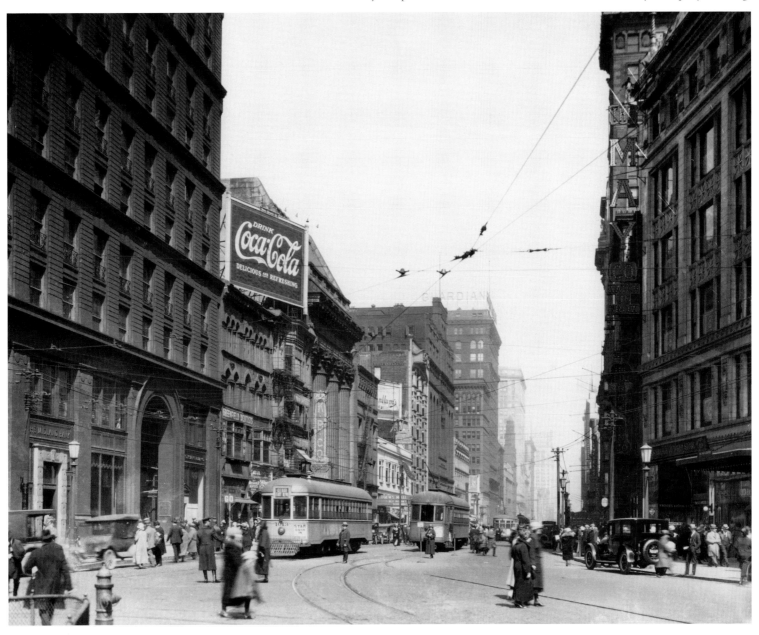

A policeman directs traffic at the northwest corner of Euclid Avenue
and East 107th Street in 1922.

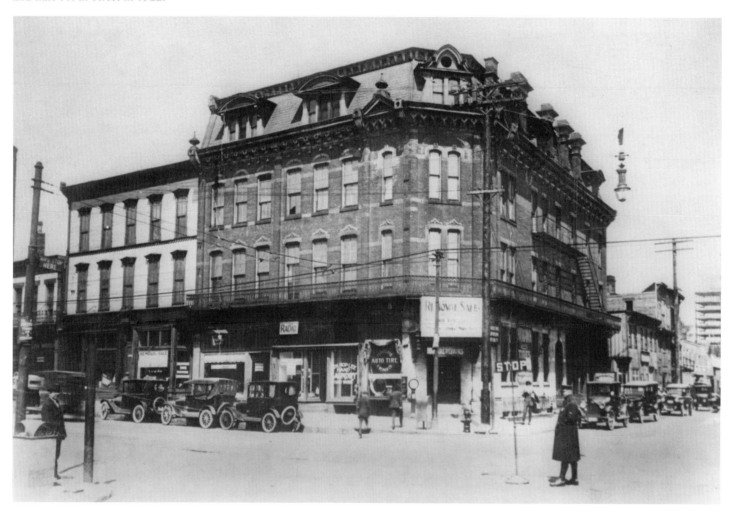

Early arrivals to the Republican National Convention, held in Cleveland in 1924, receive stuffed elephants as welcoming gifts. The women are delegates representing the Woman's Republican Club of Massachusetts and of New York.

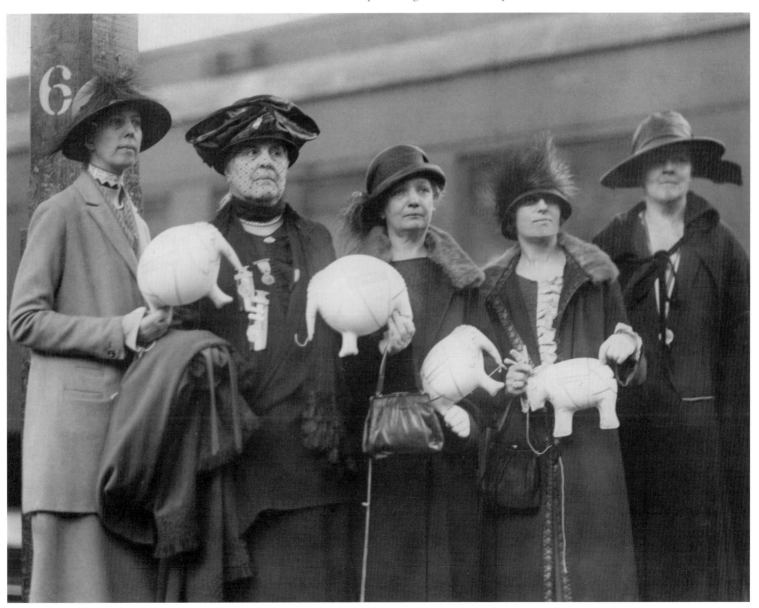

Republican delegates fill Cleveland's new Public Hall, which opened in 1922 with seating for 13,000. Public Hall still provides space for large meetings and conventions in the city.

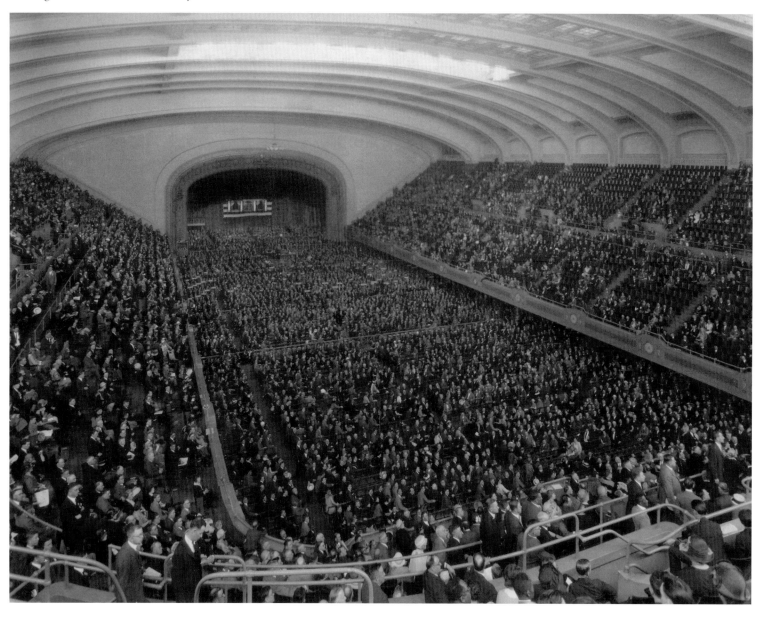

Barbers from George A. Myers barbershop in the Hollenden Hotel line up for a group portrait. The barbershop rivaled the hotel's bar as a center for political activity, and was also one of the most modern in the nation, with porcelain fixtures, individual wash basins, sterilizers, and humidors. The writer Elbert Hubbard described the shop as "the best barber shop in America," and Myers boasted of shaving or barbering eight presidents, several congressmen, and other luminaries such as Mark Twain, Lloyd George, and Marshall Foch.

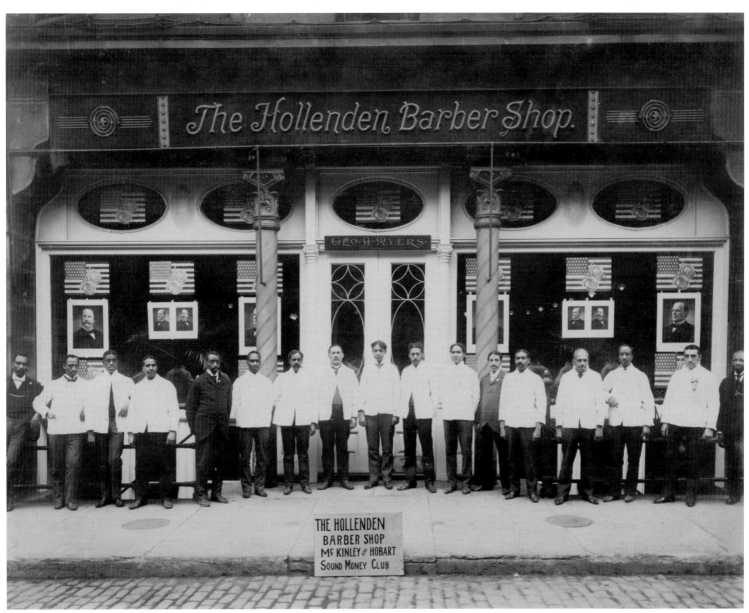

A 1925 view of Public Square and the Soldiers and Sailors Monument, from the vantage point of the Williamson Building. Left of the Old Stone Church (First Presbyterian) is the 1915 Illuminating Building, and to the right of the church, across Ontario Street, is the Society for Savings Building constructed in 1889–1890.

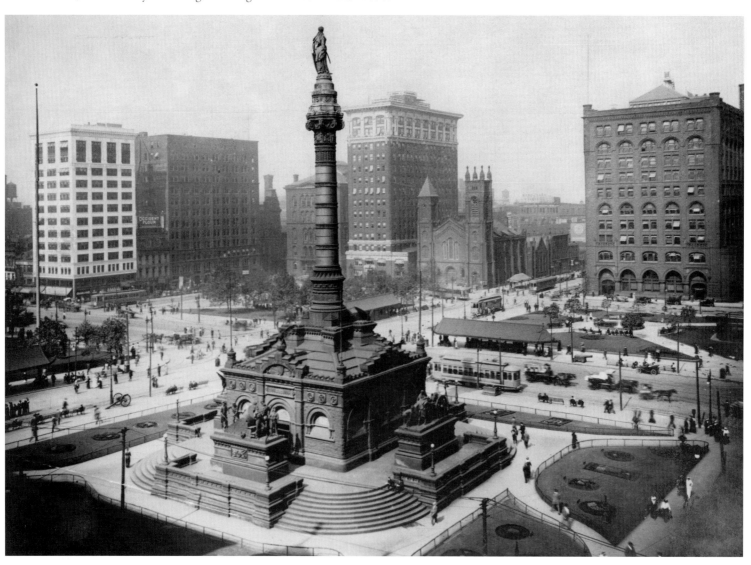

In the 1920s Cleveland was becoming a center of commercial mail and passenger flight operations. In this 1925 photograph of D. C. Batton preparing to land his biplane at Martin Field on St. Clair Avenue, flying was still a novelty, drawing a large crowd of onlookers.

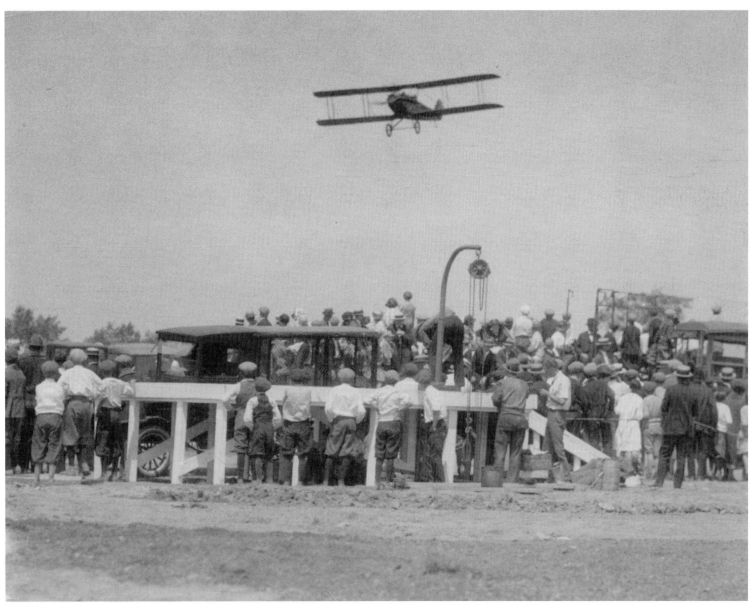

Here a Maypole dance is under way in Edgewater Park.

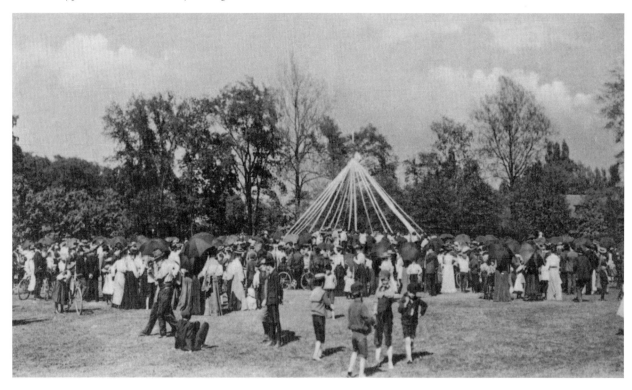

An early view of lower East Boulevard, Rockefeller Parkway. Now the Martin Luther King, Jr., Memorial Parkway, the roadway winds through a beautiful park setting lined with gardens established in honor of the numerous ethnic groups that have made Cleveland home.

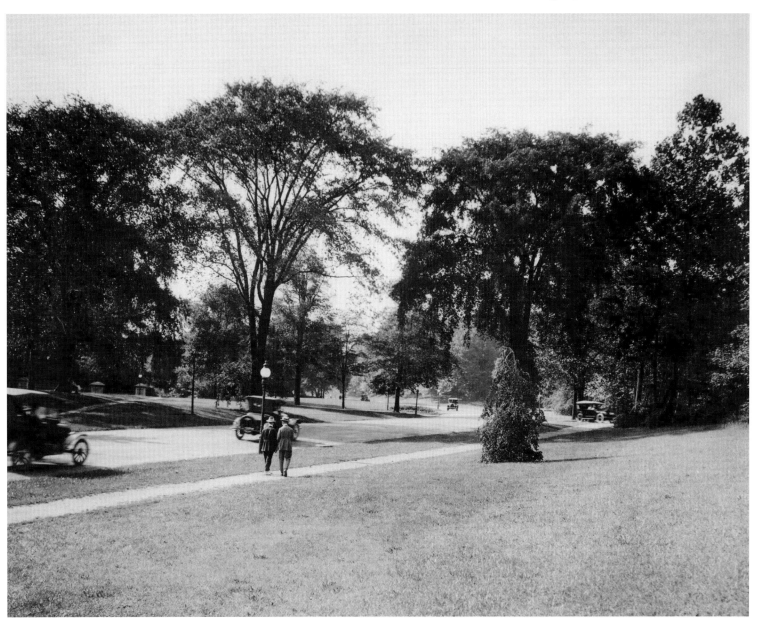

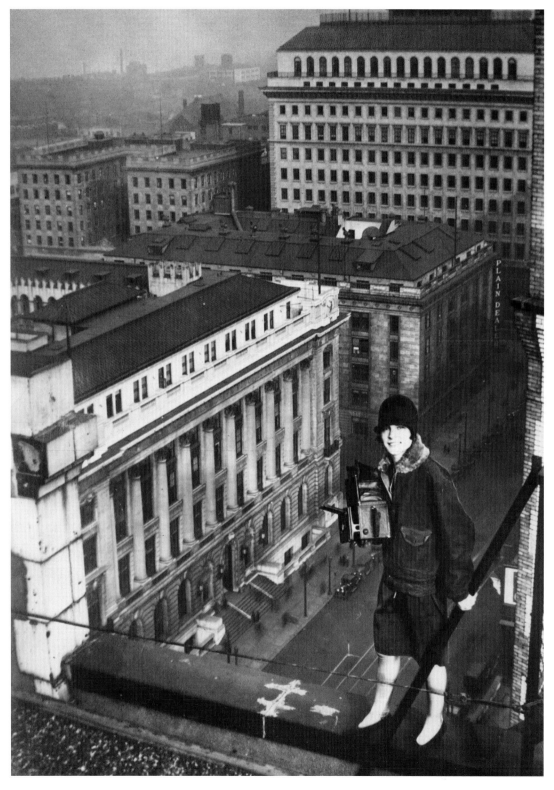

Noted photographer Margaret Bourke-White takes up a precarious position on the roof of an office building across Superior Avenue from the recently opened Main Building of the Cleveland Public Library. To the right of the library is the old Plain Dealer building, now the site of the Library's Louis Stokes Wing. The taller building behind the Plain Dealer building houses the Federal Reserve Bank of Cleveland.

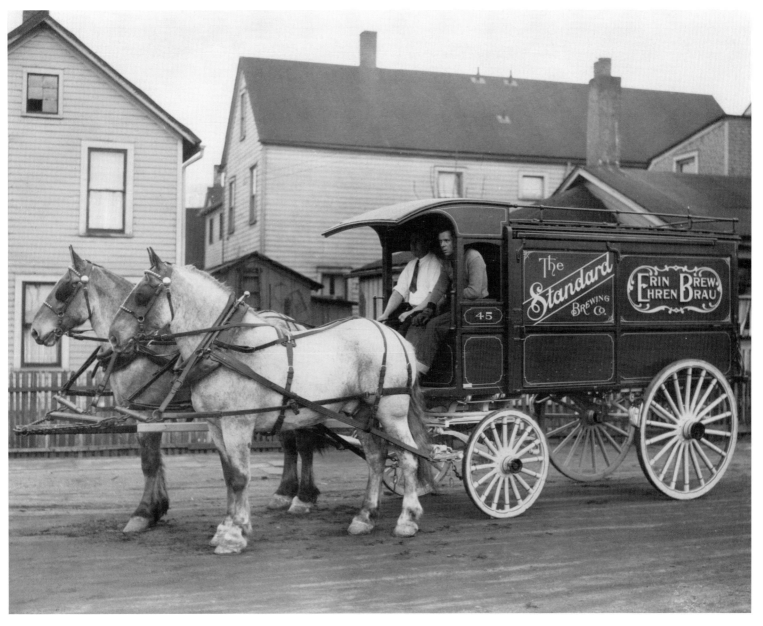

The Standard Brewing Company's horse-drawn beer wagon plies the streets of Cleveland, ca. 1910.

Massachusetts delegates arrive in Cleveland for the Republican National
Convention in 1924.

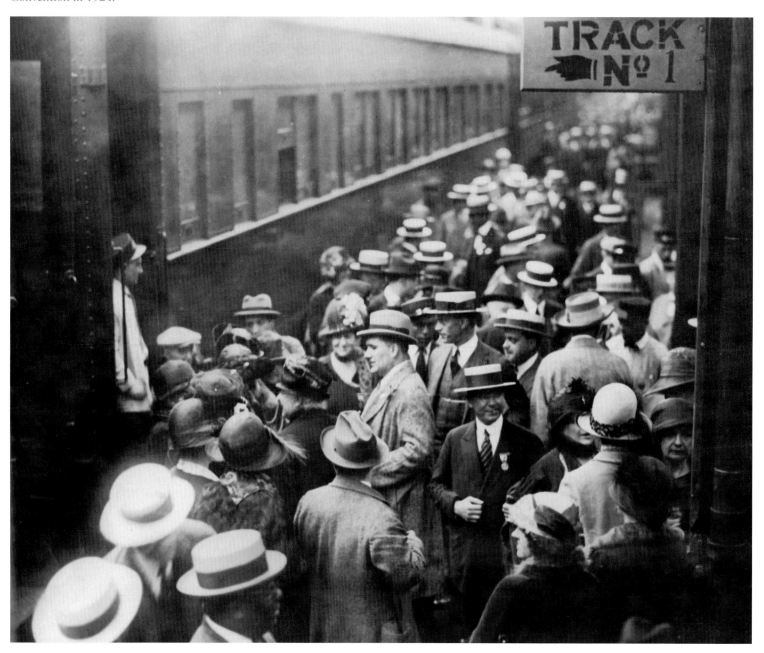

A view of East 105th Street from about 100 feet south of Massie Avenue in 1928. The busy street is shared by automobiles and electric streetcars.

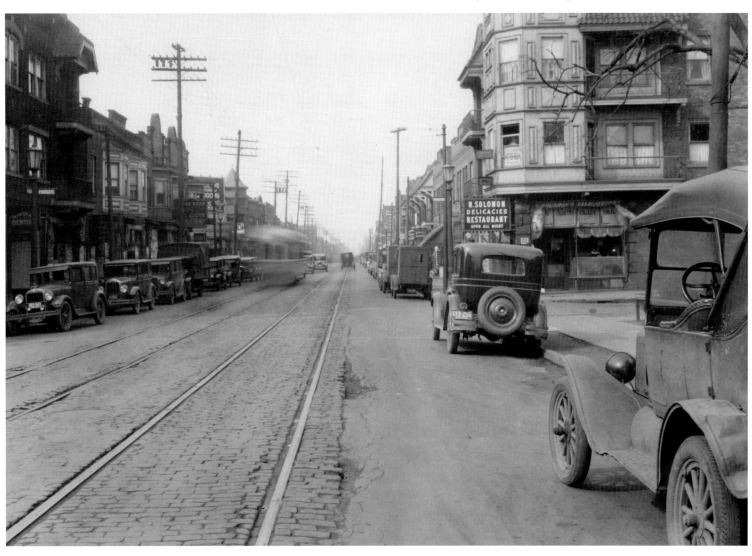

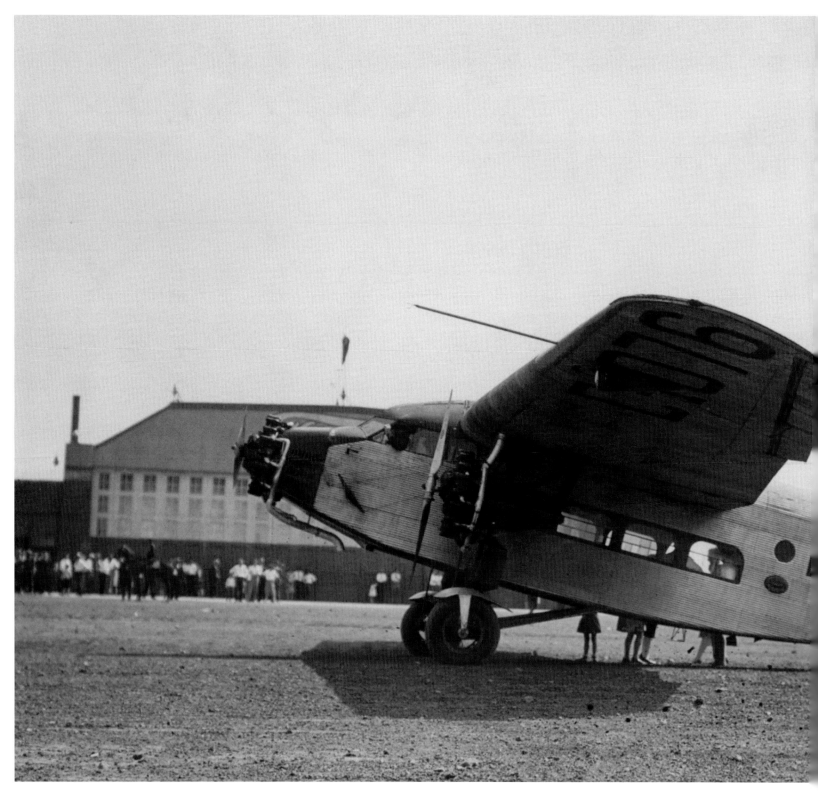

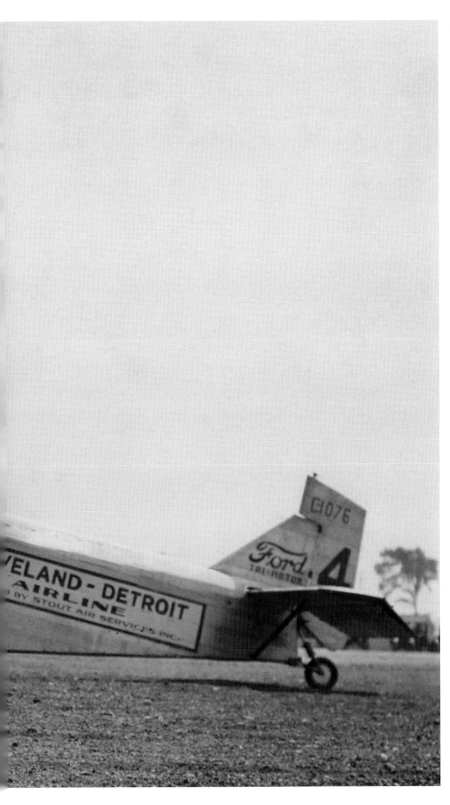

An airplane sits parked at the terminal at newly opened Cleveland Hopkins Airport in 1928. Ford Commercial Air Lines inaugurated daily flights between Cleveland and Detroit in airplanes like the one pictured here. The flight between the cities took one hour and twenty minutes to complete.

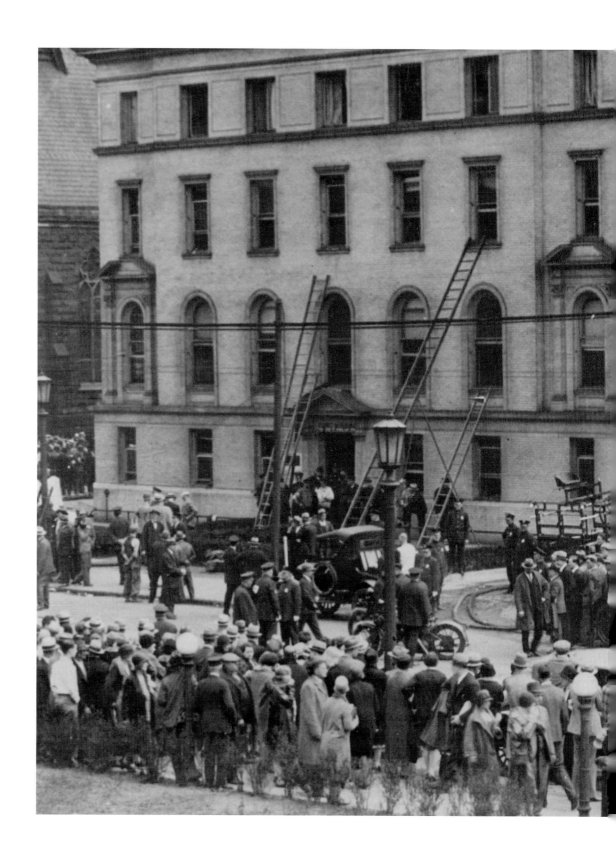

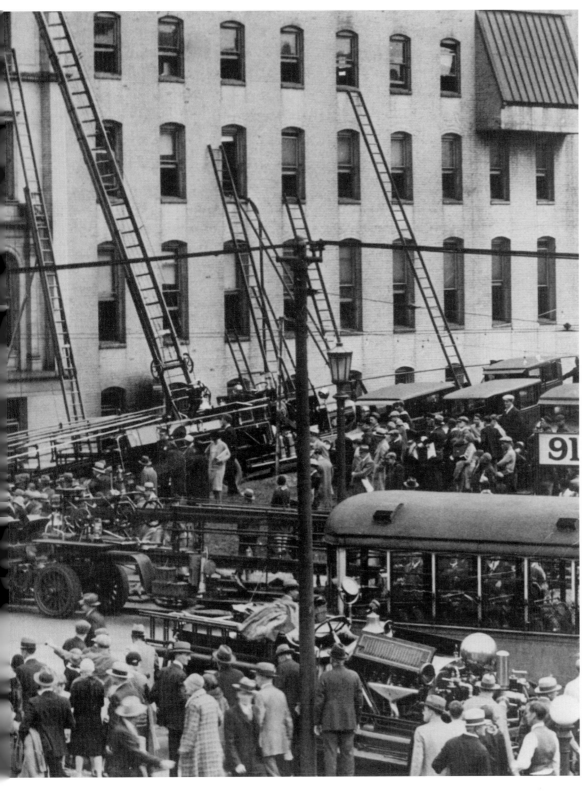

A large crowd gathers to watch firefighters work at putting out the fire at the Cleveland Clinic building at East 93rd Street on May 15, 1929. A storage room containing X-ray film caught fire, creating a lethal gas that killed 124 persons, including 9 doctors. An electric light bulb left on and located too close to the X-ray film was determined to be the cause of the fire.

Lexington Avenue at East 66th Street. This aerial view was taken during
the World Series games of October 1920. League Park, a Cleveland
landmark, was formerly known as Cleveland Baseball Park.

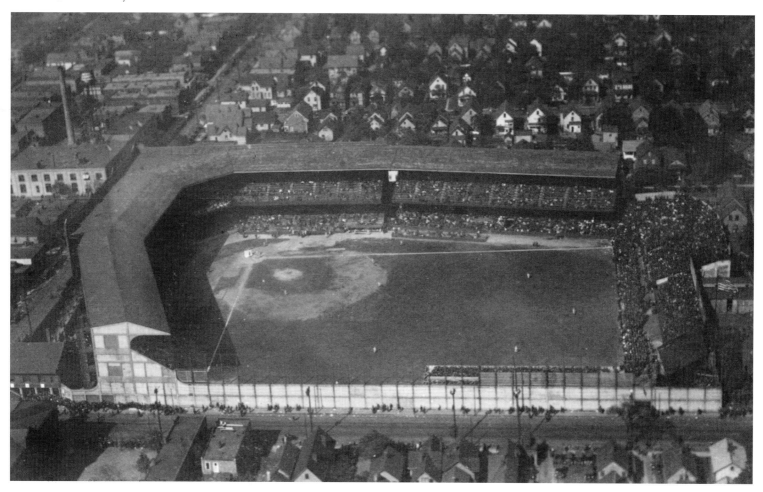

Spectators view the United States Navy's dirigible airship U.S.S. *Los Angles* at its mooring at National Air Races at the Cleveland Airport in 1929. One of the thrills of the show in 1929 was the transfer of Lieutenant Bolster from *Los Angles* to a Vought biplane moored on the underside of the dirigible.

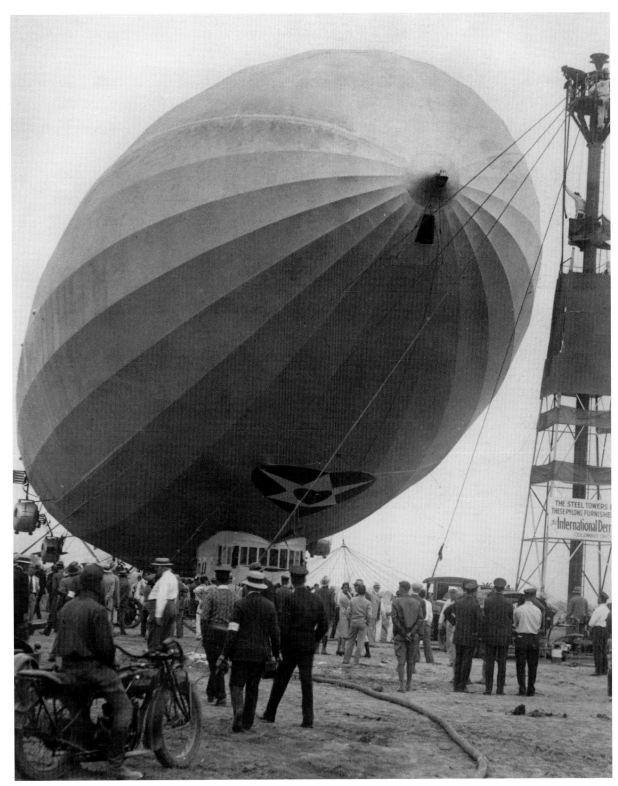

An anxious mother and small child navigate their way through a crowd of shoppers selecting fresh produce from stands set up on the sidewalk along Lorain Avenue outside the Westside Market in 1927.

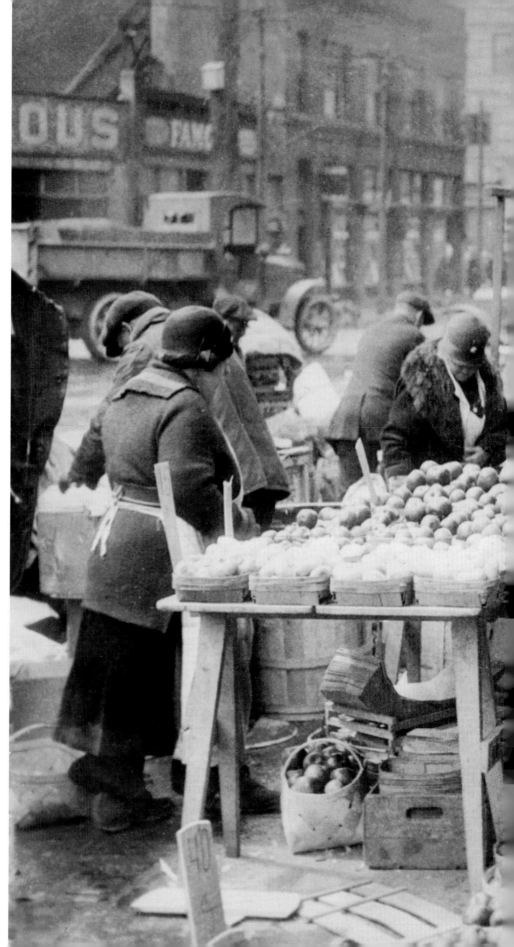

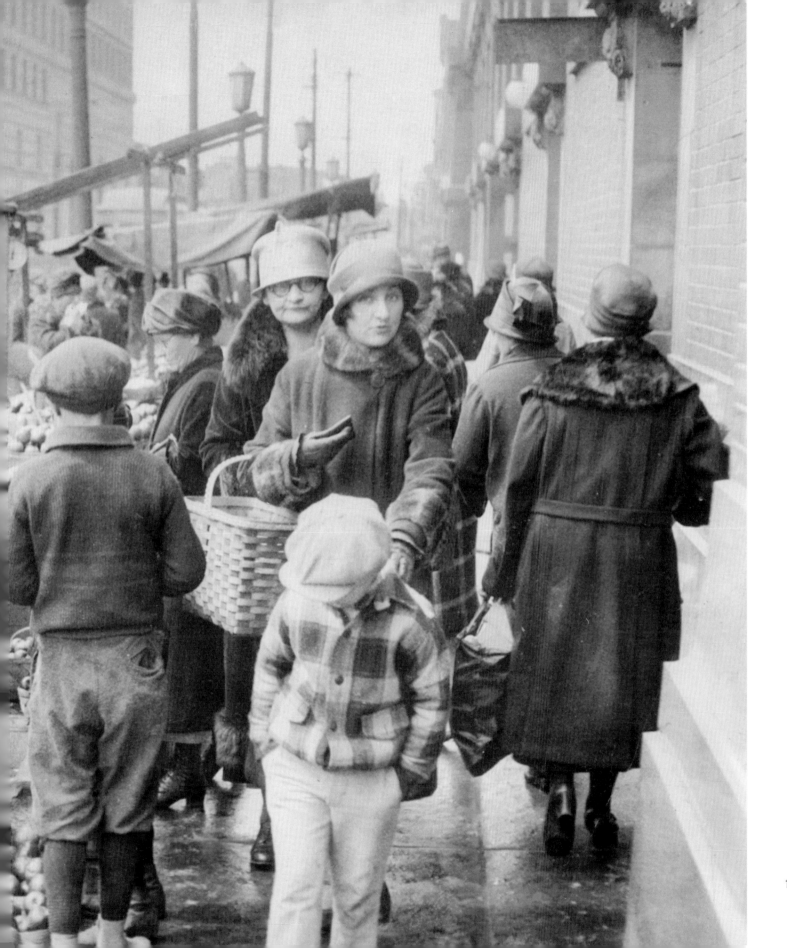

A Cleveland Public Library book caravan visits Sowinski School at
Sowinski Avenue near East 79th Street.

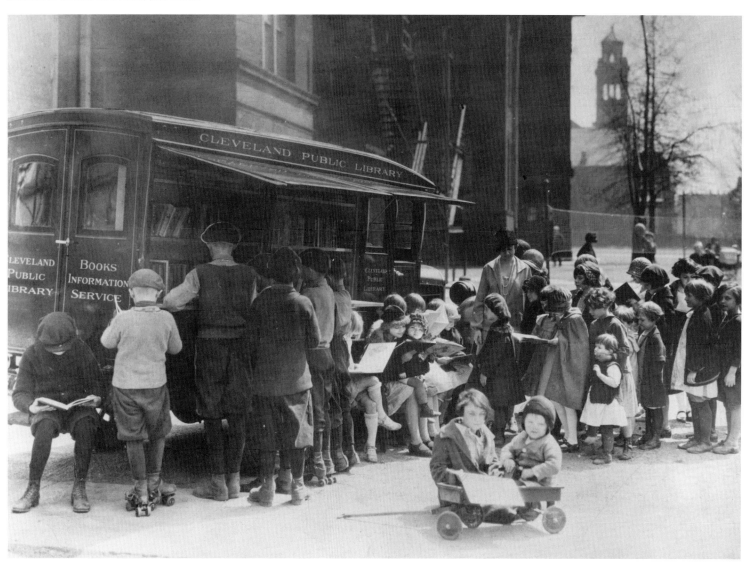

Economic Growth, the Great Depression, and World War II

(1930–1949)

The Great Depression caused a severe economic disruption in Cleveland, forcing a contraction in industry and the closure of many businesses and financial institutions. The closures were unprecedented and resulted in a large increase in unemployment and a rise in poverty.

Although the city struggled during this period, large construction projects were undertaken. The performance center Severance Hall was completed in 1931, as was Municipal Stadium, built as a WPA project. Cleveland Union Terminal and Tower complex was also completed—at the time, the largest building outside New York City and the tallest building in Ohio.

The city became a manufacturing center for the production of aircraft, and aircraft engine parts. Cleveland also began a Labor Day tradition in 1929 with the National Air Races, which lasted until 1949 when a participating plane crashed into a home, killing the pilot and a mother and child residing in the house.

As World War II began, Cleveland's position as a producer of aircraft and automotive parts was strengthened. The city's factories produced artillery, small arms, aerial bombs, binoculars, telescopes, and other war essentials.

Population growth was spurred by the growth of industry. Many new Clevelanders came from other regions in the United States. These newcomers included a large number of African Americans from the deep South and families from Appalachia.

The end of the war was a time for celebration for the city. In 1948 the Cleveland Indians would bring the World Series crown to Cleveland. The city called itself "the best location in the nation." The central business district around Public Square, and along Euclid Avenue, supported a thriving retail center. Shoppers were able to find stores catering to every need, along with an abundance of restaurants and theaters offering live entertainment and movies.

In the 1940s the city was recognized as the 6th largest city in the United States, with a population of 878,336. By the end of the decade, a peak population of 914,808 citizens had made Cleveland their home.

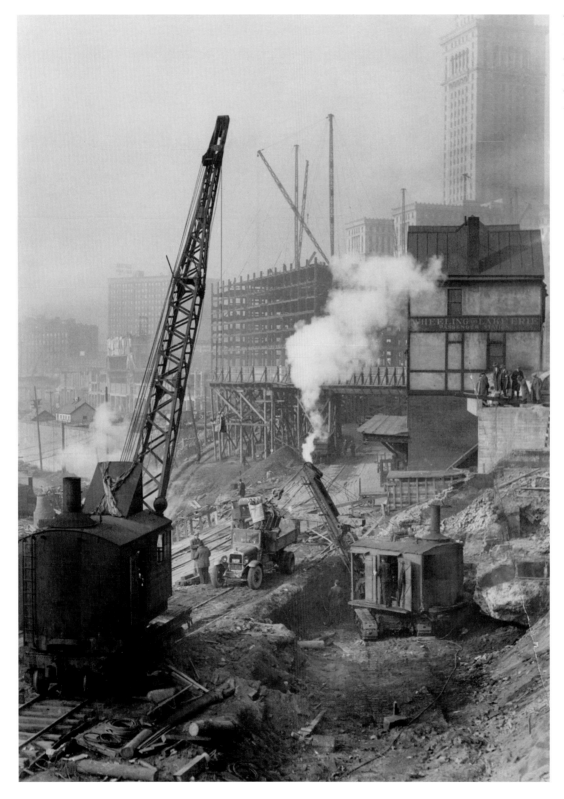

The New Cleveland
Union Terminal is under
construction in 1930 with
the recently completed
Terminal Tower in the
background.

The head of one of the heroic pieces of sculpture that will grace the new
Lorain-Carnegie high-level span is being lowered into place in 1932.
These pylons (there are four, each having figures facing east and west) rise
45 feet above the bridge sidewalk.

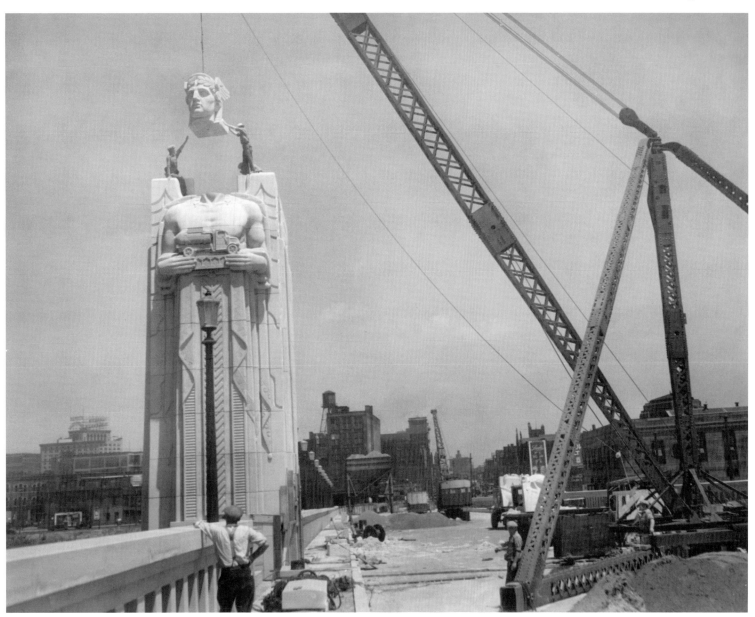

The freighter *G. A. Tomlinson* is towed on the Cuyahoga River
through the Flats in 1936.

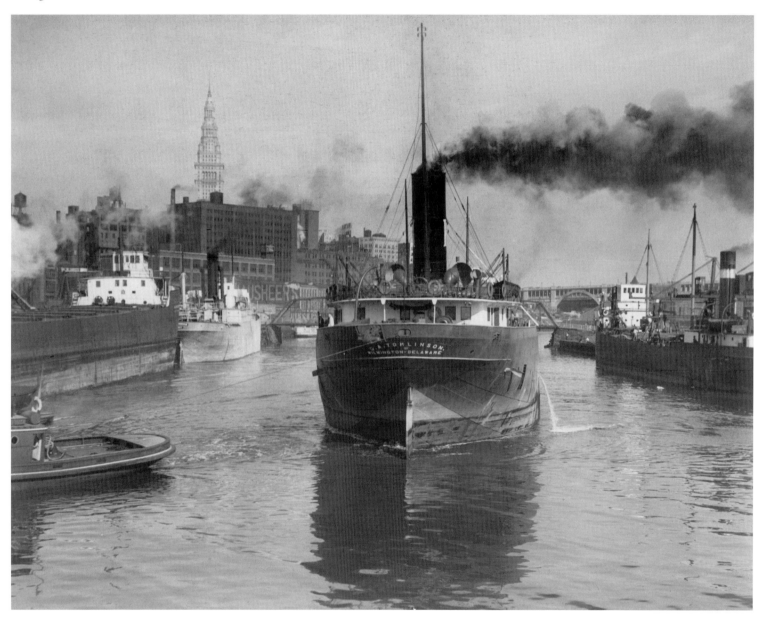

Thousands of Cleveland spectators view uniformed policemen as they proceed west on Euclid Avenue toward Public Square on August 1, 1933. This was Cleveland's first National Recovery Act parade.

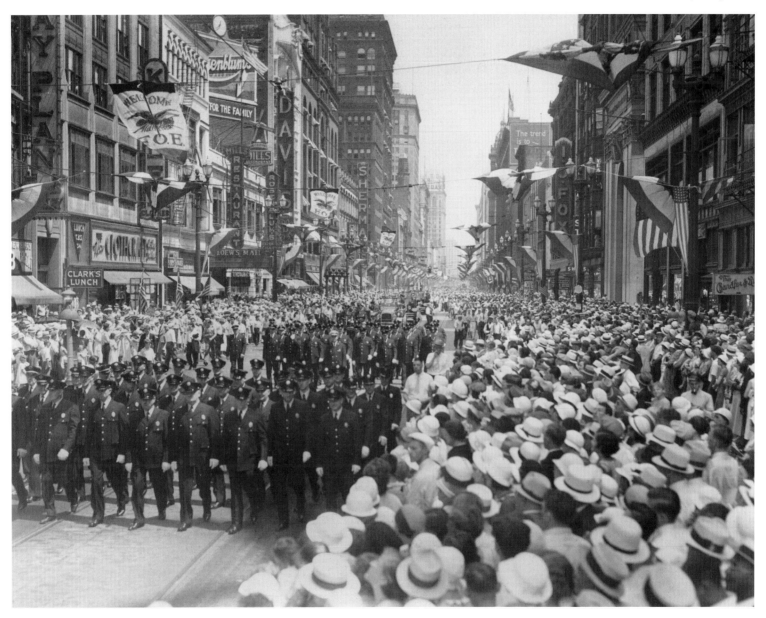

Portrait of Mantis James (left) and Oris Paxton (right) Van Sweringen. The brothers developed the Cleveland Union Terminal and Terminal Tower group. When fully completed the complex of buildings would include the Cleveland Union Terminal, the Terminal Tower, the Cleveland Hotel, and three interconnected office buildings.

An aerial view of the Cleveland Municipal Stadium. Spectators fill the walkways leading into the stadium to watch a Cleveland Indians' game in 1935. The stadium was completed in 1931.

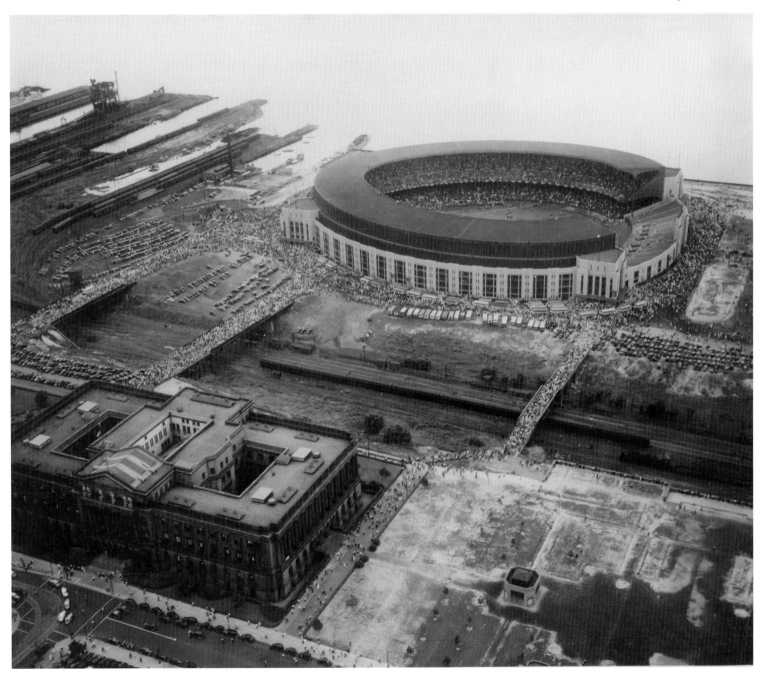

The lakefront takes on the appearance of a frozen wonderland in this photograph taken in December 1938. Captain W. E. Crapo of the United States Coast Guard and the station's mascot Rex look out over Lake Erie.

In this view south toward the entrance to the Cleveland Terminal Tower on Public Square, ca. 1936, the camera seems to have arrested the gaze of at least one curious pedestrian.

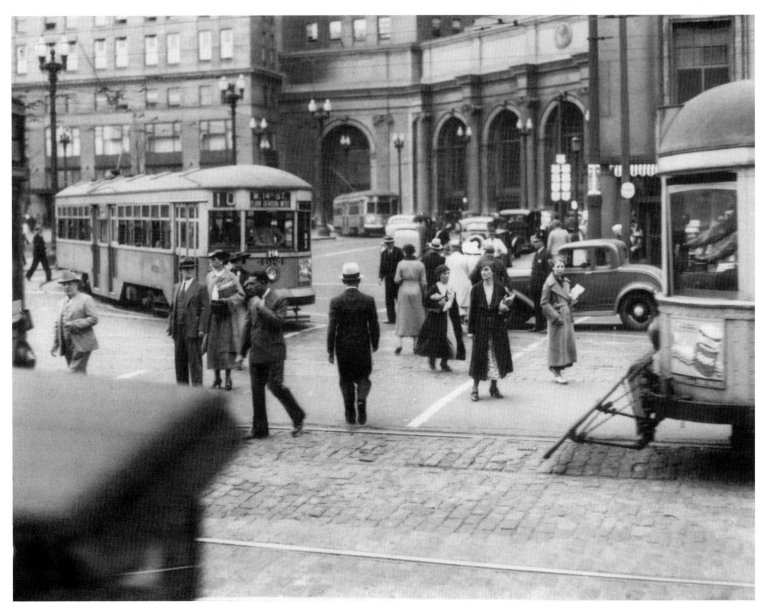

The Cleveland Cultural Gardens were established in 1926 to represent Cleveland's cultural diversity. Representing people of different ethnic nationalities who came to live and work in Cleveland, the individual gardens pay tribute to the best artists, scientists, and thinkers with sculpture, fountains, and landscaping. Work is in progress here in 1936.

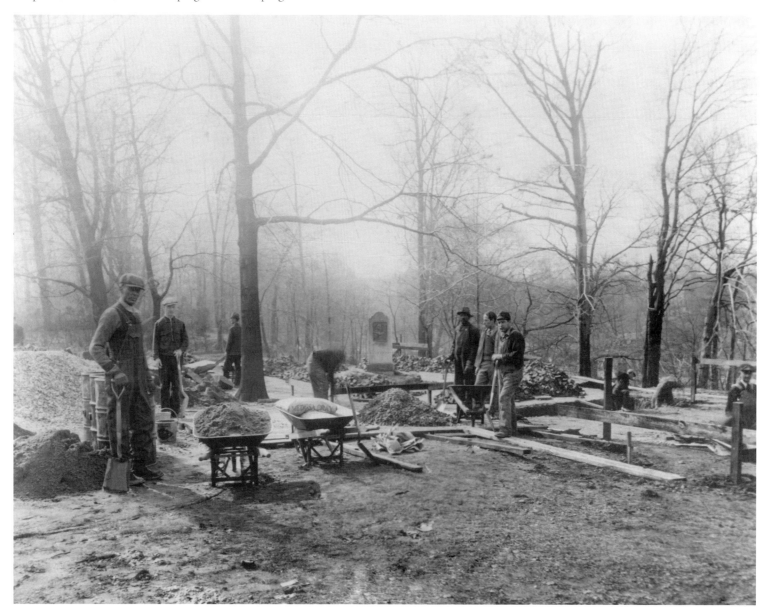

A crowd of Clevelanders welcomes President Franklin Delano Roosevelt (riding in the lead car) to the city in 1936. President Roosevelt was in Cleveland to attend the Great Lakes Exposition.

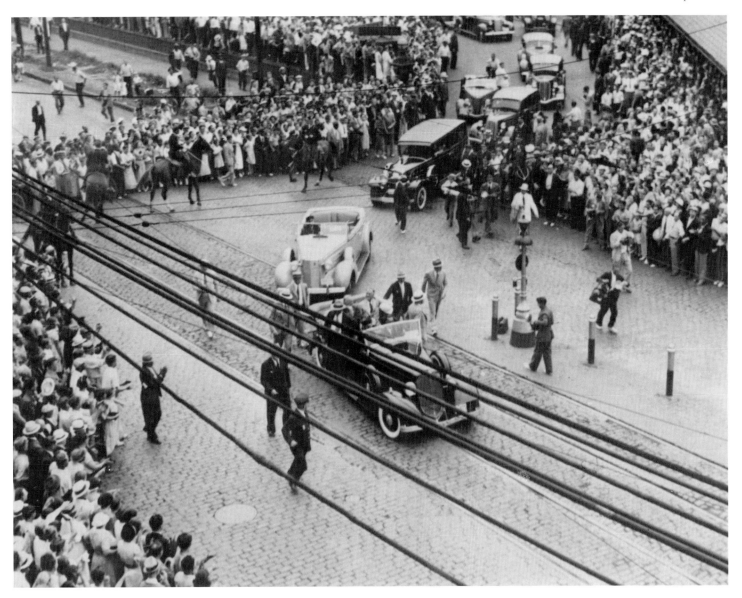

The Cuyahoga River burned a number of times in the twentieth century. Flanked by numerous industries, including oil refineries, the river was frequently polluted with flammable waste dumped into the river. The last time the river burned was in 1969.

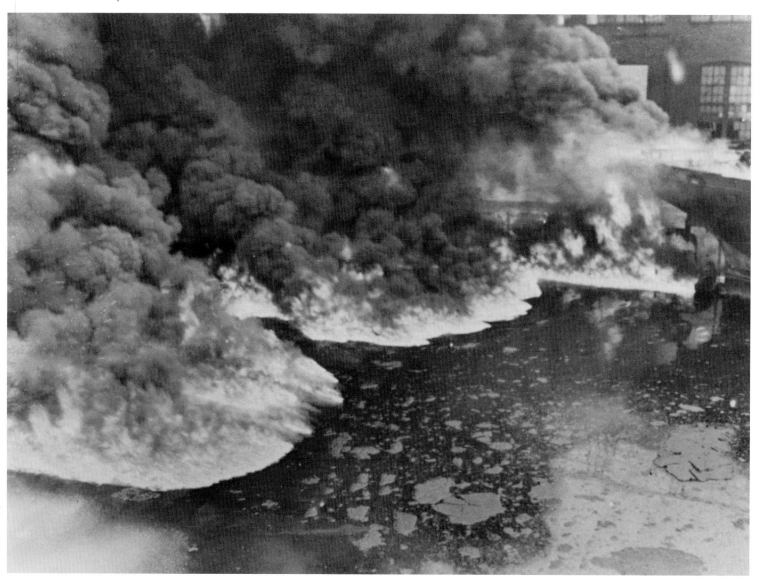

A view of the Great Lakes Exposition of 1936 and 1937 from above. Approximately 7 million visitors had spent nearly $70 million by the end of the second year.

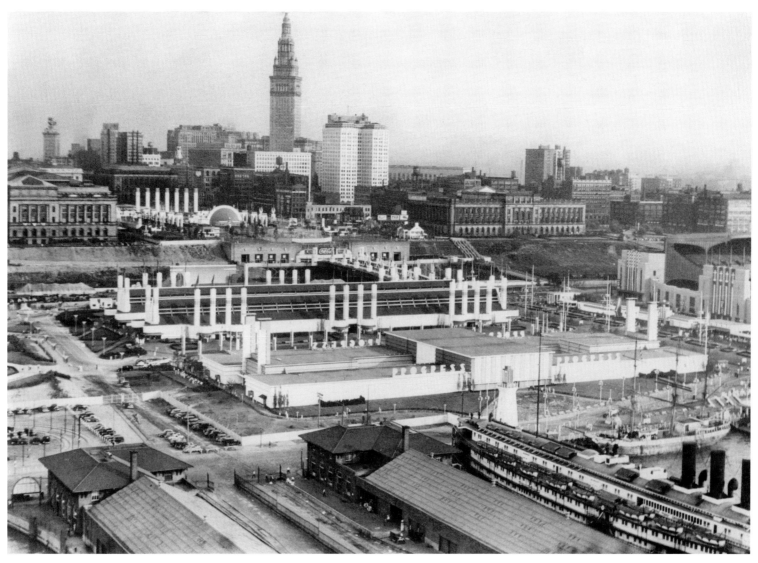

The Bug was a popular ride at Euclid Beach Park in 1937. Incorporated in 1894, the amusement park was modeled after New York's Coney Island. It would entertain Clevelanders for nearly 75 years.

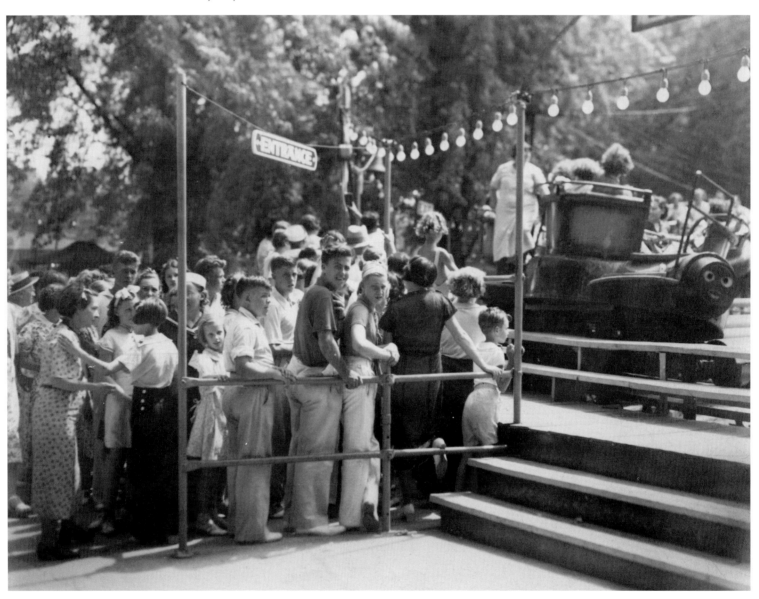

A view of the midway and crowd at the Cleveland Exposition along the lakeshore north of the city on September 8, 1936. The crowd reportedly surpassed 83,000 people on that particular day.

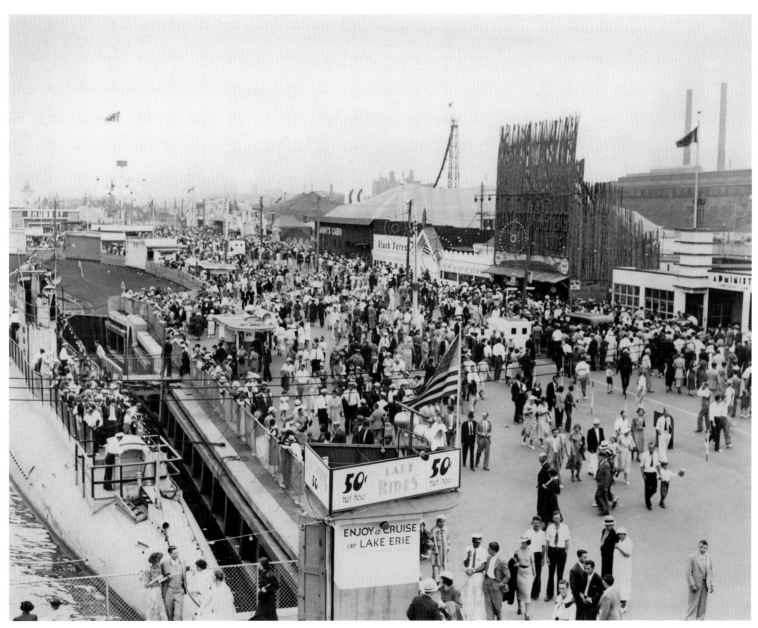

The Cleveland Public Library, 1937. Mrs. Reisland sits at the Information desk beside the entrance to Brett Hall.

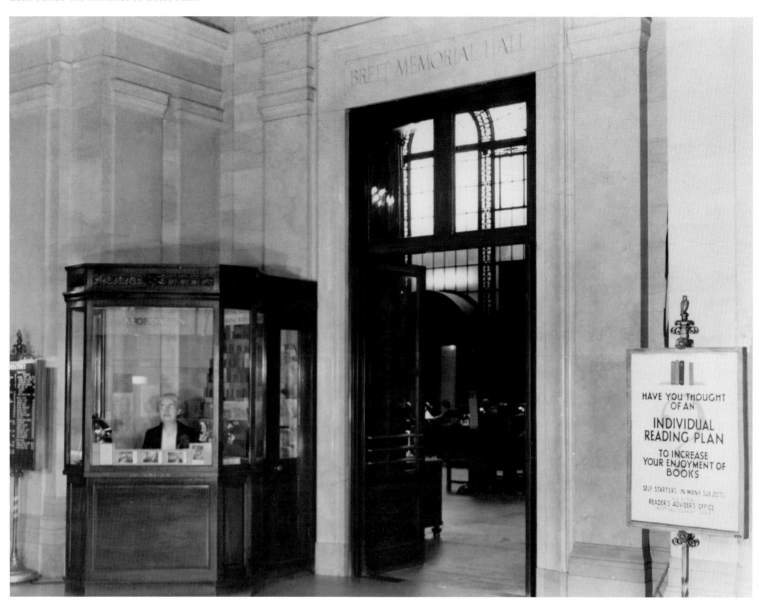

The Cleveland skyline from Edgewater Park. Choppy waves on Lake Erie suggest that Cleveland was experiencing a blustery day.

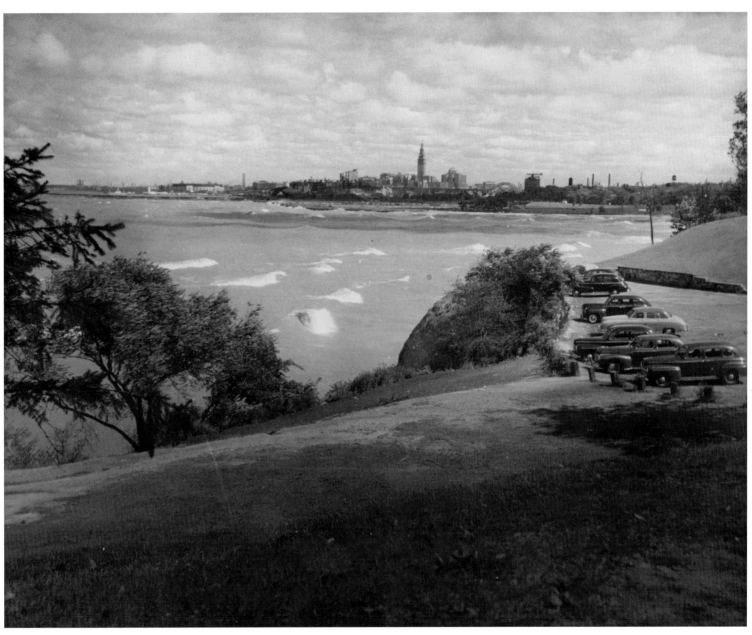

The double-deck Detroit-Superior Bridge (now Veterans Memorial Bridge) viewed from the Cuyahoga River, 1936. Completed in 1918, when it opened it was the largest double-deck bridge in the world. The upper deck of the bridge carried automobile and pedestrian traffic; the lower deck carried streetcar traffic from the west side into the Cleveland Terminal.

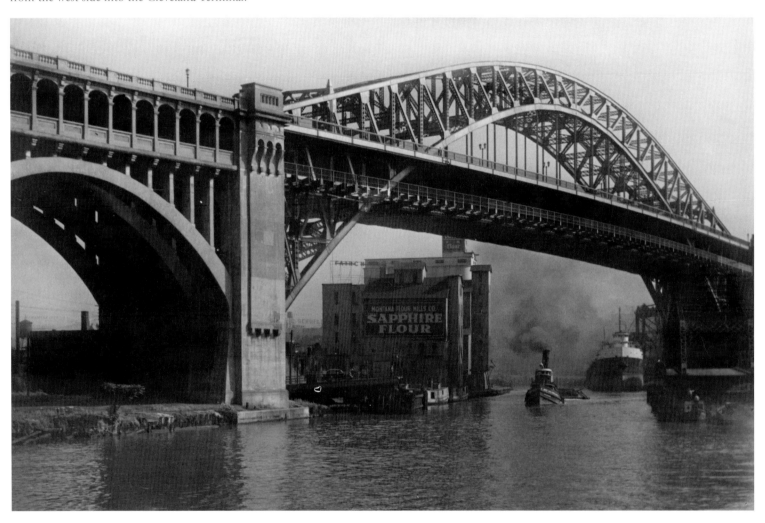

Model boat enthusiasts launch their sailboats in the Cleveland Board of Education's model boat regatta at the Rockefeller Park pond in 1939.

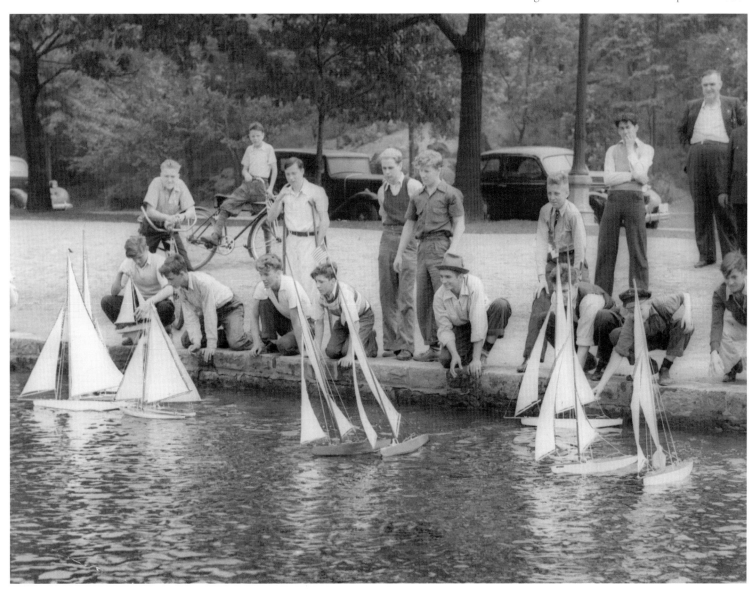

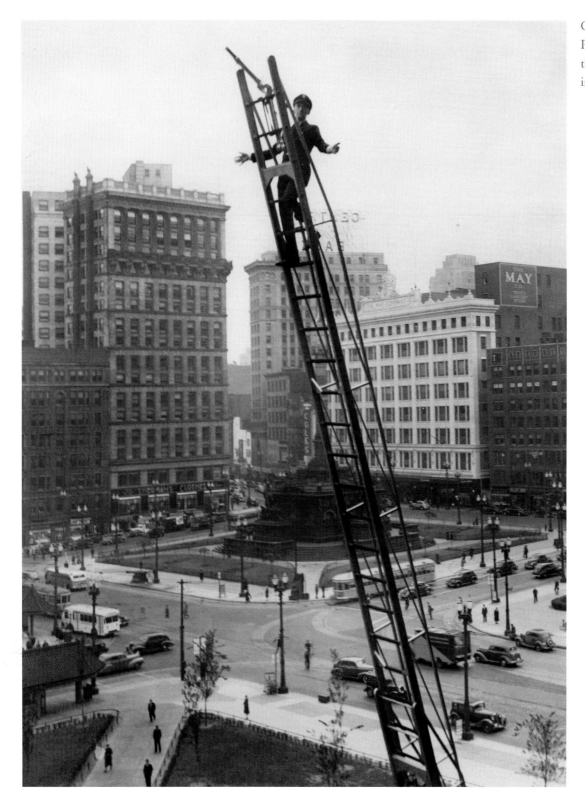

Cleveland firefighters use Public Square to demonstrate the reach of their ladder truck in 1939.

Terminal Tower completed in 1929 overlooks construction of Cleveland's new Union Terminal. The railroad station when completed in 1930 was the largest in the nation, featuring a large portico with a high vaulted ornamental plaster ceiling and skylight. The completed terminal clerestory (skylight) is visible in front of the rising girders of the Prospect buildings (Midland, Republic, and Guildhall buildings) to the right of Terminal Tower.

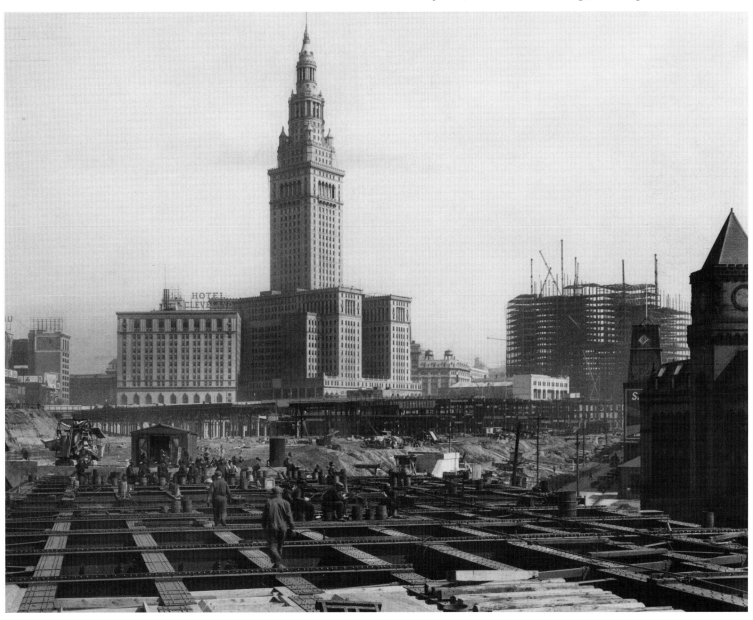

The Cleveland skyline in 1943, facing west.

In 1944, the sad aftermath of the East Ohio Gas Company explosion and fire included recovery of burned bodies from the ruins of buildings. Pictured is the search at the gas company's meter house.

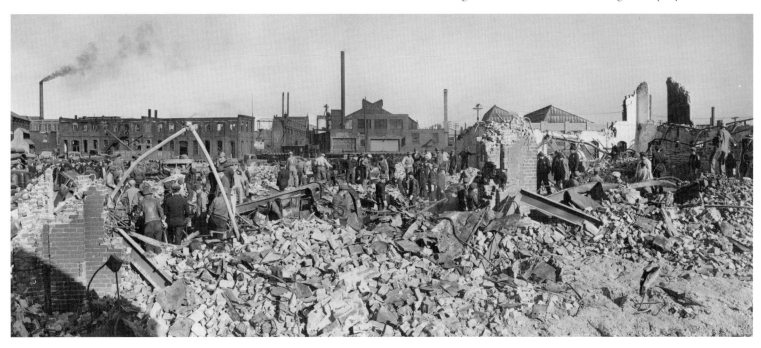

The East Ohio Gas Company explosion and fire in 1944 proved to be the city's most disastrous fire. It leveled businesses and homes on Cleveland's east side, from St. Claire Avenue to the lake between East 55th and East 67th streets.

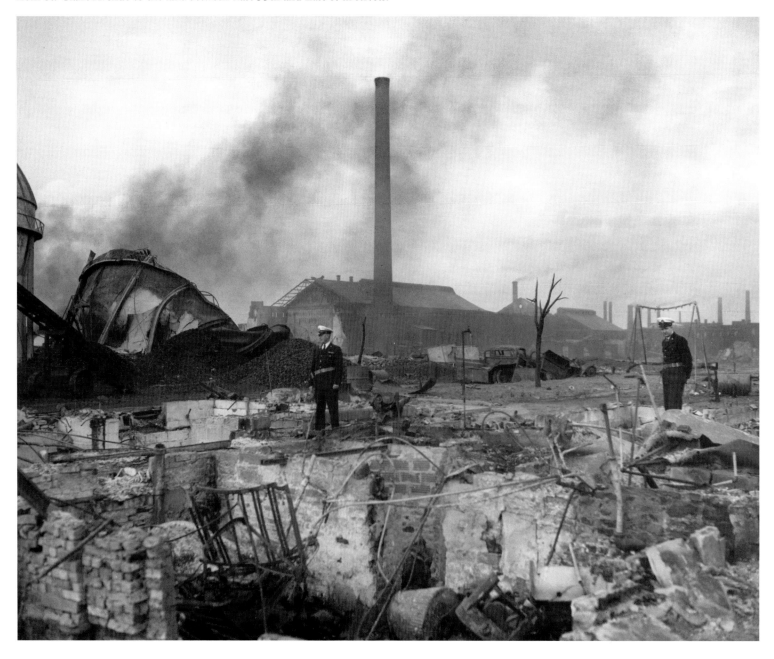

The *Carl D. Bradley* unloads limestone at the Pennsylvania Railroad dock at the mouth of the Cuyahoga River in 1938. Because it was the longest boat on the Great Lakes, it could not navigate the crooked Cuyahoga River.

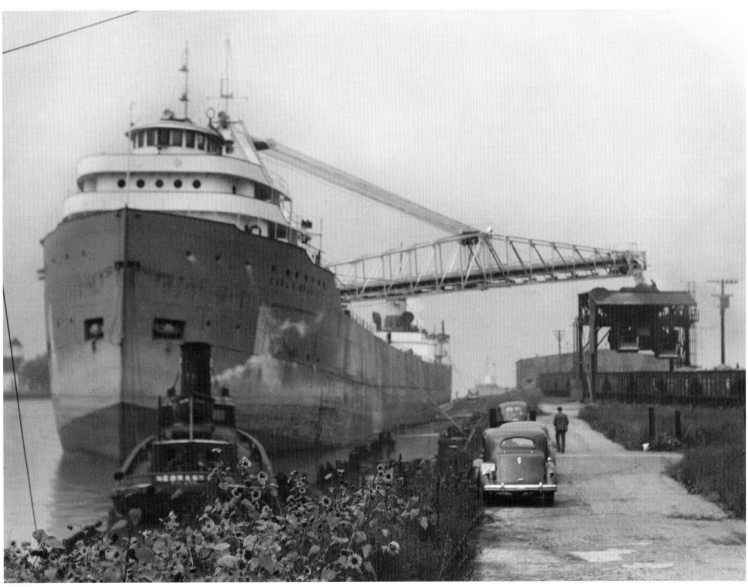

At right-center is the Woodland Avenue market in 1940. The building at
5412 Woodland Avenue housed this market and other stores.

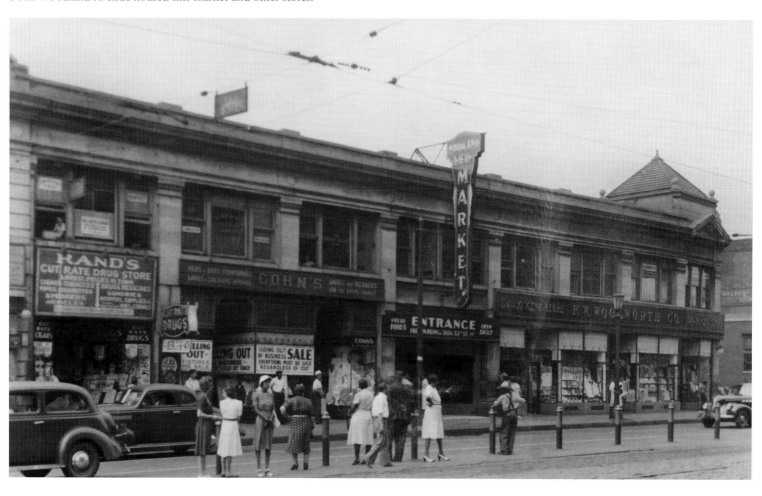

The original terminal at Cleveland Hopkins Municipal (now Cleveland Hopkins International) Airport. The airport had opened in 1925 on 1,040 acres of land on the southern edge of the city, with the terminal following in 1929.

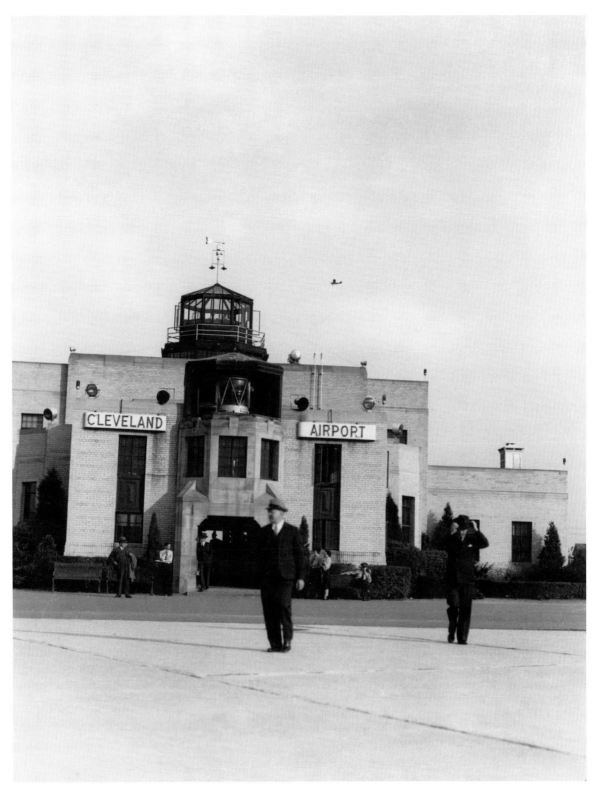

Shoppers throng the sidewalks along the 200 block of Euclid Avenue in 1941.
The street is crowded with streetcars, automobiles, and buses.

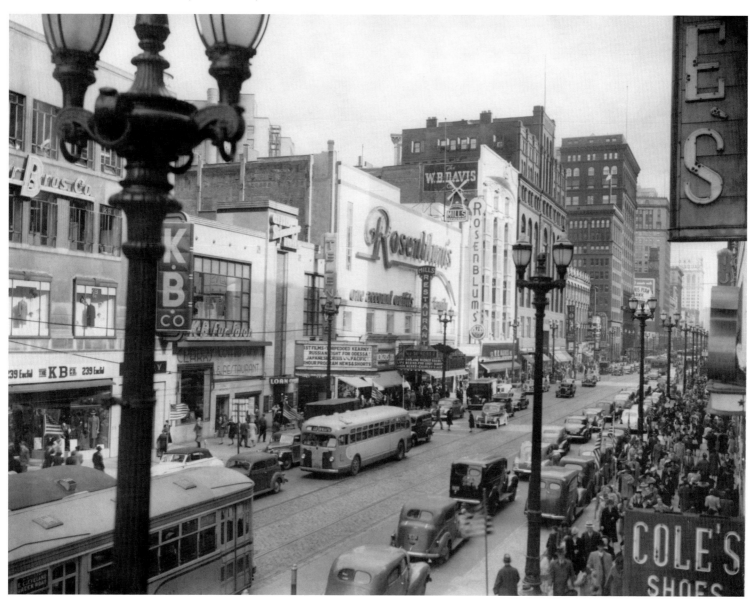

In 1941 in the northwest quadrant of Public Square, members of the Cleveland fire department demonstrate how to handle incendiary bombs. The Illuminating Building and the Old Stone Church are visible in the background.

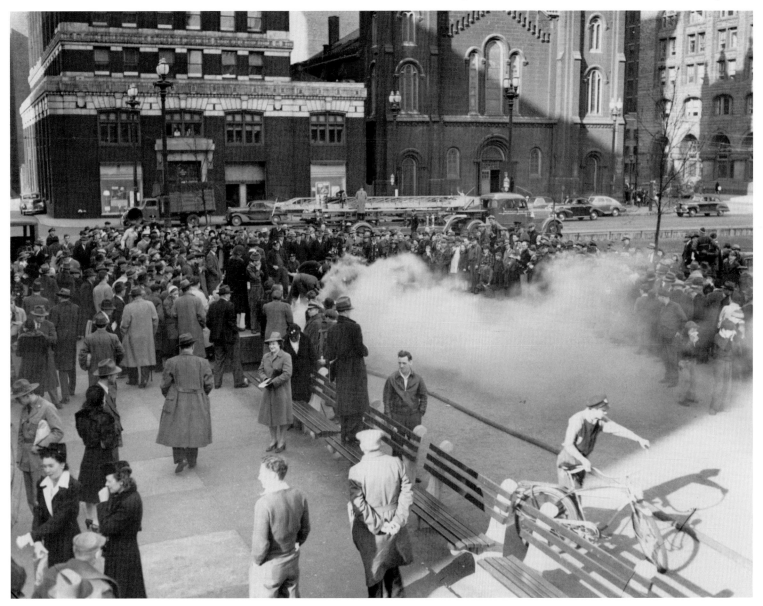

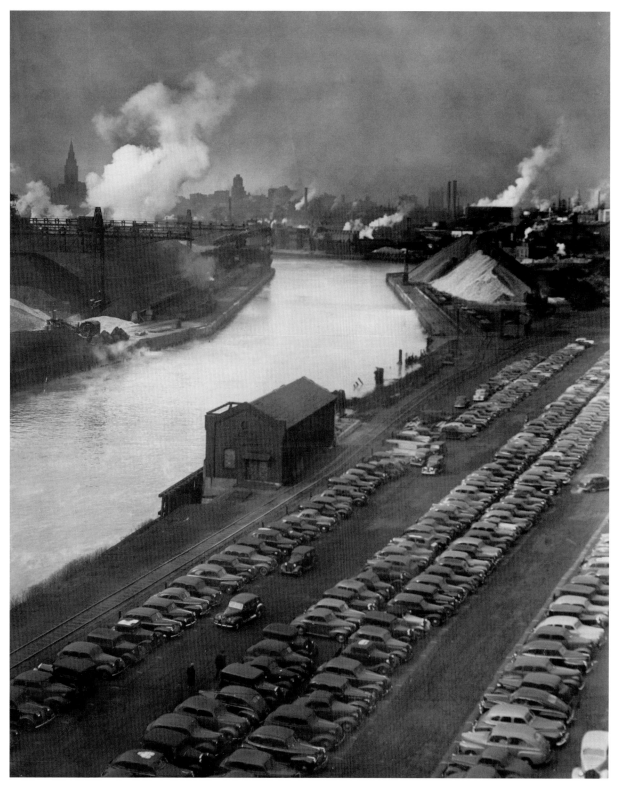

Long lines of closely packed automobiles fill only one of the areas required for parking by the employees of only one Cleveland industry, Republic Steel Corporation. In 1941, the accelerating pace of armament production, along with Christmas shopping crowds, gives the police traffic division the biggest challenge in its history.

Reservists in 1942 move through the crowd at Public Square to watch the drawing for call-up for active duty in World War II.

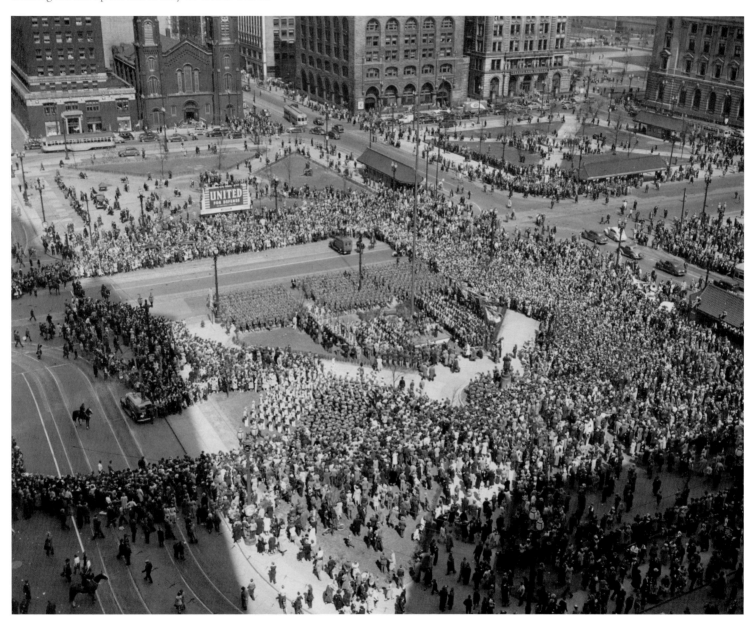

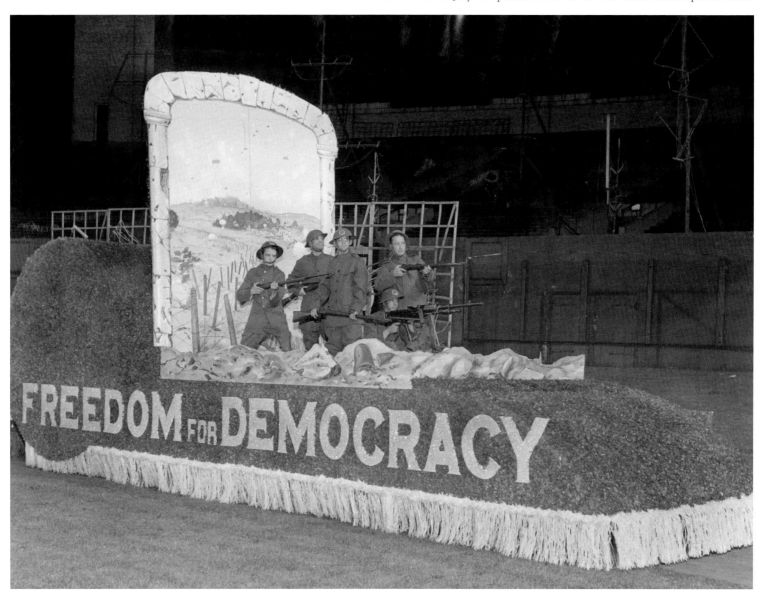

The White Motor Company, 1941. Halftrac scout cars stand in the yard, ready for Army combat duty.

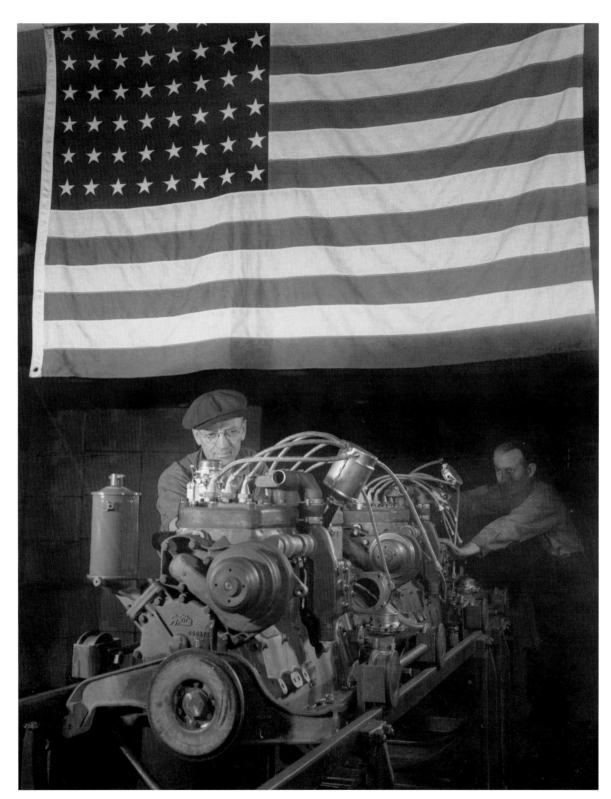

Another engine for an Army halftrac scout car is assembled at the White Motor Company in 1941. To aid the war effort, the pace of armament production was accelerating.

Colonel William C. McCally, chief of surgery and commanding officer of Cleveland's Lakeside Hospital Unit, holds a nurses inspection on the grounds of the Royal Melbourne Hospital in Australia, shortly after the unit arrived there in 1942.

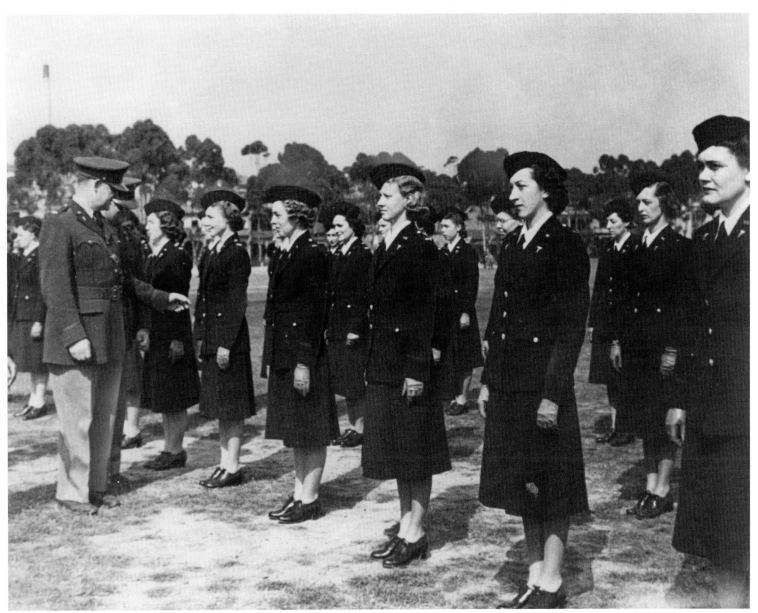

The *Spirit of Cleveland,* a four-engine Flying Fortress purchased with proceeds from the "Buy a Bomber for MacArthur" campaign. Mrs. Frank J. Lausche, wife of the mayor of Cleveland, christens the plane while a small crowd watches on July 2, 1942.

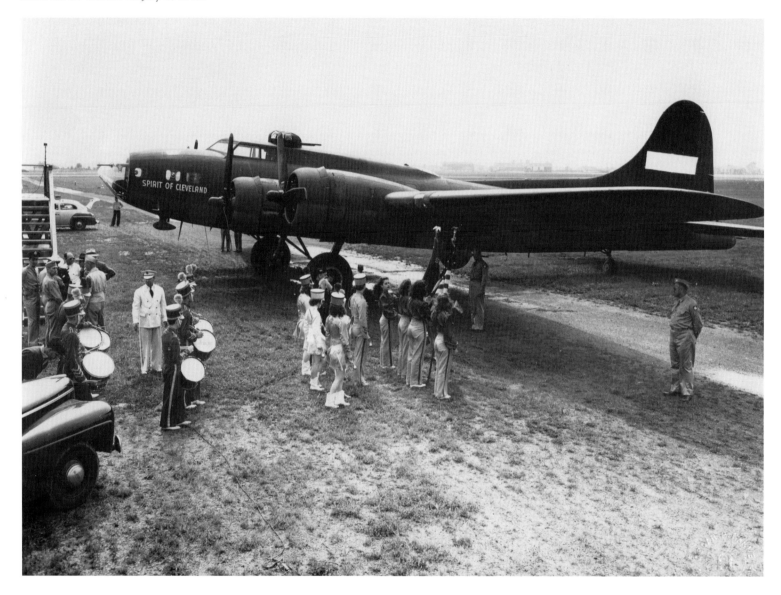

Dry dock of the American Shipbuilding Company, founded in 1899 and a leading designer and builder of Great Lakes vessels. The largest shipbuilder on the Great Lakes by 1952, labor conflicts and a decline in Great Lakes shipping caused the company to cease operations in Northeast Ohio in 1983.

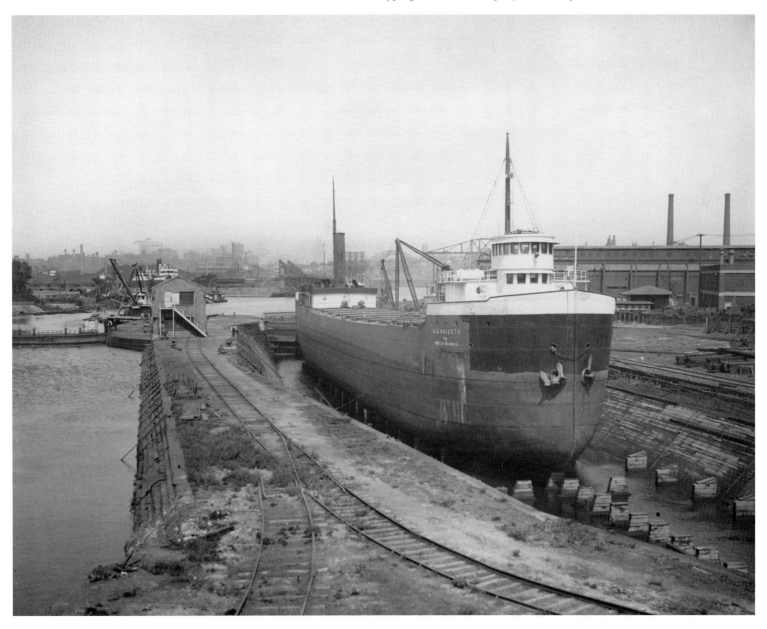

The War Service Center building at its dedication in August 1942, with war equipment on loan for the dedication celebration. The building was located on the northwest quadrant of Public Square.

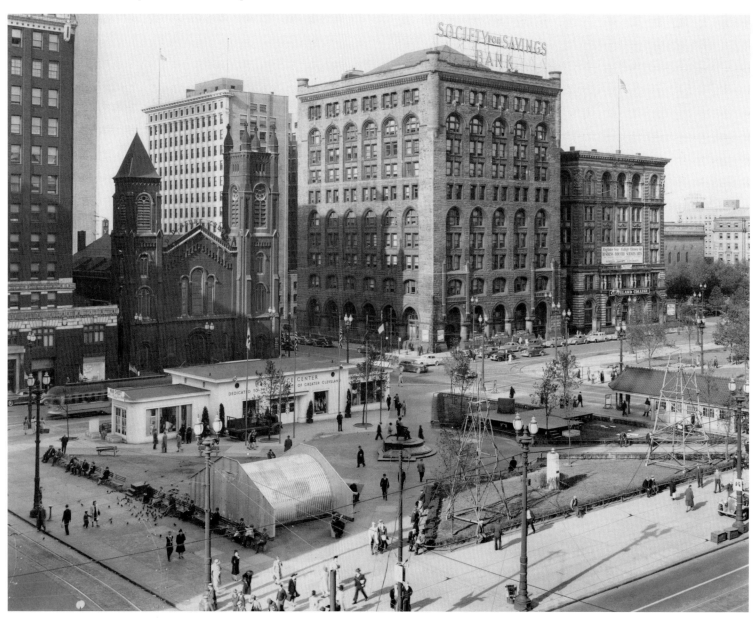

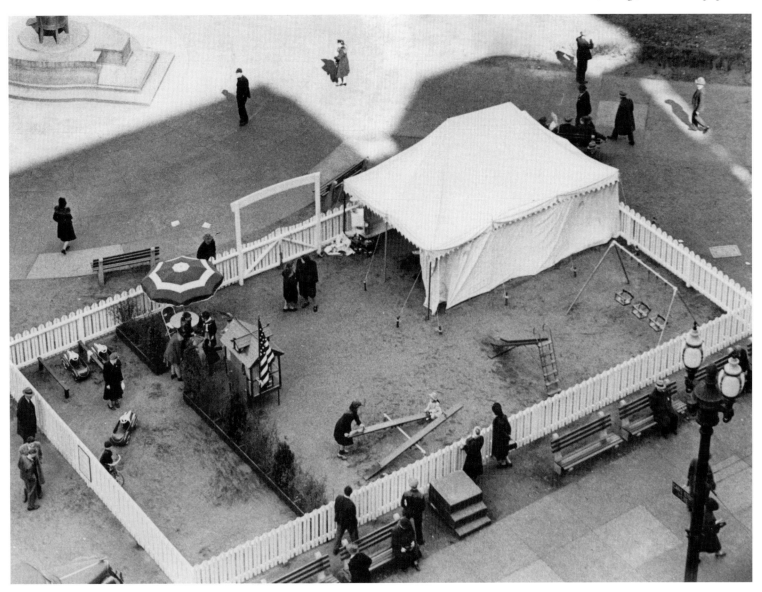

The War Service Center included a small playground area for children. In this view from 1943 children could enjoy the teeter-totter, swings, and other equipment.

Rockefeller Park Lagoon, 1943.

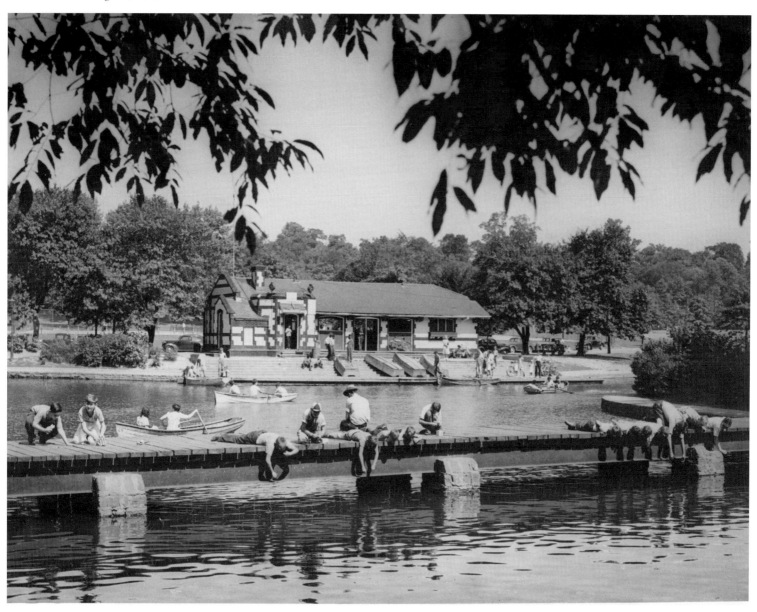

Looking north from Superior Avenue toward the Board of Education building in 1945. People in the foreground sit in Eastman Park, located between the Cleveland Public Library's main building (left) and the Plain Dealer building (right).

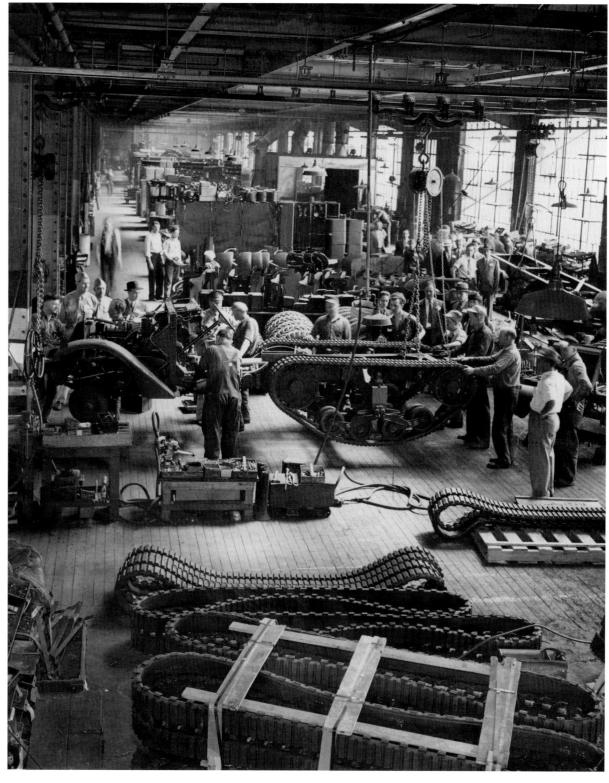

The White Motor
Company half-track
combat vehicle
assembly line, 1941.

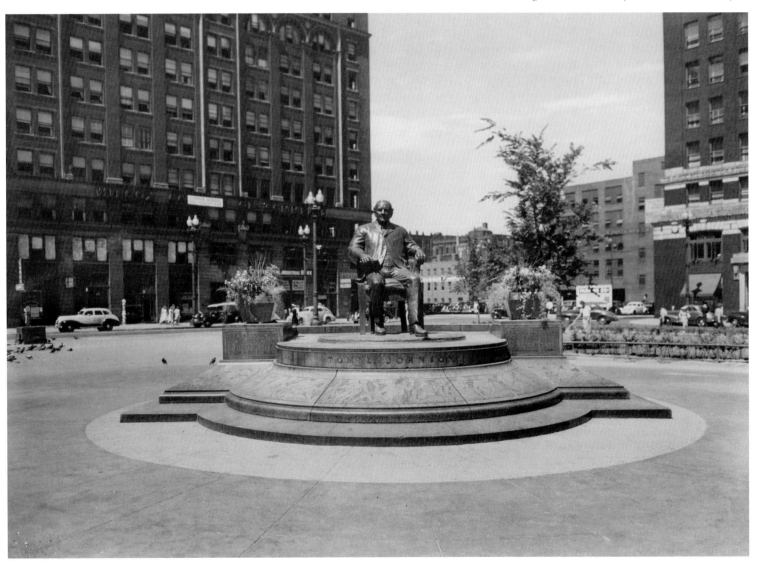

Tom L. Johnson gazes out across Public Square toward the Terminal Tower in 1943. The statue honors the five-term mayor of Cleveland in recognition of his many achievements as mayor.

The end of the Second World War in 1945 was cause for celebration.

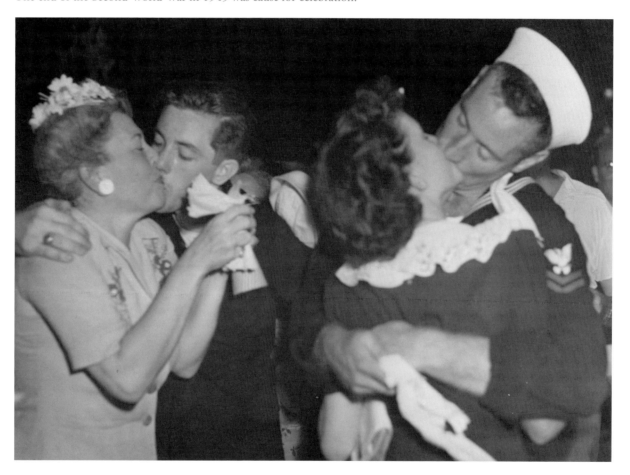

Cleveland celebrates victory over Japan and the end of World War II with a parade down Euclid Avenue near 9th Street, August 15, 1945.

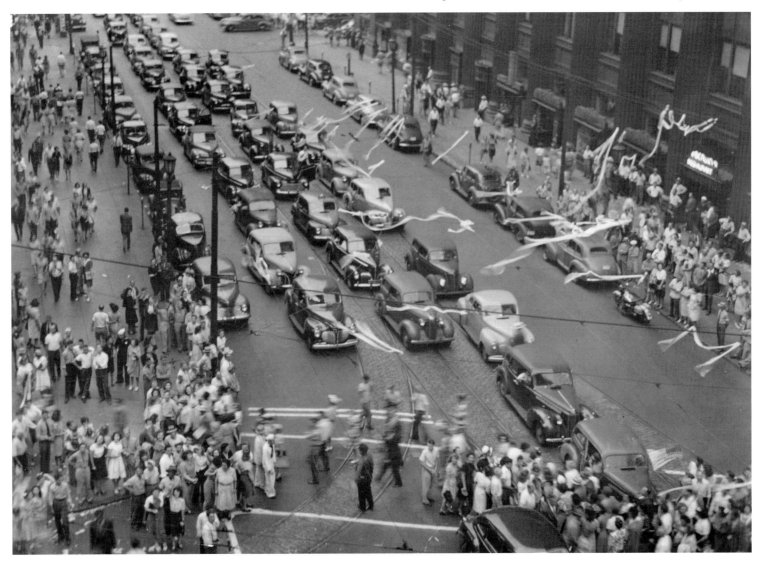

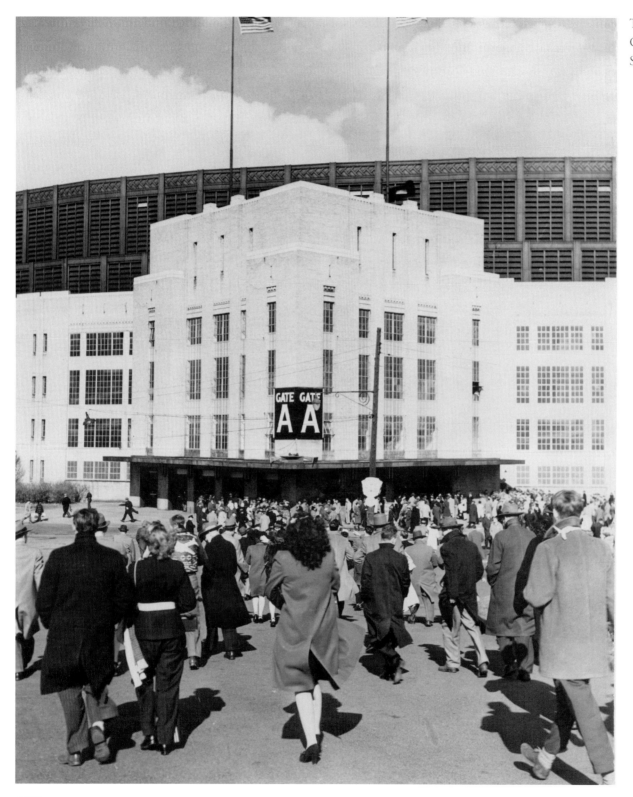

The main gate at
Cleveland Municipal
Stadium, 1946.

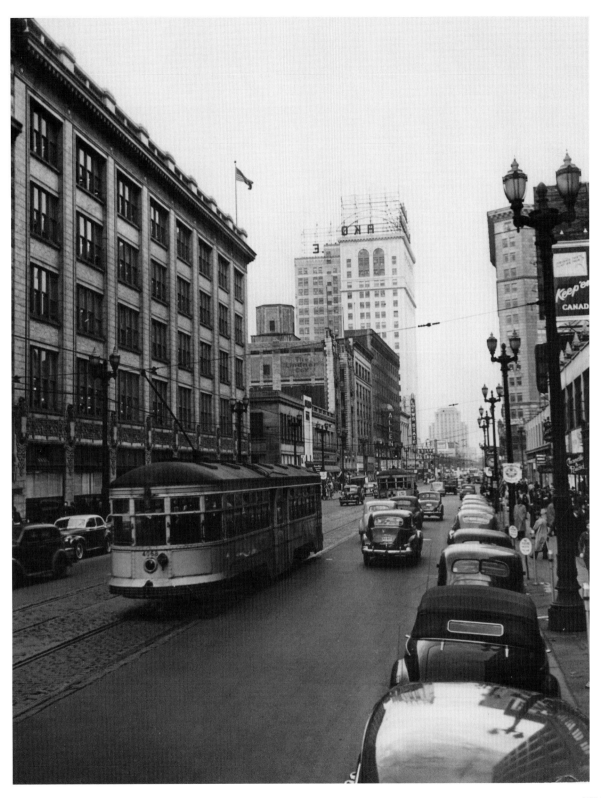

Euclid Avenue, 1946. In this view east, the former Higbee Company building is visible on the left. It was occupied by the Navy during and after World War II. In 1949 the building became the Lindner-Davis department store.

On September 5, 1950, a crowd gathers in front of the Public Square entrance of Terminal Tower to send United States Marines off to duty in the Korean War.

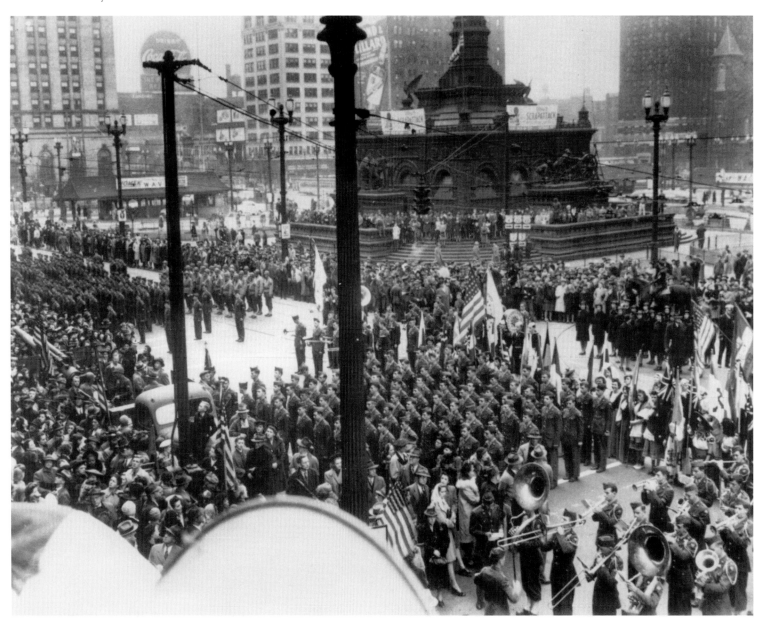

The Cleveland Browns and the San Francisco 49ers battle it out on December 1, 1949, in the Cleveland Municipal Stadium. This was the last year that both teams played as members of the All-American Football Conference. In 1950 the league folded and both teams became members of the National Football League.

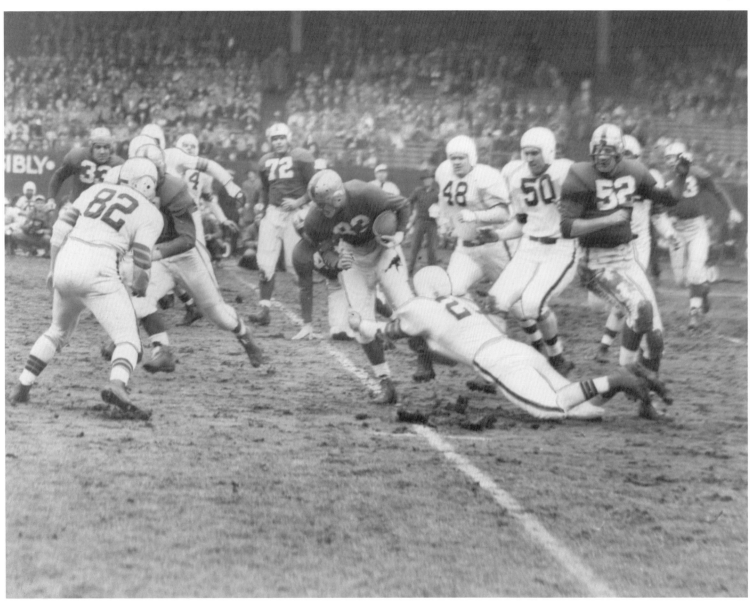

A 1947 view of the Cleveland skyline from the west bank of the Cuyahoga River. The large arched span of the Detroit Superior Bridge is to the right. In the foreground is the Center Street Bridge, the only swing bridge in the area.

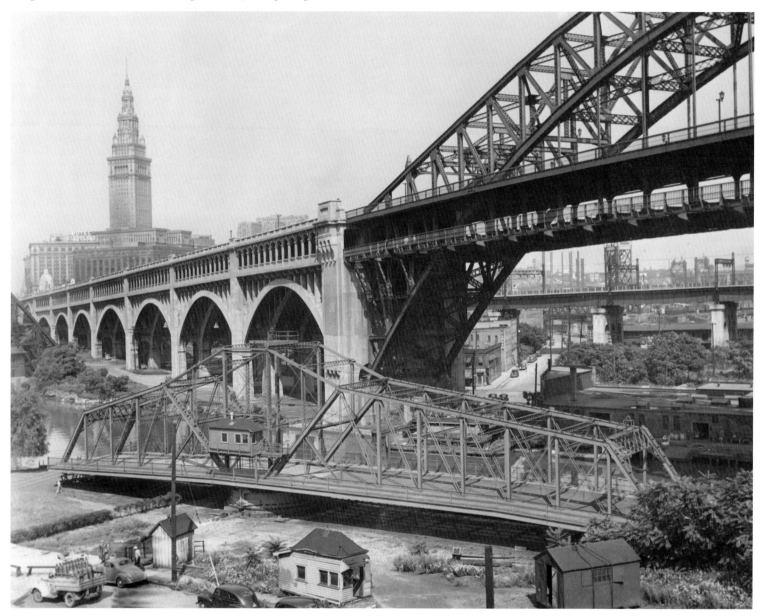

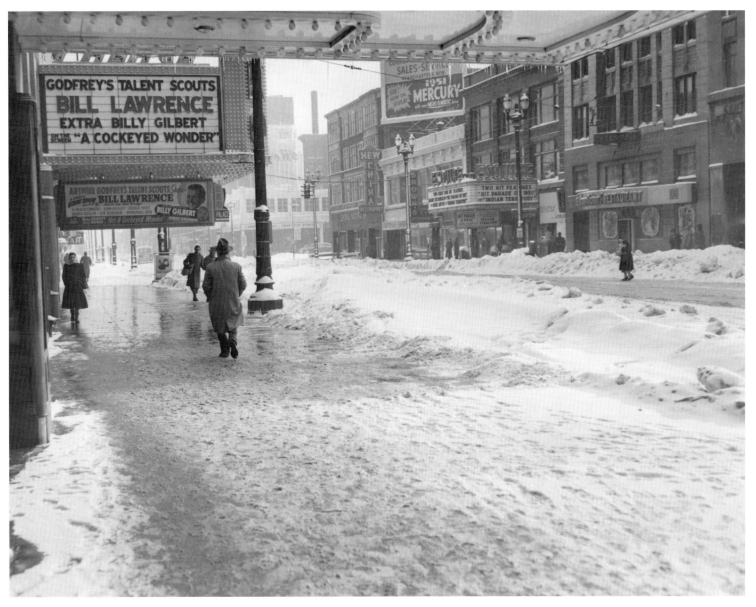

After a snowstorm in November 1949, Arthur Godfrey's talent scouts may find the pickings slim here at Playhouse Square.

Holiday shoppers do not seem bothered by the falling snow in this photograph of Euclid Avenue just east of 4th Street.

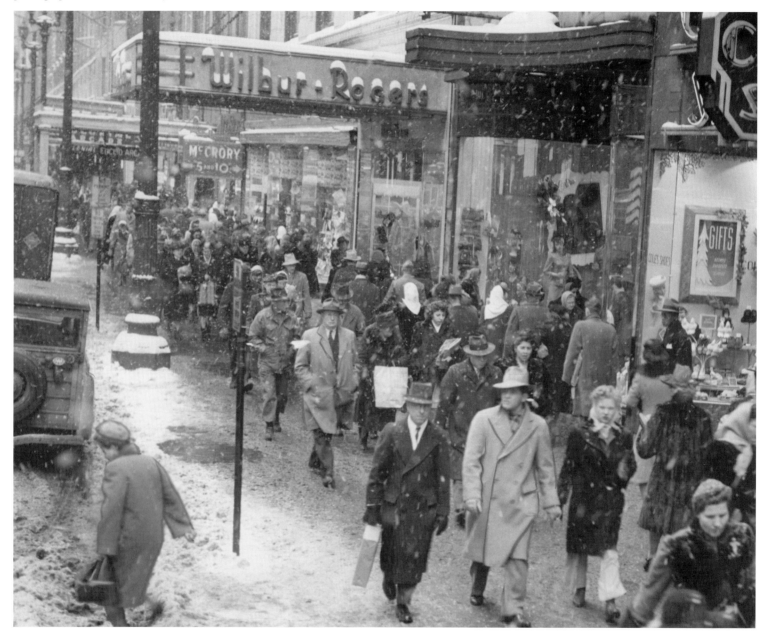

The City Deals with Adversity

(1950–1979)

The popularity of the automobile, the emergence of freeways, and the growth of numerous commercial, residential, and retail developments in suburban areas around the city during this period had an adverse impact on Cleveland's economic and social vitality.

The most visible change was the beginning of a steady decline in the city's population. From a high of 914,808 residents in 1950, Cleveland's population had declined to 750,879 by 1970. This population decline changed the economic base of the city.

Residents who could afford to purchase homes in the newer suburbs began an exodus from the older inner-city neighborhoods. The surrounding suburban communities gained more than 200,000 residents and more than 150,000 jobs. In Cleveland's neighborhoods the population loss of more than 125,000 people, or more than 21,000 households, along with the loss of more than 18,000 housing units, contributed to social and racial tensions. Poverty in neighborhood households rose. Riots devastated the Glenville and Hough neighborhoods.

Coupled with this movement of residents out of the city was the decline of the central business district. As people moved out, new suburban shopping areas were built, which drew shoppers away from Cleveland's once vibrant downtown.

Like other Midwestern cities with concentrations of heavy industry, Cleveland suffered in the 1950s and 1960s as several large industries were forced to downsize or move. Many companies moved into outlying areas, and a significant number moved out of state, taking thousands of jobs with them. The term "rust belt" was applied as an adjective to describe the decline of manufacturing in Cleveland, and in other Great Lakes cities.

Adding to Cleveland's woes the city became the subject of national attention and ridicule, when the polluted Cuyahoga River burst into flames in 1969. The burning of the river was a low point in Cleveland history, but it rallied a drive to improve conditions in the city. As a result, a Cleveland renaissance took root in the 1970s and began to revitalize residential neighborhoods and the central downtown area, resulting in positive changes that are still being felt today.

On September 24, 1950, Cleveland experienced what was described as the shortest day in the city's history. By noon sunlight had begun to fade and by 1:30 P.M. the Municipal Stadium lights had to be turned on for the afternoon game between the Cleveland Indians and the Detroit Tigers. Smoke from a forest fire in Alberta, Canada, caused this unusual phenomenon, and baseball history was made: for the first time a major league game was played under artificial lights.

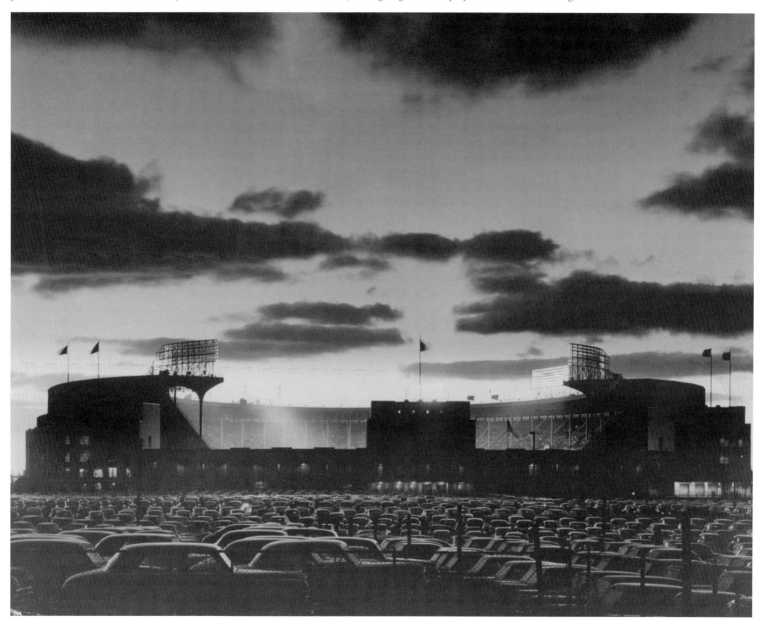

An aerial view of Cleveland ca. 1950, facing south. The Terminal Tower dominates the city skyline.

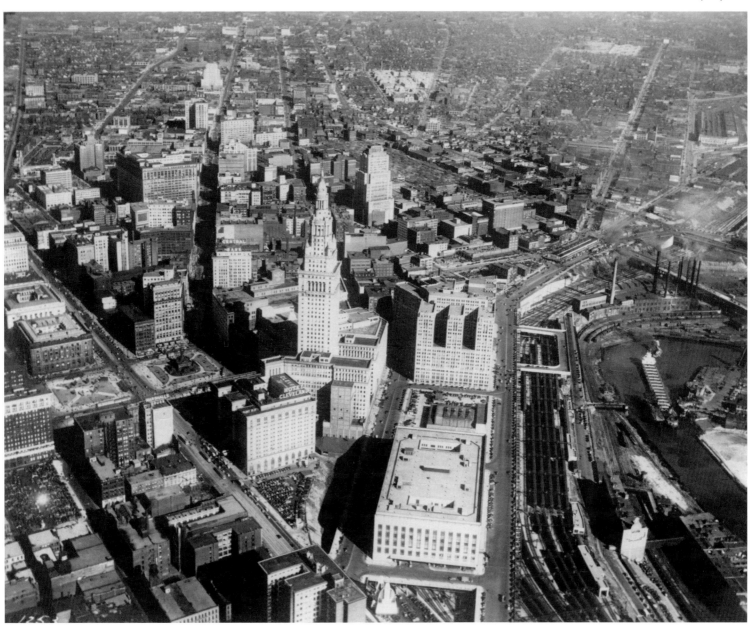

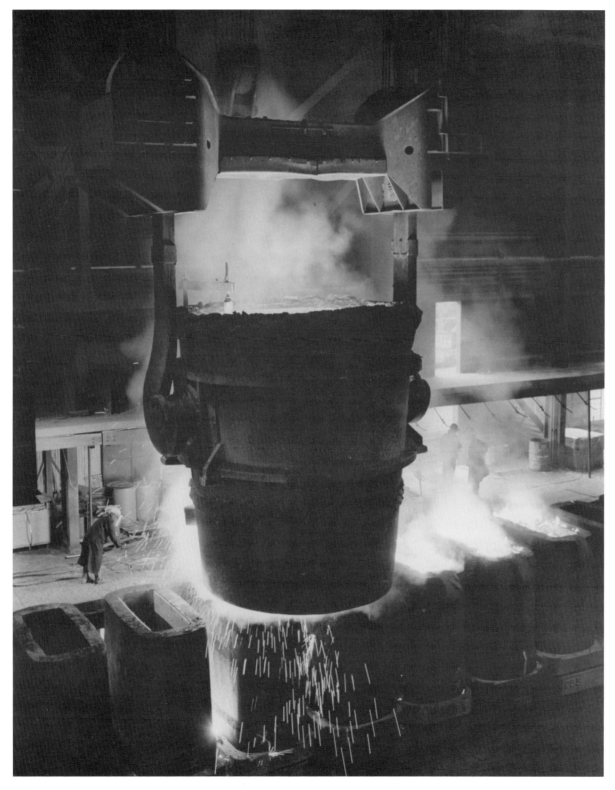

In 1976, work is under way at Jones & Laughlin Steel Corporation (Cleveland Works).

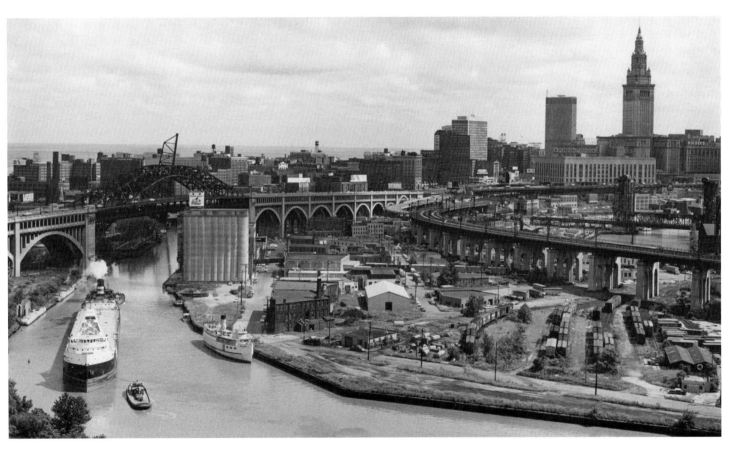

A Lake Erie freighter maneuvers up the Cuyahoga River, ca. 1960. The Flats (flood plain) and the Cleveland skyline are visible in the right foreground and background.

A view of Euclid Avenue at East 105th Street ca. 1956.
Buses have replaced streetcars, which ended service in
January 1954. Playing at the theater is *Written on the Wind*,
starring Rock Hudson and Lauren Bacall.

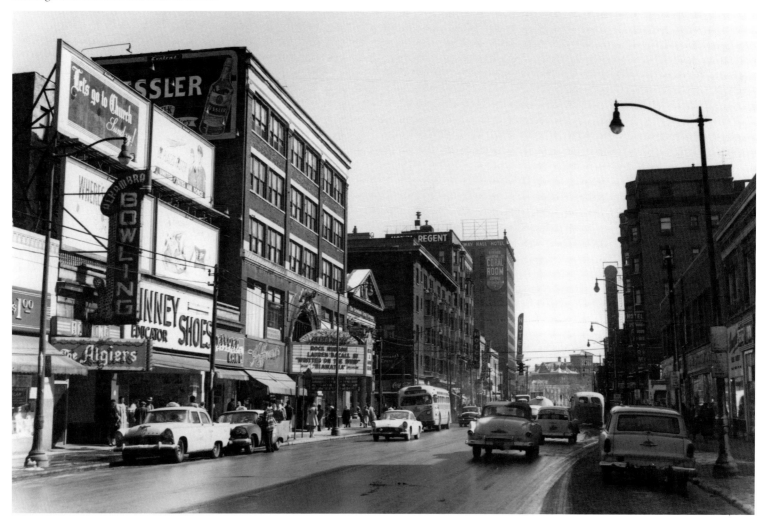

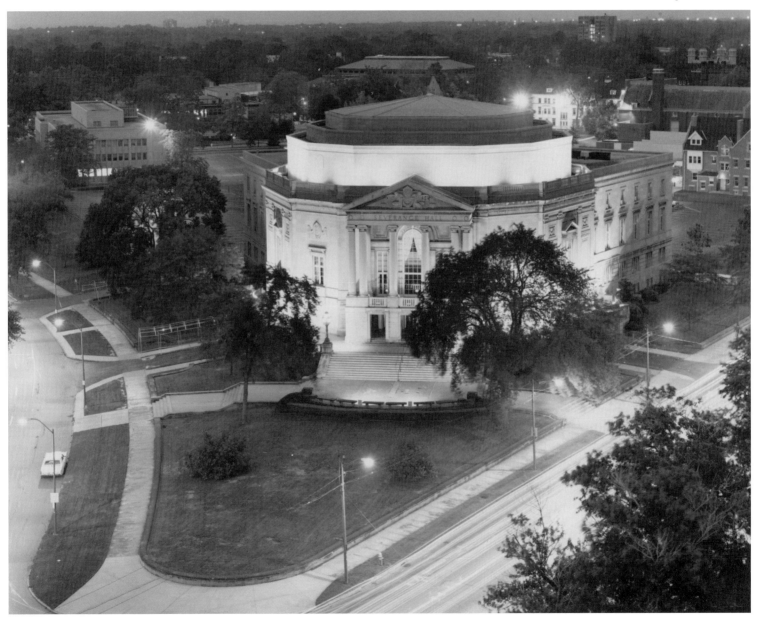

Severance Hall, in University Circle, home of the world-renowned
Cleveland Orchestra, was completed in 1931.

A Cleveland fireboat hoses down a charred railroad trestle in the aftermath of the 1969 Cuyahoga River fire.

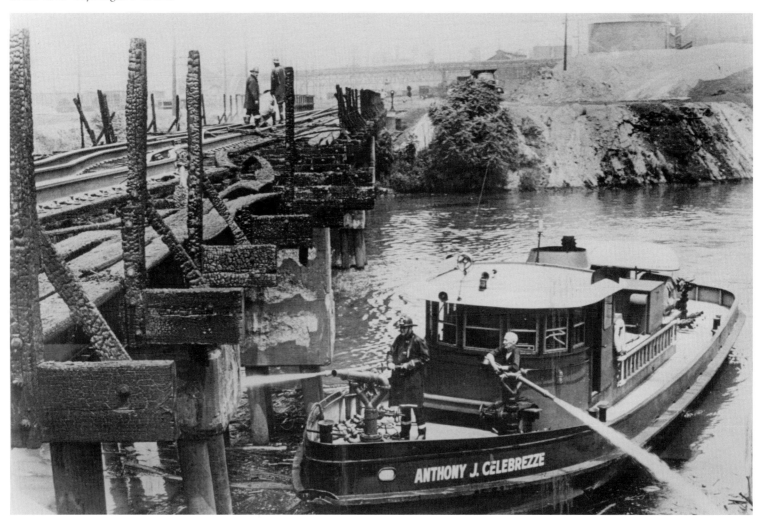

The Cleveland Pops performs at the Cleveland Municipal Stadium while the Public Auditorium is being air-conditioned, 1953.

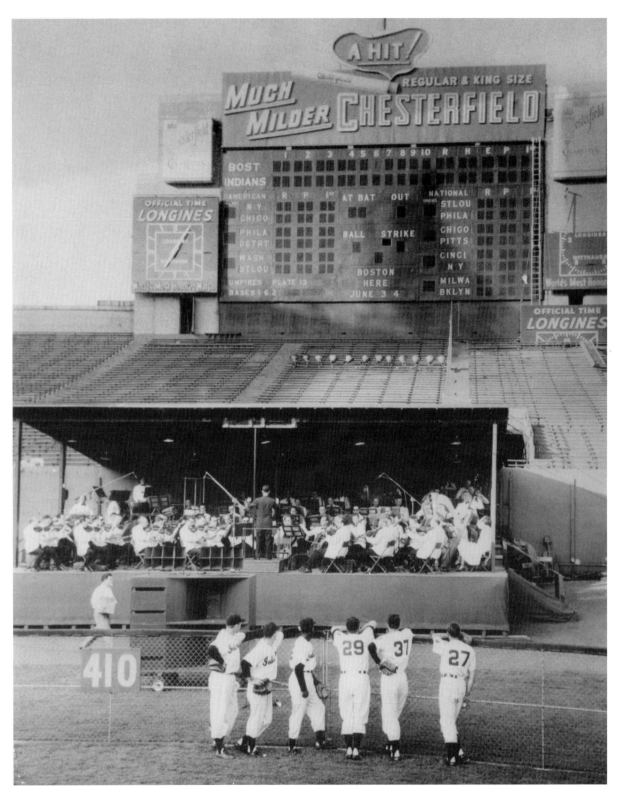

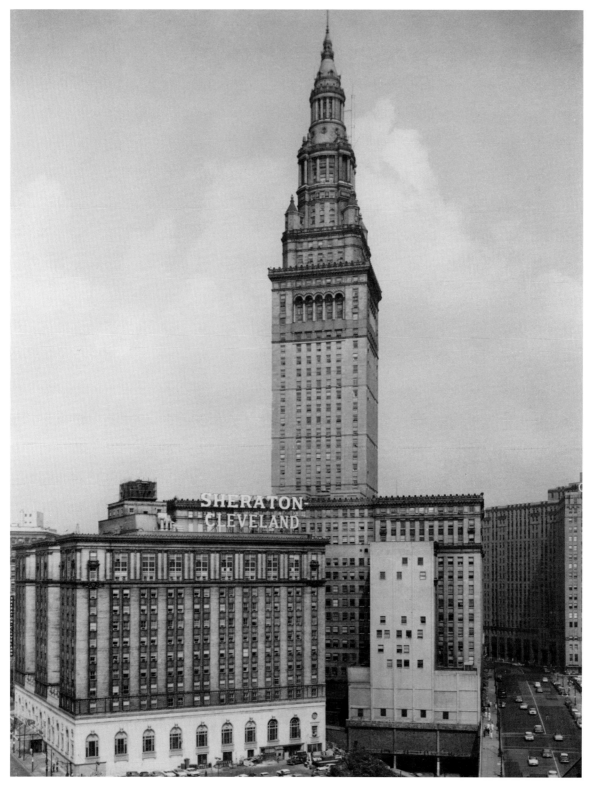

The Sheraton Cleveland Hotel's new sign adorns the south side of this landmark building in 1959. Today the Cleveland Renaissance Hotel occupies the same site and building. Beginning with the Forest City House, a hotel has occupied this site along the southwestern edge of Public Square since the mid 1850s.

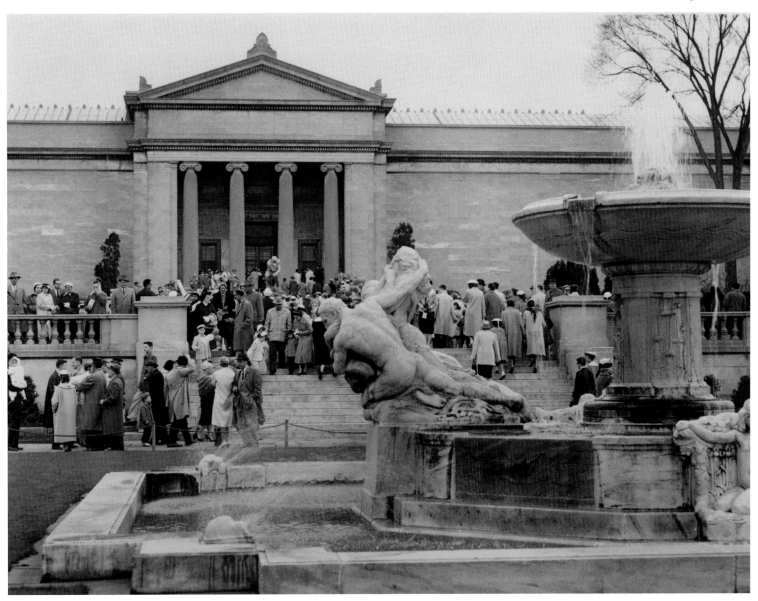

The Cleveland Museum of Art, 1959. At the back of the photograph, between the two middle ionic columns, is the *Thinker,* a Rodin sculpture. In the forefront is the *Fountain of the Waters.*

Thousands of Clevelanders gather in front of the Terminal Tower to welcome Dwight D. Eisenhower to Cleveland.

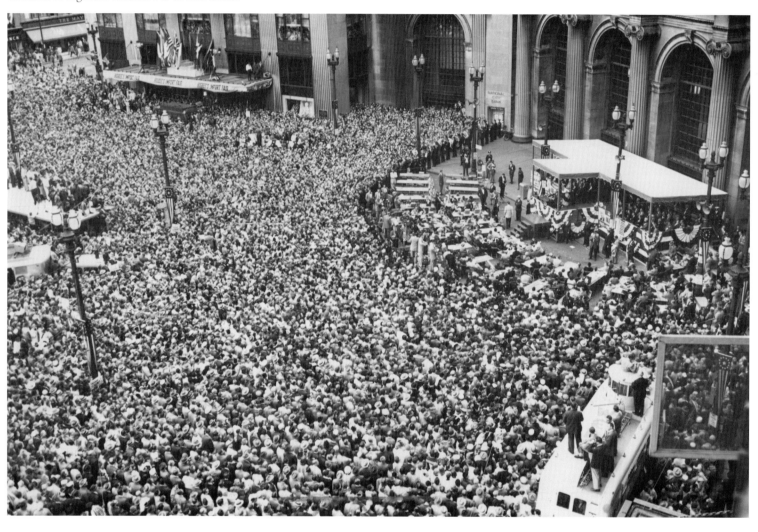

Euclid Avenue at Public Square is decorated for the holidays, November 30, 1961. Santa Claus and his sleigh adorn the front of the May Department Store, and decorated trees line the brightly lit street.

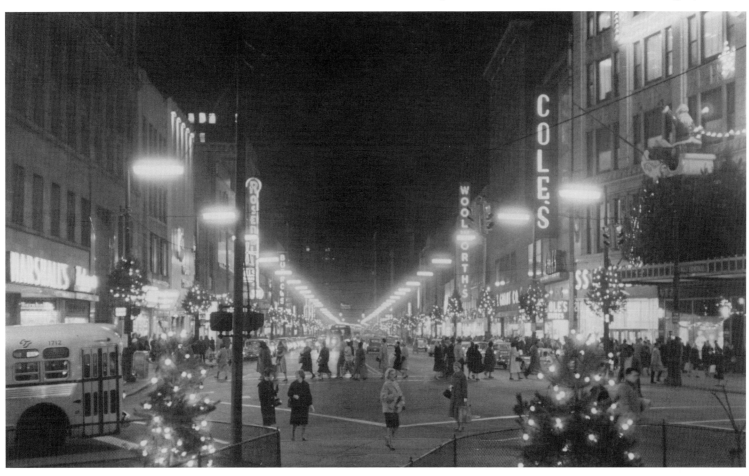

In 1962, the Cleveland Hopkins Airport tarmac is crowded with arriving and departing airline passengers and planes.

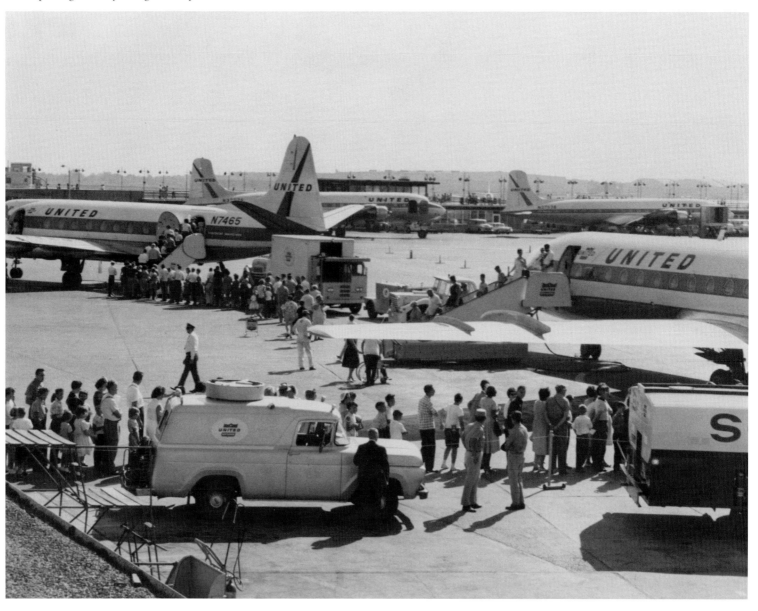

Old Stone (First
Presbyterian) Church,
ca. 1960.

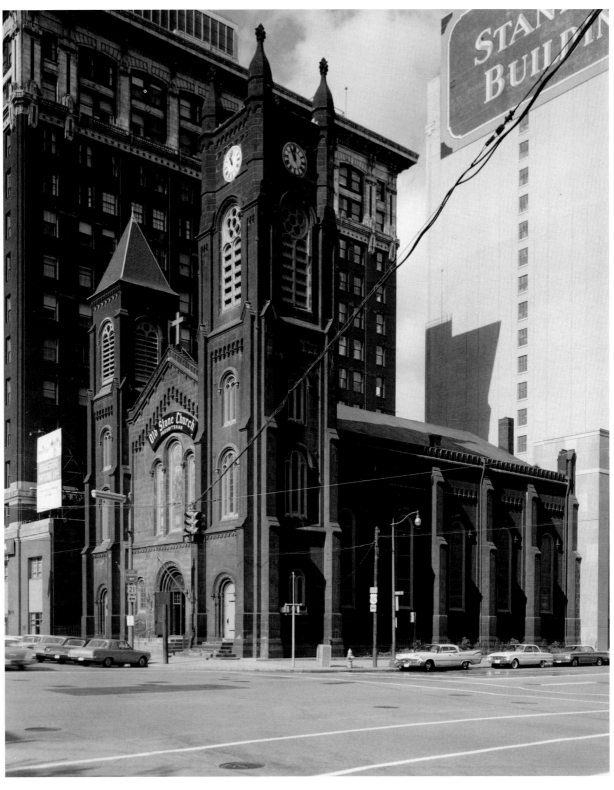

A band marches past Soldiers and Sailors Monument on Euclid Avenue in
a parade commemorating the sesquicentennial of the Battle of Lake Erie
during the War of 1812.

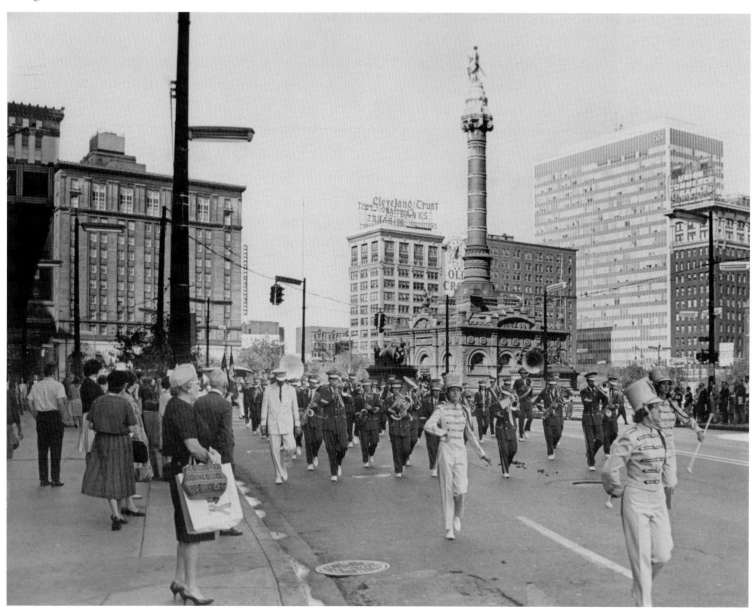

St. Michael Roman
Catholic Church, at
3114 Scranton Road, in
1965. Built in 1892 on
the edge of the Fulton-
Clark neighborhood,
the church is a local
landmark and the
232-foot bell tower is
recognized for miles
around. As a tribute to
St. Michael, statues of
archangels adorn the
church.

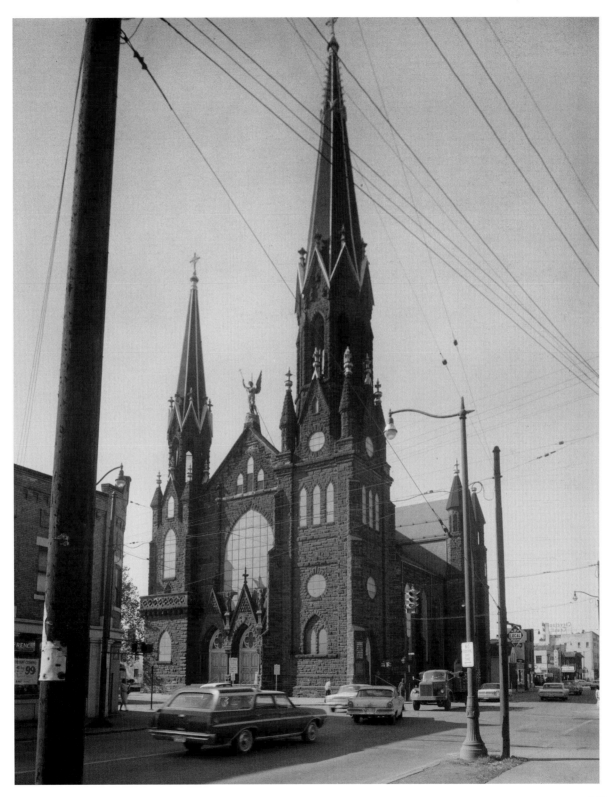

The Ohio National Guard patrols a street corner in the Hough
neighborhood following two days of rioting in 1966.

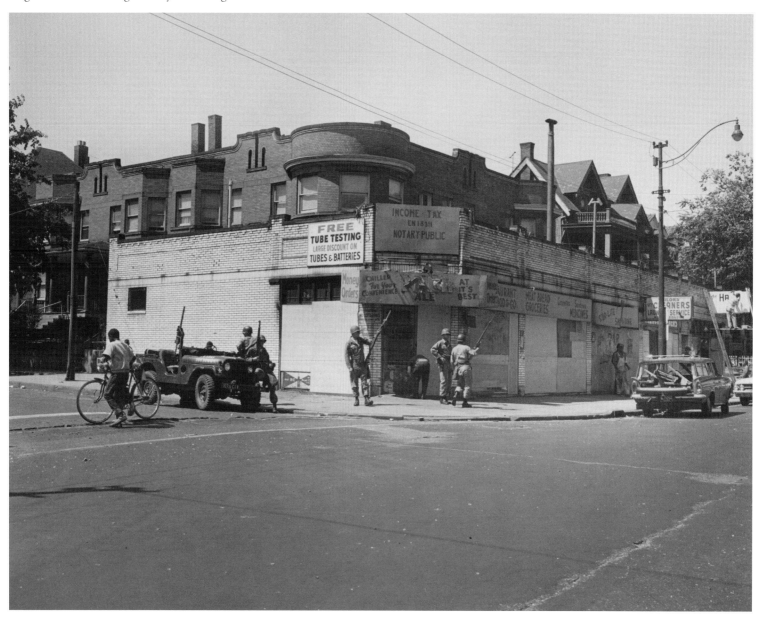

The interior of the Arcade, from the Superior Avenue entrance, ca. 1960. Built in 1890 and opened on Memorial Day, it cost $867,000 to complete. The structure is internationally known and has been compared to the Galleria Vittorio En Arcade in Milan, Italy. The Arcade is 300 feet long, 4 levels high, and is crowned with a glass-domed ceiling rising about 100 feet above the main floor.

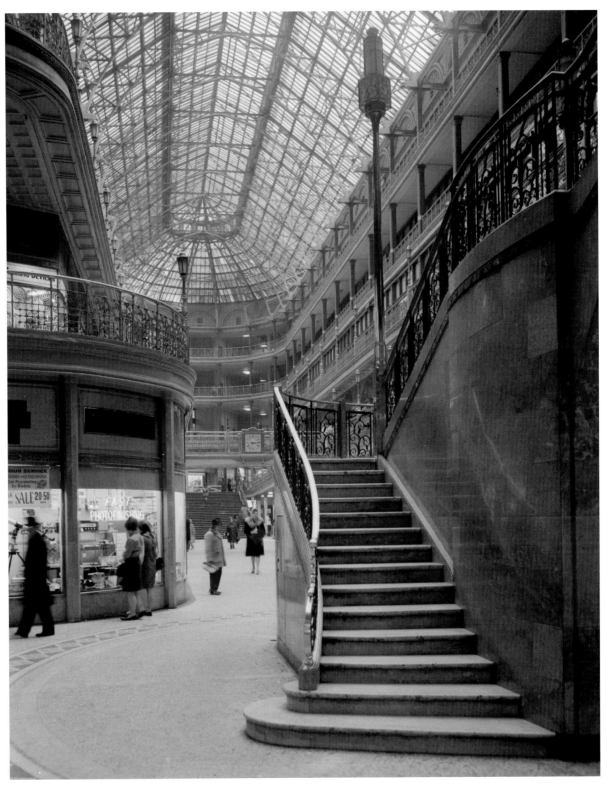

A view of the gardens at the Samuel Mather house on Euclid Avenue in 1965. This was one of the last remnants of Euclid Avenue's "Millionaires' Row" to survive. The gardens were later paved over and used as a driving school for the Cleveland Automobile Association.

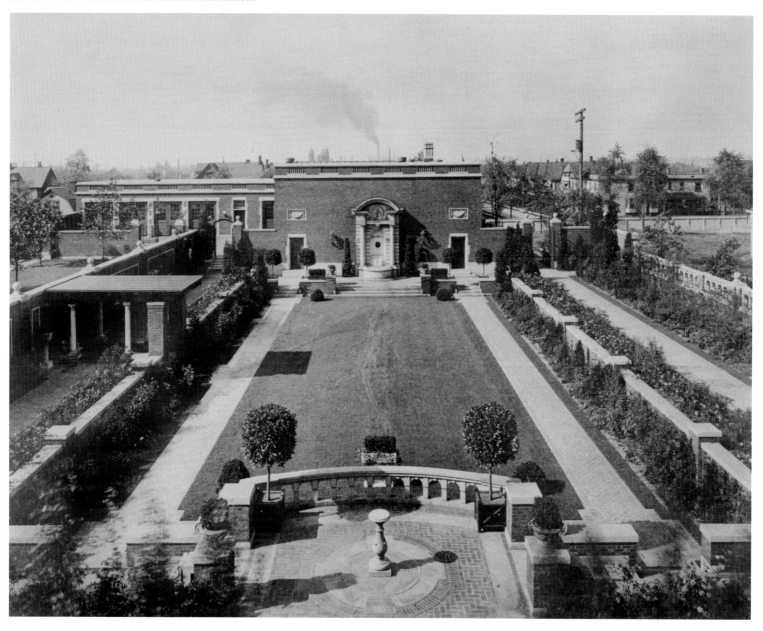

Carl B. Stokes campaigns for mayor in front of the White Motor Company on St. Claire Avenue in 1967. Stokes would win the election to become the first African American mayor of a large United States city.

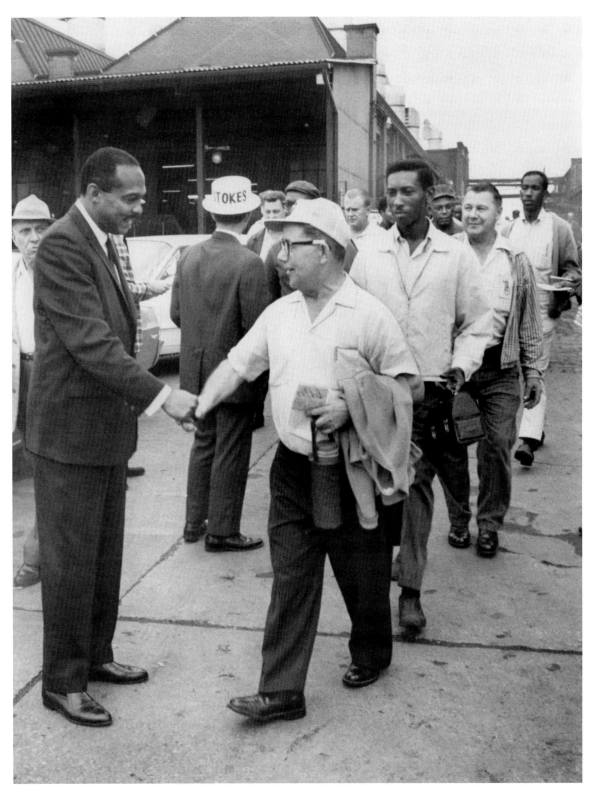

Jim Brewer, of the Cleveland Cavaliers, has a double problem here in 1976—
Dwight Jones (13) and Connie Hawkins (42) of the Atlanta Hawks.

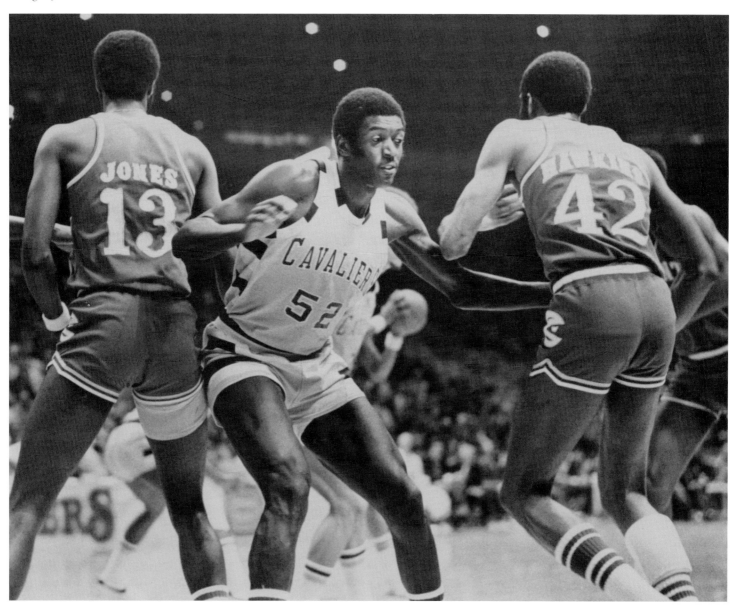

Euclid Beach Park closed in 1969 just one year short of being 75 years old.
All that remains is the archway entrance gate.

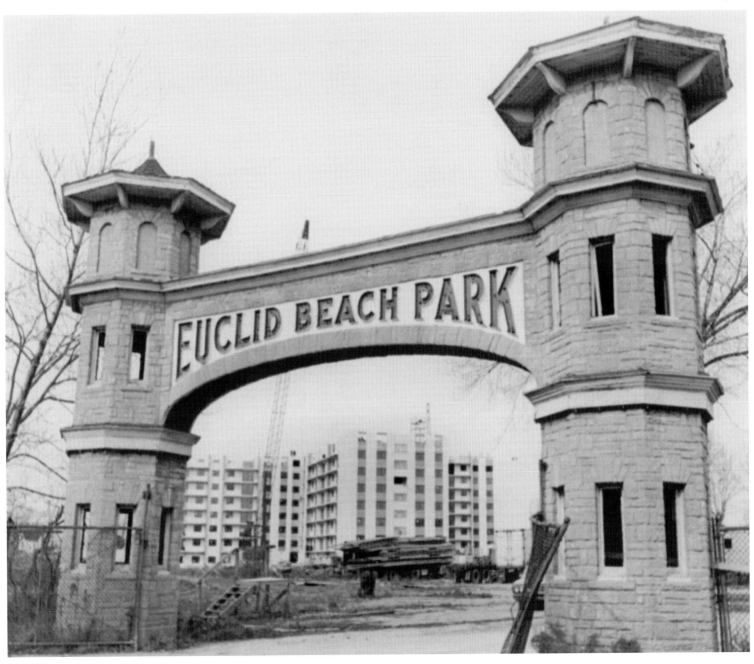

NOTES ON THE PHOTOGRAPHS

These notes, listed by page number, attempt to include all aspects known of the photographs. Each of the photographs is identified by the page number, photograph's title or description, photographer and collection, archive, and call or box number when applicable. Although every attempt was made to collect all available data, in some cases complete data was unavailable due to the age and condition of some of the photographs and records.